SUFISM
The Heart of Islam

SUFISM
The Heart of Islam

■

Sheikh Khaled Bentounés

Foreword by
Father Christian Delorme

Translation by
Khaled Elabdi
of interviews
conducted by Bruno and Romano Solt

HOHM PRESS
Prescott, Arizona

Cover design: Kim Johansen
Interior design: Book Works, San Diego, California

Library of Congress Cataloging-in-Publication Data

Bentounès, Khaled.
[Soufisme, cœur de l'Islam. English]
Sufism: the heart of Islam / Sheikh Khaled Bentounès; foreword by Christian Delorme; translation by Khaled Elabdi. p. cm.
Includes bibliographical references and index.
ISBN 1-890772-26-7 (trade paper: alk. paper)
1. Sufism. I. Title.
BP189 .B4613 2002
297.4—dc21
2002009224

HOHM PRESS
P.O. Box 2501
Prescott, AZ 86302
800-381-2700
http://www.hohmpress.com

This book was printed in the U.S.A. on acid-free paper using soy ink.

06 05 04 03 02 5 4 3 2 1

Originally published in French by La Table Ronde Editions, Paris, 1996.
Original title: *Le Soufisme, Cœur De L'Islam*. Original ISBN 2-7103-0719-7

Lá eláha ella 'Lláh.
There is no god but Allah.

■

"The servants of The Most Merciful are those who walk on earth with humility, and who answer 'Peace' to the ignorant who address them." (*sura* 25, verse 63).

■

"What is Sufism?"
Abu Sa'eed Abeel Khair, may God bless him, answered, "That which you hold in your mind, forsake it; that which you have in your hand, give it; and that which strikes you, it is meant to be."

To my beloved and venerated teachers,
To my brothers in the path of God,
And to the young in our society,
Our hope for tomorrow.

■

Acknowledgments

We wish to thank from the bottom of the heart all those who contributed, directly or indirectly, to the publishing of this book, by giving us a piece of information, by rereading and correcting the manuscript, by offering us a cup of mint tea, a smile . . . We also thank our parents whose help and availability were too precious.

—Bruno and Romana Solt,
interviewers and compilers

Contents

Destiny—*The Barzakh,* Heaven and Hell—Reincarnation—
Fear of Death

Translator's Note

Thanks be to God for all the blessings He has bestowed on us. Peace be upon our master and beloved, Mohammed Ibnu Abdee Llah, the last prophet and messenger, sent to us as a mercy to all, and on his family—a model of the Truth to those who consider them as such—and on his comrades—the stars of the right path for those who seek them as such. Peace be upon Jesus, Moses and all the prophets and holy men and women of God.

I am very happy to have been given the opportunity and privilege to dive again into the Sufi treasures of At'Tariqa Al Alaweeya by translating this book, *Sufism, The Heart of Islam,* whose source is none other than the honorable Sufi master, Sheikh Sidi Khaled Bentounès, the present head of Tariqa Al Alaweeya. It is by his consent that I have engaged in this work. I thank him from the bottom of my heart for this great honor.

The book in its general pattern represents a divine spiritual experience so special in its kind. It extracts from the religion of Islam its deepest truths and finest facts, all of which illuminate the servant's path toward God. On a deeper level, however, the book is an ocean

with no end, no shore, leaving amazed the brightest minds and the most pious of hearts.

It is not easy to understand a religion without going through it, step by step, in all its stages—educational, social, economic, spiritual. Sheikh Khaled deals with all these issues in a very explicit manner. Yet, behind every sentence, every word, every letter, there is an infinite number of messages for those who seek not the laws but their Maker.

In a world where freedom and love are but words on the lips, words that fly in the air, comes this book from the heart of Islam itself to expand people's views and ideas about religion and allow them to go beyond mosques, churches, synagogues and all dogmas of theology. Is it not somehow strange to attend a Friday prayer, a Saturday Sabbath, or a Sunday mass with the idea of cleansing oneself and then leave all behind once back in the real world? Where is God then? It seems as if He is left behind in these premises since people do not observe Him in real life.

Sufism, as presented by Sheikh Khaled Bentounès, is far from being an eremitic doctrine where masters and disciples lock themselves in remote places seeking personal spiritual achievement. It is rather a disciplinary path which seeks to unite mankind in all its aspects, body and mind, sight and insight, matter and essence; a path based on forgiveness, generosity, love and peace.

Simplicity in life, as described in this book, is what allows people to be at ease with themselves and with their fellow humans; it opens the way to interaction and dialogue, things so much needed in our world, for without them we are lost and far from realizing a oneness of being.

I hope that this translation is as correct as possible in transmitting Sheikh Khaled's views and ideas to those who are interested in going beyond their own sphere of living, those who seek a plenitude of being, above all restrictions, be they of language, race or belief. No matter how different we are, we still are the same—"And to The Lord is the final destination," says He Who is Above All.

I wish to thank my wife, Theresa Kruser, my mother-in-law, Mary Kruser, and all the friends who have assisted me in this project. In addition, I'd like to thank Regina Sara Ryan of Hohm Press for her outstanding effort and her gentle guidance in the editing of this book.

Footnotes of different categories were added to this translation in reference to verses of *The Holy Qur'an* or the *hadiths* (sayings) of Prophet Mohammed, peace be with him, from many different sources. This is a humble attempt to shed more light on the meaning of some words, phrases, and sentences.

—Khaled Elabdi

■

Foreword

by Christian Delorme,
Priest of the diocese of Lyons, France

I t is rather unusual for a Muslim Sheikh to manifest the wish that his
publication be introduced by a Catholic priest. I must say that I feel
honored and, at the same time, I fear not to be deserving of this trust
and friendship.

Sheikh Khaled Bentounès is the spiritual leader of a large mystic
brotherhood *(tariqa)* which covers tens of thousands of members in
the Muslim world; it is At'Tariqa Al Alaweeya. In the early eighties, I
had heard news about The Friends of Islam Association[1] which the
Sheikh initiated in Paris, and I had my first contact with it then. Later,
I discovered the book, *Sheikh Ahmed Al Alawee (1869–1934),* written in
memory of Sheikh Khaled's maternal great-grandfather by Martin
Lings, who is also the author of one of the most beautiful biographies
of Prophet Mohammed. The personality of this Muslim saint of the

[1]This association is known today as Terre D 'Europe.

twentieth century, who is the root of At'Tariqa Al Alaweeya, fascinated me. I still have on my desk a picture of this friend of God with the beautiful face of Christ at an old age. Later, I met some of the members of *tariqa* from Paris and Lyon, and at the same time I was amazed to discover themes and writings of the paternal grandfather of Sheikh Khaled, Skeikh Adda Bentounès, who is also a great spiritual figure and to whom we owe a great deal for a wonderful manuscript on Jesus, *Soul of God.*

Naturally, this progressive acquaintance with the spiritual stream of At'Tariqa Al Alaweeya increased in me the desire to meet Sheikh Khaled some day. The event took place in 1993, thanks to a mutual friend of ours who wanted to interview us in front of the cameras—fulfilling her part in the realization of a program on Arte [a French-German television station]. Right away the Sheikh and I felt friendship toward each other, and this was not only because of our similar age. His modesty immediately affected me; he, the spiritual leader of tens of thousands of those who seek God, came as an ordinary man, with no guards around him, dressed in a European suit, which made him look no different than others. I was more enchanted with his personality when he happily agreed to be the one to ask the questions instead of being the one to answer them. Throughout the show, it was he who asked me about my ministry of priesthood and my commitment against racism. Usually, it is from him that the members of the brotherhood expect a strong word; I felt confused!

The book of interviews which he publishes today at the initiative of Bruno and Romana Solt is a great joy to me, and I surely hope that this delight of mine will be shared by readers of different religious and/or philosophical horizons. Actually, this book, in itself, is a breakthrough, for it is one of the first times that a Muslim man of God exposes to a large audience, and particularly a Western one—an audience with a very limited knowledge about Islam—his faith, his relation with God, and the paths he undertakes to know Him who is above and within all things.

Sufism today is sometimes presented as a path above all religions. Sheikh Khaled firmly establishes it in the religion of Islam, of which it

is actually the fruit and, most probably, the heart. It is by diving into *The Holy Qur'an* that the Sufis first seek to benefit from the Presence of the Infinite. Sheikh Al Alawee beautifully expressed this idea in his *Deewan* (a collection of poems) when he said, *The Qur'an* "has fixed itself in our hearts and on our tongues, and it has blended with our blood, our flesh, and our bones, and with all that is in us."

By presenting with simplicity, yet with all its depth, some of the teaching which he usually transmits to the followers of his Tariqa, Sheikh Khaled renders a great service to Islam and to the Truth. He acquaints us with a mystic way of an exceptional spiritual richness which many of us in this era do not sense, influenced as we are by the images of violence in the Muslim world. This mystic way, of diverse tendencies, has sometimes been scrutinized by the most orthodox of Muslim organizations, but, at the same time, it has inspired Islam with its most beautiful prayers, its most beautiful hymns, its most beautiful poems. It is the Sufis who have spread the message of Islam in a large part of the Muslim world, from India to the Balkans, passing by the Sahelian Africa. And if this message were to disappear today, especially under the attacks of the orthodox and/or the so-called Islamic ways, it would be a huge mutilation for Islam and indeed for all religious quests regarding mankind.

Because of my position as a Catholic priest, I could by no means advocate syncretism. Christianity and Islam—not to forget Judaism—are branches of the same tree, the tree of Abraham. And yet they deeply disagree on the approaches and knowledge they have of God. But how can one not be full of admiration before "Those who, when God is mentioned, feel a tremor in their hearts," (*Qur'an, sura* 8, verse 2), those who, pure in their souls as spirits of the above, seek to be full of God by emptying themselves of all that is not He? How can one not see that those who maintain in themselves the perpetual memory of the Divine have God in them who proclaims in the holy book of *The Qur'an*, "We (God) are nearer to him (man) than his jugular vein," (*sura* 50, verse 16). Christian and Muslim theologians in the field of law—needed as they are—cannot completely agree on a subject

concerning God. But the men and women of prayer who have a heart that quivers at the mention and invocation of the name of the Almighty, these do have something real to share.

Sheikh Ahmed Al Alawee first, and then his successors, Sheikh Adda Bentounès, and Sheikh Al Mehdi Bentounès have had a most special attachment to the identity of Jesus. Involved as they were in the best of Muslim traditions, they always said, "Jesus was the divine who speaks divine; the divine soul revealed to our word," all of which is held by Christian hearts.

Sheikh Khaled is listed in the same tree of fidelity; his respect for Christians is enormous, but without diverting, from the paths of his Muslim faith. May his book then invite all Christians—and others too—to respect and learn to cherish the best of Islam. For the world today is in need of this effort on the part of the believers to understand and love each other.

Sheikh Khaled Bentounès in 1988

Introduction

by Bruno and Romana Solt

W hile searching for its own identity, Islam today is evidently in crisis. It is often reduced to an ideology because of ignorance and fear. And in spite of the abundant assets of its past, this secular culture has probably not always known how to adapt itself to the demands of the modern world. Sheikh Bentounès has shared with us his concern about the matter: under the fallacious pretext that it is all for the interest of Islam, and for political goals, knowledge has been chained and the Muslim scholars who could bring a revival to religion have not been heard. Those who today spread the message of Prophet Mohammed as an ideology use Islam in order to promote their immediate interests to the detriment of the interest of Islam itself.

Because of the current Muslim fundamentalism, there exists an "Islam" which occupies the media headlines. This phenomenon that is developing in many countries must be neither minimized nor overstated, but above all, it must not be the tree that hides the forest. It is

urgent to declare that there exists another aspect, another face of Islam, as Amadou Dramé has skillfully portrayed it:

> Islam is a religion which deals with man in his entirety. It takes into account his body, his soul, and the physiological and spiritual laws that control him. Islam is submission to God (Allah) and a path of realization. Islam advocates the total embracing of life and the human condition as it is. In this sense, it is a religion of the middle path, one that harmonizes the contrarieties of exterior-interior, profane-sacred, terrestrial-spiritual, going beyond the walls of separation, thus incorporating every single matter in itself in a balanced fashion.[1]

Far from disgrace, clumsiness, and deception, Islam is in essence an eternal message which can be lived in every era and in many different dimensions. In the Muslim community, the diversity of races is extraordinary. A cultural world separates the Mongolians, the Turkish, the Indonesians, the North Africans; still, they are all influenced by the same message, adhering to it accordingly, but without stopping their evolution within their own sociocultural environment.

This religion is recorded in a continual prophetic transmission which passes through Judaism and Christianity. It is therefore surprising and painful to see that these three religions, which originate from the same spiritual crucible, have generated for centuries so much lack of understanding and intolerance among them.

It is in the heart of this religion (Islam) that the ancient tradition of Tassawwuf (Sufism), which is the Muslim mystic way, is rooted. It is kept alive and passed on through an initiatory chain. In the case of Tariqa Al Alaweeya, forty-six spiritual masters have uninterruptedly succeeded one another, starting with Prophet Mohammed and his son-in-law and cousin, Ali, all the way to the present representative, Sheikh Khaled Bentounès.

[1]*Friends of Islam Magazine,* no. 7, p, 17; "The Perspective of Islam"; in *Aurores,* no. 59, November, 1986.

Sheikh Khaled was born in 1949 in Mostaghanem, a small town on the Algerian coast, a true sanctuary for Islam, but which is also famous for having been, in 1840, the scene of the battle of Mazagran during which the French laid siege against the rebels of Sheikh Abdelqader Ibn Muhyedeen. Sheikh Khaled descends from an old family of Mostaghanem, one that counts among its members men of law and religion, one of whom is the illustrious Muslim saint Sheikh Al Alawee, his maternal great-grandfather.

It was in April 1975, at the death of his father, that Sheikh Khaled Bentounès was designated as Sheikh of Tariqa by the congregation. It was a total surprise to him, for he considered himself less qualified than others to fulfill this mission. However, since that acknowledgment, he went through a radical inward transformation that made him turn his initial refusal into acceptance.

Today, in spite of his professional occupations, Sheikh Khaled travels all over Europe, the African countries, and the Middle East in order to transmit—in his turn—the traditional education of Tassawwuf, the core of Islam, this mystic way by which people rediscover how to "enjoy the savor of The Lord" in the silence of the moment.

The Sheikh is a discrete man, not to mention mysterious. In his presence, one discovers a quality of being and an art of effacement, both of which are an education on the depth of real human nature.

We must admit that between the time the idea of a book was conceived and the time we had our first meeting with Sheikh Khaled, three years have passed. He had never rejected this idea, but had always asked us to be patient, thus allowing the project to ripen. He was somehow ready to share his experience but was certainly not eager to talk about himself, even less engage in proselytism. We are, however, particularly sensitive to the fact that he had never written a book, and that this one is his first.

Contrary to what we normally read on the subject, this book is not an academic collection on Sufism, it is rather a testimony and a sharing of an authentic spiritual experience. This piece of work reminds us of the educational and spiritual foundations of distant history, and, as

the Sheikh will often repeat during his interview, its reading will never allow the exclusion of practice. And so, he who wishes some day to follow this path, must not expect to find a rose-lined trail suitable for a promenade.

All three of us have hoped that this piece of work would be as accessible as possible, so that we can offer it to a great number of readers, be they already engaged in this path or hopeful to discover the foundations of a very ancient spiritual tradition.

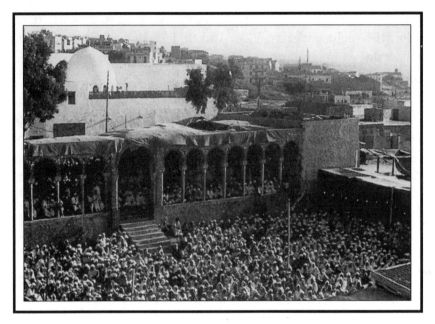

View of the Zaweeya of Mostaghanem (Algeria) in 1948

View of the same Zaweeya in 1967

I

The Years of Learning

The Educational Role of Zaweeya

I have lived a great part of my youth in the *zaweeya*,[1] a place where the community lives, works, and worships under the management of a master (Sheikh). There, I followed an appropriate schooling, one which we usually call a "Spiritual Instruction," involving traditional learning and an initiation. And although my father, Sheikh Sidi Hadj Al Mehdi Bentounès, was my spiritual master, four other masters had preceded him. Ever since I was four, I, together with the other children of the *zaweeya*, started to memorize the *suras* of the Holy Book under the management of a teacher of *The Qur'an*. And it was only later, about the age of fifteen, that we learned to interpret it. And then there was a teacher for the *sharee'aa* (Islamic law), Islamic rights, rituals, the moral code, philosophy, and grammar. And last, but not least, I had two other teachers, one for poetry and chant *(sama')*, which are tools for the exaltation of the soul, and the other to teach me the subtle and esoteric aspect of life.

[1] The great *zaweeya* of Mostaghanem, Algeria, the mother of all.

1

After this long preparation, upon reaching puberty, the age of religious responsibility, we were able to ask for the initiation which represented the entrance into the path where we received the "spiritual bondage" to the Sheikh—spiritual master—and through him to this tree of ancestry which goes as far back as Prophet Mohammed, peace be with him. It is only then that I was really introduced to my father. My relationship with him was mostly based on the model of a spiritual relation between a master and his disciple, rather than a kinship between a father and his son. Because of his numerous responsibilities and the importance of the community, I saw little of him, mainly in the morning and evening. In fact, I can say that I felt his presence mostly through the respect which all people who lived in the *zaweeya* showed him.

My father completely trusted the teachers to whom he delegated our education. But this did not impede him from calling me, from time to time, to ask me questions which would lead to a dialogue. In this respect, he never gave me any orders, always leaving me free to decide by taking his suggestions into consideration. After the spiritual attachment to the tree of ancestry, my father took charge of my education and became more demanding on the spiritual level.

The Public School

In 1963, our education was conducted by two French men—working abroad in lieu of military service—and one of them was a fervent communist. He taught us about the liberal and socialist authors, including the arduous reading of *Das Capital*. Taking my young age into account, I do not know whether I understood its meaning. One day, while I was immersed in the book of Karl Marx, my uncle asked me about this subject. After the few explanations I gave him, he protested, "What! This is heresy!" At dinner time, vexed, he went to complain to my father. I still remember the smile and the answer the latter gave him: "In order to recover from vice, we must introduce it, by small dose, into the body of the person. It is the principle of vaccination. Do not worry, they are in the process of vaccinating them!" In fact, in the *zaweeya*, my father had never prohibited me from reading *Das Capital* or any other profane writings. One must admit that it is rather paradoxical; there it was, the most anti-spiritual book in the heart of a Sufi brotherhood! He simply knew

that I was able to read a book, seemingly negative, and extract from it a profitable concept.[1] In this respect I was very lucky, for, unlike the other high school students who were fed from one source, I benefited from two brands of learning, one *liberal* and the other *traditional*. And even if at that time we commented on *The Devil and The Good Lord* by Jean Paul Sartre, I attended the Qur'anic school early in the morning and in the late afternoon, before and after public school.

The study of *The Qur'an* really started around the age of fifteen, and mainly during the month of Ramadan. It was a fertile period of time during which, under the supervision of the master, we commented and debated, sometimes till dawn, on the historical, ritual, and spiritual aspects of the Qur'anic text. In his commentaries, the master gave us half the truth. The other half we had to discover through our quality of reflection and our inner experiences. He never said, "Two and two make four," but "Two and two? . . . it is your task to do the addition." Truth is the same as butter, one must shake the milk well to separate the cream. The master gave us the milk and, through our efforts, our meditations, we were able or not to produce the butter. Of course, everyone advanced according to the quality of the task accomplished. Following the same path, we saw differences between us emerging, and the masters revealed certain things to some and not to others. It was a question of maturity. The teacher always said, "We do not feed a baby meat but milk." It is not because of our wish to see a baby grow up that we are to give it meat; we will kill it thus! We must rather feed it in stages. Prophet Mohammed, peace be with him, says, "Address people according to their ability to understand."[2]

[1] "I will keep excavating falsehood until truth bursts out from its side," Ali, Prophet Mohammed's cousin, used to say.

[2] There are many versions to this *hadith* of the Prophet, peace be with him. Ibnu Abbas, God bless his soul, reports it as such, "We were told to address people according to the ability of their minds." And Al Bukharee in his *Saheeh* (collection of the Prophet's sayings) quotes Ali, bless him, reporting on the Prophet, "Address people with that which they know, you surely don't want them to disbelieve God and His Messenger." And Muslim, in the introduction of his *Saheeh*, quotes Ibnu Mas'oud, God bless him, saying, "The Prophet, peace be with him, says, 'Every time you address people with a subject above their ability to understand, it would turn into confusion for them,'" (Tamyeez At'Tayyeb).

Zaweeyas have an educational function and represent a cultural anchorage. These days, we are witnessing the progressive destruction of these premises, or their marginalization, both of which bring a depersonalization to the individual in Algeria and in all countries of the Muslim world. Subsequent generations, who have pursued a standard education only, have lost their traditional points of reference. They were told they were Muslim, but in what way, if there exists no education allowing them to know and live this religion inside them? The situation does actually worsen if religion itself becomes an instrument used for power. Thus, during the cultural revolution in Algeria, some Qur'anic texts were manipulated in order to justify politics. I always ask myself, what on earth is the actual relationship between politics and *The Qur'an*? I cannot hide the fact that I find this relationship dangerous, and we surely can see today the outcome of this approach. People have lost their inner side, their spirituality. Religion has become an ideology, a manipulating instrument of people.

The Traditional Education

Spiritual education leads to the dimension of spontaneity; which means that everything that I do, I accomplish instinctively. The case is not so, however, in the West where speculation is omnipresent: "Why do I do this? Why do I do that?" When we are, from the age of four, nourished through the savor of the Lord, doubt does not exist. To worship God is like breathing! It is an integral part of our being. We all have faith, but some are less alert than others to this internal thought, which is a means to Self-consciousness, a means to the quest for the Truth.

Truth can only be acquired by one who is after it, and it is a permanent quest, for our perception of the Divine is in constant change. According to *The Qur'an,* "Every day, He is different," (*sura* 55, verse 29). He presents Himself to us in multiple faces according to time, term, and place. The Sufi education is never fossilized, fixed, or bounded. And so, there is always an ample liberty of thought and the need for a daily quest.

Some Muslims are then satisfied with their condition and do not try to go farther. Others believe that the human being is born and lives for one sole purpose, the encounter with the Divine, the Absolute. This

education prepares them for the experience of the ultimate encounter. We are not talking about an egoistic education, or an intellectual one, sought for the purpose of being assessed, honored, or in preparation for a diploma. The only goal here is to move to a life that is more and more enriching and ample, thus facilitating the encounter with the Absolute. This is the actual sense of the term, "realized."

Even though people need to eat, to have a family if they wish, to accomplish their duties toward society . . . these aspects are secondary, let's be clear on this! The role of this worldly life is not denied, but from the standpoint of the traditional education, the division between the two ways is clear. The absolute priority lies in anchoring in people this aspiration which will allow them to go forth toward God throughout life. The notion of uniqueness must never be lost from sight. This education aims at peace, at certainty, and submission to destiny, to the world. We must, however, make it clear that submission does not mean to accept everything; it is not passive. The Sufi is not a revolutionary in the sense we mean it nowadays, but rather a reformer, one who revives. The Sufi renews, but never uses aggressive ways toward society. He or she uses awakening ways. The Sufi fights the ego, but not the person; it is fundamental.

This is how we were strengthened in our youth, knowing that in our adulthood we were going to live moments of perturbation, difficulty, ordeal, happiness, sadness, and mostly, moments of forgetfulness. For this reason, traditional education had to engrave itself in us, while young, and create inside us a center, a conscience, and after that, only God decides on our realization.

This education usually ended at about the age of eighteen or twenty, and then came the pilgrimage. Some left and traveled all around the world, driven by this quest for knowledge and realization. Traditionally, this journey started from Morocco or the East. But in my case, Morocco was only a stop since I left right away for Europe.

The Escape to Europe

Difficult circumstances, or rather the Hand of God, caused me to leave Algeria. My father never imposed any choices on me; he simply said,

"You must protect this tie, never cut it; you must always be attached to something." He did not object to my choice of going to Europe, but he did make some recommendations. My departure coincided with the time when he was arrested, for the socialist ideology of that era was against the education offered in the *zaweeya*. We must know that this traditional education was being fought by certain authorities of the government to the point where a plot was instigated against my father, who was judged as being too influential. I, too, had created, together with other students of the *zaweeya*, an association to expose this education to the young. We were very dynamic, and, in only a few years, the movement had achieved a considerable growth throughout the country. Wanted as a very active member of the association, I narrowly escaped from being arrested.

On the evening of the eleventh of February 1970, I had to escape. Right before the arrest of my father, I quickly left for Morocco in order to join my maternal family members. It appeared to them that I would be safer on the other side of the Mediterranean. Taking their advice into account, I left for Europe.

Initiation into the Active Life

After a visit to the *zaweeya* of Ivry, in the suburbs of Paris, I went to Oxford and Cambridge in order to prepare a thesis on Islamic history. However, in spite of the intellectually and culturally rich environment, I found it hard to adapt to England. I then made the choice to go back to France, and, through the advice of a friend of mine, I started to get involved in business in order to meet my needs. We imported from Morocco, and from Afghanistan, handcrafted objects, clothes, and furniture. Our business soon flourished, for we dealt with the core of the Oriental fashion, especially through our inevitable pilgrimage to the city of Katmandu (the capital of Nepal). This business suited my education, since it was a question of building a bridge between the East and the West. Destiny had prepared me at a young age to engage in dialogue with different cultures.

I also recall from this period of time that I was never uprooted in my spiritual quest. I permanently lived in the *zaweeya* of Ivry. And

even if my father, as a master, was not physically present, he was so spiritually. Thus, I had the chance to find in Paris things I experienced in Algeria. The *zaweeya* represented an oasis in the heart of the highly charged business life. In it, I found my roots! At the same period of time, I met my wife, who was European and knew nothing about Islam. She was perfectly at ease in her culture and her tradition. In spite of difficulties, my encounter with her was very enriching. Way above rigid ideas, our union allowed us to concretely see whether the two traditions could coexist without the amputation of either of them.

The instruction I received in Mostaghanem was founded on faith, but I still lacked the experience. Having put faith on the path of practice, I was able to verify the foundation and the veracity of the education. In Sufism, God is present in the very heart of the most concrete problems of existence;[1] and practice renders all acts, even the humble ones, sacred. In Paris, amidst the usual business, I discovered a different state of mind; I discovered the other face of the coin. The latter was engraved with individualism and the "everyone on his own" notion, while I had learned only the value of sharing. I discovered a world where the strong crushes the weak, when I had learned to privilege the poor over the rich. In our faith, for example, we never break our word. And thus, when we fix a price in a commercial exchange, it is final. But when things appeared on paper, suddenly the parameters changed, and I was obliged to verify all, up to the comma itself! I can assure you that I had unpleasant surprises more than once because of too much trust.

Another important belief I have is that money is a means and not a goal. Money is useful to live and to nourish one's family, but we must also fertilize it in order to give it to those who need it most. The money we are given is not ours, it is only entrusted to us. It is in fact a test we are administered to see what we do with it. Prophet Mohammed, peace

[1]Sheikh Al Alawee says in one of his proverbs; "There is not an atom in existence that carries not a name of The One Adored."

be with him, says, "Generosity increases the span of life."[1] But if we say that the angels fix the dates of our births and our deaths, how can the span of life be extended? In intensity, I say! Generous people live more intensely, for the more they give the more they receive. Consider the image of a full cup; if it is not emptied, it cannot be filled again. But if it is, beneficial effects emerge. It is a continuity. Those who hoard money do no good, neither to themselves nor to others. But those who are generous benefit themselves greatly, they create an atmosphere of joy around them, and this increases their own delight in living. It is in this sense that they live intensely. Of course, generosity is not limited to money, but nowadays money is the master of the world.

Strong through this learning experience, imagine my surprise when I discovered that everything was only a matter of profit. A total absurdity! Profit for no other reason but for profit itself, and it is the stability of the individual and society that pay the price. For the profit of some puts the stability of the world in danger; people destroy their health, and neglect the upbringing of their children.

Spiritual Life and Material Life

If I had used my education only to protect myself against the aggressions of the outside world, I would have been deceived all my life. I would have lived outside this world without feeling it in its reality. The other face of the coin, too, represents a powerful absolute truth, with its followers and its masters. It was imperative for me to take into account this truth which controls the material world. All these discoveries and

[1]This *hadith* has been mentioned by Ibnu Abde Rabbehe in his book *Al Eqdu Al Fareed* —*The Precious Necklace*—in the chapter of invocation, "*Du'aa* is the believer's weapon, it pushes back destiny, and generosity increases the span of life." "Nothing pushes back destiny but invocation, and nothing increases the span of life but generosity," reported by At'Tabaranee and quoted by Salman. "Kindness toward the parents increases the span of life," reported by Ad'Daylamee and quoted by Ibnu Abbas, bless them both. "Generosity and kindness toward the neighbors increases wealth and the life span," reported by Ibnu Abde Al Barr and quoted by Abee Sa'eed, God bless them both. "He who would like his life span and his sustenance to be increased, let him be good to his parents, and keep alive his family ties," reported by Al Imam Ahmed and quoted by Anas Ibnu Malek, bless them both.

Sheikh Al Mehdi, father of Sheikh Khaled

experiences have allowed me to see for myself whether my spiritual convictions, my capabilities, and my limits, were strong enough. They have allowed me to better know myself and the world where I live.

The moment I speak, I have the conviction of being privileged. What I have received represents a considerable richness. I dealt with many people who lack this dimension. Today, I know that I possess an exceptional treasure which I must protect. It gives a sense to life, far from power, money, and glory—fake devices of happiness so dear to humankind. If men and women manage, in spite of the difficulties of life, to return to their essence, they calm down and perceive the ephemeral aspect of all things, happy or sad. This perception, this relation to the essence of their being, brings with it relaxation and submission. Why suffer if we lose something which lasts only an instant, when eternity enlivens us? But those who have never been tested, who have never been in need, or who have never been confronted with a hostile environment, cannot take off to look for this force, for they have remained captive in their own cocoon. If I had stayed in Mostaghanem, that is probably how I would have lived. I would have assimilated education without putting it into practice in the very arena of the contemporary life. My whole stay in the West consisted of putting my learning into practice and acquiring the force that resulted from it.

Spiritual Energy

Energy is like a compass; the indicator moves but never loses the north, it always comes back to the axis, to the right direction. One who holds a direction in life is able to choose this or that way in order to get closer to the goal. But first, they must know where they want to go. I repeat, this education gives a precise direction: uniqueness. We do not get lost in adverse paths, and if we do, it is so that we can better learn and progress. One who does not make mistakes is not a human being. We must correct constantly; it is the game of life!

Energy always takes us back to the true nature of man. It reminds us not to cross the border between the human and the animal. For what do we know about that which resides deep inside us, about the con-

tents of our unconscious? Demons lie dormant in our bosom, and they can generate worse conduct than that observed in the animal kingdom. I can affirm that the spiritual education I received is a stronghold against crime, depravation, hatred. When we assimilate this kind of learning, we cannot fall into such ideas or acts. We can be angry, but we can never hate another human being. A constant self-reminder comes to being.[1]

The Death of My Father

At this period of my life, another test deeply transformed me: the death of my father. Had he been a father more so than a master, I would have suffered intensely, and for a long time. In fact, the moment he was declared dead, the intensity of my suffering expressed itself in an instant. In the face of death, spiritual education protects, for we know in a

[1] In his collection of *Al Ferdaws,* Ad'Daylamee reports Oum Salama, God bless her, saying, "When the Lord wants to bestow His blessings on a servant, He provides him with a reminder from within himself advocating good and renouncing evil."

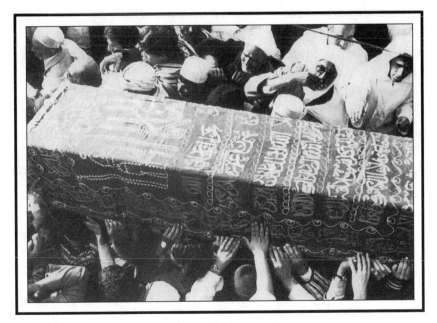

Funeral of Sheikh Al Mehdi

very intimate way that the master does not die.[1] We do not attach our-
selves to the body, which is nothing but an illusion. Before the death
of my father, I had a hard time conceiving this notion. His departure
allowed me to experience it, intimately that is. I used to tell him that
the dearest being for me was the master, and he used to answer, "The
master? What do you hold on to? The true master is he who destroys
all idols in order to reveal the Lord Almighty in the disciple." On an
intellectual level, it was perfectly acceptable, but when it really hap-
pened . . . when I saw the coffin and touched the mortal remains, it
was a terrible shock, as if I were outside reality, and I was unable to at-
tend the funeral ceremony.

Succession and Transformation

In the Sufi tradition, the master never designates his successor. It is the
duty of the community. The sages gather amongst themselves in coun-
sel; they pray, meditate, and fast. During this period, every one of them
receives a sign which can be produced during a dream, a vision, or
through intuition, all of which become concrete subsequently. In my
case, this happened even before my arrival at the burial ceremony, and
it is only after the funeral that I was called to the mausoleum wherein
the circle of the sages took place. Then, each one of them came to me,
giving me his rosary and offering me his hand in order to renew his
oath of allegiance. I told them they were crazy, that they were defi-
nitely mistaken, that just because I was the son of the Sheikh I did not
have to take his place. But soon after, I had to admit that I could not
fight their decision. A part of me was in constant refusal, but at the
same time, I was feeling a deep transformation inside me which corre-
sponded to the progressive emergence of another character.

This process lasted for three months, and I must say that it was very
intense and difficult to endure, both psychologically and physically. At
night I sweated profusely and could not sleep, and during the day I

[1]Reference is to the Lord's words, "Think not of those who are slain in God's way as
dead. Indeed they live, finding sustenance in the Presence of their Lord; they re-
joice in the bounty provided by God," (*sura* 3, verses 169-170).

vomited constantly and felt as if my chest was burning. I was able to eat only very pure things, and in small quantities. I had an aversion to everything that contained animal life. At the same time, it seemed to me that I was able to live some aspects of the mystic education I had received and which I was not able to understand—up until then—except on the intellectual level. I was living a double life and a journey through time. I was also receiving teachings on another level. Traditionally speaking, people talk about spiritual entities, angels, demons, and genies, and form their own ideas about them. At that moment, I was directly confronted with this reality.

This internal transformation grew day by day, as if a being was leaving and another one was replacing it at the same pace. The Spirit took possession of my body, which had already been prepared to receive it. The transformation was both psychological and physical. I was living these changes without having asked for them. It was as if I was being transported into another world. It is difficult to explain; it is a radical experience.

This process can be compared to birth, to maturity, in the image of a child who leaves the mother's womb—it cannot return to it anymore. In the womb the child was fed, but it was another world, one that is sealed. After birth, the child's status has changed, so have his world and his nature. It is from this standpoint that the transformation is radical. This experience has a beginning and an end, with no return.

When we talk about realization, it is a matter of different stages; we discover different inner states. We live them through the body, the mind, and the spirit, all of which, completely absorbed in the contemplation of the Lord, lose their illusion of what is left and wholly dwell in Him. Whatever direction we turn our sight to, He is there.

A Sufi travels a long way to Mecca, and out of exhaustion, sleeps with his feet facing the sanctuary of the Kaaba. A devout person passes by and shakes him, "Aren't you ashamed to stretch your dirty feet in front of God's house!" The Sufi responds, "Brother, help me, tell me where I can put my feet, show me a place where He is not!"

The enlightened sees God in every thing and in every space. Whether in the company of family or alone, whether asleep or awake, whether eating or engaged in any task, the Holy Presence is there, everlasting. If It were to disappear, the person would die. An atom which no longer turns around its nucleus is in the process of destruction. The moment it stops, it is annihilated, it disappears. The Holy Presence is always around, and It expresses Itself through silence or words, through music or recitation. It is a constant reminder, sometimes intense and burning, other times soft and affectionate. The difference here is of stations, of degrees, not of facts. We understand that we are only the shadow and that God is the Light from which we draw our existence. Let's take an example. What is the human being? Conscience, mind, spirit, body. And if we look closely at this body, what is it? Flesh, blood, muscles, bones. And if we look even closer, cells; even closer, molecules; and then atoms. Where is this truth of humanity to be found then? Who is man? The atoms which turn around a nucleus and of which we are made up are the same ones that make up the wall, the table. These atoms are in the air, in the sea, in the tree. What are we then? That is why we go back to this verse from *The Qur'an,* (sura 24, verse 35), "God is The Light of the heavens and the earth. His Light is comparable to a niche and within it a lamp. The lamp is enclosed in a glass; the glass as if it were a brilliant star. The lamp is lit from a blessed tree, an olive tree, neither of the East nor of the West, whose oil illuminates though fire touches it not. Light upon Light! God guides to His Light whom He wills. God sets forth parables for men, and God knows all things."

He is the light; it is through It that we see, it is through It that the universe exists. Existence is in God. Outside of Him, nothing exists.

Some people experience a desire for the Lord, a desire for the Absolute that surpasses everything. It is a great desire, comparable to a fire which takes them as a dwelling and embraces them. Because of this desire, all that reminds them of the Divine, that gets them closer to Him, transforms them and enlightens them. They begin to hear and to see more profoundly. The sound of the wind, for example, suddenly becomes a language for them; it talks! Everything talks: the noisy leaves, the running water, the singing bird. An opening over a new

world, which is already here and of which we are unconscious on a daily basis, is created. We can also perceive the discrepancy between the outward aspect and the real being of the individuals.

I had nothing to do with this transformation. If the quest for God was my main motivation before, it is possible to say that after, He imposed Himself on me. I simply had to submit. It is the submission of the soul to the Spirit. The soul has no choice, and the more it resists submission, the more it feels pain, until it surrenders and feels appeased. It is like a hammer that forges you. If the metal is really hard, we put it in fire until it becomes more moldable. God acts the same way. He forges you until He makes of you that which He desires. I am talking here, of course, about my own experience. And if this transformation happened to me, it is because there was some basis for it. The being was prepared. But I can say that I had no control whatsoever over this change. In fact, I was the spectator and the subject therein. It was no longer a matter of knowledge, education, and practice; it was real-life experience.

The result of this transformation is the extraordinary sensation of feeling concerned by everything. The Sheikh lives then in the essence of the eternal being whose function is beyond time. He is at the receiving end, just like the ocean in which flow streams and rivers. All creatures come to him. He exists through them and sees himself in every single one of them. He is the rescuer of all, the good and the bad. Sheikh Al Buzaydee, the master of Sheikh Al Alawee, used to go to brothels to teach prostitutes, whom he later married to his disciples. "There is more merit," he used to say, "in getting people out of hell than in teaching good men." Sheikh Adda, too, created craft schools for delinquents.

Every person finds what he or she needs in the answers of the Sheikh. It is as if the latter responds to one hundred questions in one answer; everyone can address themselves: "The Sheikh is actually talking about me," or " He is answering the question I have not asked." Sometimes, people who do not even know the Sheikh come to him spontaneously and are thus appeased by his words or feel good in his company. An atmosphere of peace and trust is established.

It is possible that nature has prepared certain creatures to receive more than others. It is their destiny, involving no merit on their part. It is a choice instituted by a higher will that surpasses all of us. The human person takes the path, but their endeavor is already pre-established. The way is already outlined; we do nothing but follow it. We place our steps here and not somewhere else. We are the artisans, we are the ones who perform, give, and speak, but it is only afterwards that we realize there was a will in the matter and that we had to take that way and not another. We can say there is free will, but it is so ephemeral! When we make an evaluation of our lives, if we really had free will, we would only choose things that were to our benefit. There are so many occasions, however, when we perform acts that harm us, acts which we swear never to commit again and yet end up repeating. Those who are on the spiritual quest must have no presumptions of their own. When they take the path, they must simply do what it asks of them. The rest is in the Hands of God; but they must, of course, desire Him. In fact, is it not He who has desired us before we do Him? Who has desired first?

I was twenty-six years old when I was designated by the assembly of scholars to succeed my father. I could not believe it, because the position was of such great importance. In fact, I thought it was a matter of provisional duty, and that the real master would appear after some time. Confronted by this new orientation, I was able to understand the great importance of the five-year experience I lived in Paris. I was able to live life just like everybody else, taking care of daily problems, of money; I was able to live all values. I believe that this was the secret behind my readiness. Destiny had prepared me to live and integrate these two experiences, this bipolarity: the experience of the spiritual life that I had acquired through the traditional education, and that of the material life with its different facets.

After my nomination, I discovered that the material structures of *tariqa* were profoundly weak, for when my father was imprisoned, every material asset (schools, land, prayer sites) was disintegrated and nationalized. These tribulations took us back to the fundamental question, "What is the essential thing in this path?" Without any material re-

sources, were we able to assume this spiritual heritage? This difficult test was good, for it allowed us to separate ourselves from the superficial. The events helped in reorientating each of us toward the fundamental understanding that it is God Who gives and it is He Who takes away. Whatever He takes today, He may give back tomorrow in a different way; material goods are not the essential thing in the path of God.

With these new concepts in mind, and after multiple trips, I liquidated my business in France so that I could entirely dedicate myself to *tariqa*. This was a heavy burden, and the financial resources of the *zaweeya* were feeble. There were 130 people living permanently in the building, and they all needed to be looked after. Besides, there were other *zaweeyas,* not only in Algeria where the political situation was very delicate, but also in Morocco, in other parts of Africa, as well as in the Middle East and in Europe. I had to get back in touch with them, reestablish contact, and find those who could take charge of education. Thank God, the people who designated me as their leader also assisted me in all areas, spiritual, psychological, and financial. Whenever I summoned somebody, the response was immediate. People did all they could to be totally available, and never did anyone try to avoid responsibility.

Moreover, when our opponents noticed that the newly elected was a young man with long hair and living in Paris, they did not find me dangerous. Our heavy burden was then alleviated; that allowed us to breathe a little and, in secrecy, begin to reassemble the pieces in a slow fashion. Little by little, things went back to normal.

My contacts with Europe were useful. We accomplished there every business we could not do in Algeria: meetings among delegates, seminars including about three thousand people, all of which has allowed this flame to subsist. Europe has been a sanctuary, permitting and facilitating this transition.

II

The Sufi Tradition

The Sufi tradition is hardly known and engenders many misconceptions, such as the link between Sufism and Islam. We often think that they are two different things, when Sufism is in fact the esoteric way of Islam. We can say that if Islam is a body, Sufism is its heart.

Sufism and Islam

Islam has been turned into an ideology, a narrow religion, something limited. Most people even confuse Islam with the fact of being Arab, thinking that it is the same thing, when two thirds of Muslims are not Arab. We cannot say that the Europeans, the Pakistani, the Indonesians, the Turks, the Iranians, and the Muslims of Africa are Arab! But the Muslims have absorbed some traditions—Arab, Berber, Oriental, Asian, or African—which were not originally Islamic. Islam is way above all of this.

After the advent of the Prophet, peace be with him, Islam spread in different countries where it blended with the native customs. This interpenetration has given birth, with time, to a mixing of the Islamic message with the pre-existing ancestral traditions. Even today, out of

ignorance, people confuse Islam with custom, religion with culture, the essence with the shape. Most of the time, everything that is decided and accomplished in the Muslim countries is, in its major part, based on custom rather than the directives of Islam in the strict sense of the word. The question of the veil[1] is very revealing in this subject. To be Muslim is not a matter of dressing this or that way. As the Prophet, peace be with him, has so eloquently put it, "God does not look at your appearances, or at your acts, He looks into your hearts [the intention]."[2] Islam is always based on the intention and on the peace of the heart. The proverb, "You cannot judge a book by its cover" is true for the Muslim, and even more for the Sufi, who lives Islam not only in the word but particularly in the spirit.

Islam is a divine revelation, eternal in essence and without any bias, which incites man to discover his potentiality and all the richness that inspires him. Very often, and with obstinacy, human beings limit themselves to their immediate external environment and refuse to relate to their internal energy. They do not want to see that they live only to witness and transcend this perpetual miracle of life. And so, we can say that this message is enlightening—that it appeases us; it makes one a better person with oneself and with others; and that it pushes one to act in the way of peace, goodness, and mercy. We have placed *The Qur'an* in a computer program, and this allows us to see that there are many verses where God, speaking of the believer, reminds us that we cannot be believers unless we act the right way. If evil is committed, the act itself shows that faith is not yet present, or that it is blind or immature.

In this respect, we can say that there are Muslims and that there is Islam. When a person is Muslim, it does not necessarily mean that he or she is a believer; it only means he or she believes in Islam. We can be Muslim by birth, because of the fact that our parents were Muslim

[1]Veil or *hijab,* as it is called in Arabic, refers to women dressing in a discrete and modest manner. This notion has been carried out differently based on cultural and political environments.

[2]Reported by As'Sayootee in different wordings. Muslim reports it as such, "God looks not at your bodies or your shapes, but at your hearts."

themselves, and without having really asked ourselves the question: "Why am I Muslim?" Islam requires that every person, individually and voluntarily, adhere to this message and put it into practice. Most people do not experience it, for there is a difference between things we choose and things we are subjected to.

In order to live the divine message, man must know that he is to make various efforts, accomplish some things, and reject others. In Islam, men and women cannot have rights without having obligations, for the two are inseparable. But people today do not like constraints or responsibilities. They want everything with no effort.

It is true that Muslims nowadays, like everyone else, are going through a crisis concerning their religious identity. But no matter what we say about Muslims, Islam remains a stimulating message, up-to-date, that unites man with the Absolute. It is a religion where the invocation of the Supreme Name and the transmission from teacher to disciple are kept *alive*. We are not talking about wise or realized people in the past, but in the present, for they live among us and give us examples. Let's not then fall into confusion; there are Muslims, and there is Islam. I am sure that the original Islamic message will always remain alive, even if the Muslims today have strayed far from it. It is urgent that they return to it! Being Muslim myself, I say it with full knowledge of the facts.

The Origin of Tassawwuf

Let's go back now to the word *Tassawwuf,* which is the exact Arabic term for Sufism. The origin of this tradition goes as far back as the dawn of mankind. When we ask the great masters about this subject, they all affirm that Tassawwuf started with the advent of humanity. The moment man became conscious of his relation with the Absolute, he started looking for the Truth. With the advent of Prophet Mohammed, peace be with him, the Sufi precursors were named *hunafa,* and they were even mentioned many times in *The Qur'an:* "And they have been commanded nothing but to worship Allah, offering Him sincere devotion, being true in faith (*'hunafa),* to establish regular prayer, to give alms. And that is the religion right and straight," (*sura*

98, verse 5). It is the case of Abraham, peace be with him, who is mentioned in the Holy Book as a *hanif*. We thus have the proof that these people existed before the Islamic Revelation.

There are many versions on the origin of Tassawwuf. Some do not hesitate to affirm that Sufism has no root in Islam. Others link it to the Indo-European civilization. It is true that man has always been thirsty for God, and, while reading *The Qur'an,* we can easily see that Sufism has been able to express itself in many ways. But with the birth of Islam, it wedded the Mohammedan revelation in both its exoteric and esoteric aspects.

In the beginning of Islam, the revelation Mohammed, peace be with him, received, consisted of two messages: one for common mortals, and another, more subtle and more esoteric, for the intimates. That is why the Prophet, peace be with him, used to ask his companions, before uncovering secrets of this mysterious wisdom, "Is there a stranger among you?"

In fact, the Sufis have the same obligations as all other Muslims. But, in addition to this characteristic of obligation which religion imposes on them, they are the ones who will seek God, for their thirst for Him can never be extinguished. The Sufi will take a path already marked by the experience of the masters who have traced a clear and limpid way where love, humility, and brotherhood stand solid. Tassawwuf is the pearl of Islam! With time, this path becomes a memorandum, kept alive and authentic by the masters. When the Muslim world is in deep crisis, it always ends up calling them for help. Their presence assures a return to the source, to stability, and to a new beginning. Whatever the era, each master is a revivalist of the essence of the prophetic message. "At the beginning of every century, God sends a man to revive your religion," as the Prophet, peace be with him, says.

Historically speaking, Tassawwuf did not become a real school—with masters, a discipline and a brotherhood—until after the Mohammedan Revelation. Sufism goes as far back as the first companions of the Prophet, peace be with him. It is said, "In the beginning, the name Tassawwuf did not exist but almost everyone was Sufi, whereas today the name exists but there are few Sufis." There still exists in the

mosque of the Prophet, peace be with him, in Medina, an elevated place called Ahl As'Suffa, right in front of his tomb. At this spot, his companions used to practice their prayers, invocation of God, *dikr*, and meditation. They were the guardians of the tradition (*sunna*) and the Name. It is them whom God mentions in *sura* 18, verse 28, of *The Qur'an:* "And keep yourself in the company of those who, morning and evening, call on their Lord, seeking His Face. And let not your eyes pass beyond them, seeking the pomp and glitter of this life; nor obey him whose heart We have caused to neglect the remembrance of Us, one who follows his own passions, whose case has gone beyond all bounds."

Other dubious theories, even biased, affirm that the origin of Sufism is linked to the contact of Muslims with the Indian peninsula, with Buddhism or Hinduism, or even Greek philosophy. All of this is erroneous. Sufism is in fact an ancient tradition that has been reactivated and anchored by the message of Prophet Mohammed, peace be with him. It has organized itself through the line of the masters. The source is *The Qur'an* and the message of Prophet Mohammed, peace be with him, and after him his kin, Ali. In one of his sayings, the Prophet, peace be with him, says, "I am the city of knowledge and Ali its gate." This is a confirmation that Ali is the first link in the esoteric chain to which all the others are connected.

Some have subsequently privileged the offspring of the Prophet by choosing Ali and his descendants as the only secular and spiritual successors. They have been called the Shiites. For them, this transmission can be passed on only through the direct bloodline of the Prophet, peace be with him—his kin and his grandchildren. On the other hand, the Sunnis, who represent eighty percent of the Muslim community, do not consider kinship to the Prophet, peace be with him, as an absolute criterion to claim this supreme function among people. According to them, it is not necessary to be a descendant of the Prophet, peace be with him, to be able to lead and guide the Muslim community. On the basis of this assumption, they declare that the successor of the Prophet, peace be with him, can be any Muslim, provided he is able to govern with justice and unite all the faithful. Here, the spiritual di-

mension is not taken into account. It is only a matter of temporal qualities revealing a straight man, just and competent, designated to be the guarantor of the religious law. This divergence has never ceased to raise disagreements and misconceptions among Muslims.

Let's now return to this spiritual chain whose source is the Prophet and his revelation. Ali is the first link therein, and then his sons. Later, this chain stretched outside the blood family of the Prophet, peace be with him, and branched out. There were Arab masters, Berber, and Persian teachers too . . . and we can say that these masters are part of the spiritual family. One day, the grandchildren of the Prophet, peace be with him, ran toward him, and he covered them with his cape. At that very instant, he looked up and saw Salman Al Farissee, the Persian, in front of him; he was a stranger and without family. The Prophet, peace be with him, said then, "Salman, come!" and he covered him too saying, "This is my family." The Sufis say that the Prophet, peace be with him, has integrated in his kin the notion of the spiritual family. We can then be part of this family without being Arab, for the notion of the spiritual family started with the Prophet, peace be with him, himself. First, kinship exists through blood and spirit, and, with time, it expresses itself only through the last aspect.

Mohammed, the Prophet Messenger

There are two types of prophets, the prophet messenger (*rassul*), and the prophet (*nabi*). Islam was revealed through the message received by Mohammed, peace be with him, who was the channel of the divine plan. With this title, we define him as prophet messenger, for his spiritual message changed that which existed before him. Among the principal prophet messengers (*russul*, plural of *rassul*) there is—starting with the nearest one to us—Mohammed, peace be with him, then Jesus, peace be with him, and Moses, peace be with him, etc. But between them, there were many prophets (*anbeya*, plural of *nabi*) who came to remind people of the Truth, human destiny, and its relationship with God. Jesus, peace be with him, is a prophet messenger, for he has renewed the Hebrew message of Moses, peace be with him, who was sent before him. We can see that between Moses, peace be with

him, and Jesus, peace be with him, no prophet has renewed the spiritual message—they always restored the message of Moses, peace be with him. In a way, humanity has evolved through the message of these messengers.

The messenger declares that the preceding message is no longer fit for the era and reveals a new version of it. Thus, each prophet messenger was given a different title. Noah, peace be with him, is the "Savior of Mankind." Thanks to the ark, he has allowed the human species—who had reached a level of perversion and decadence so low that it could no longer attain the Divine—to regenerate. In his time, there was a rupture which needed the sacrifice of a large part of humankind to save the rest of humanity. Noah, peace be with him, is considered the symbolic artisan of this rescue. In this prophetic genealogy, Abraham, peace be with him, is called, the "Friend of God," for he highly incarnates this intimacy, this friendship between man and the Divine which is so eloquently revealed in his message. The biblical patriarch, Moses, peace be with him, is the "Speaker." It is he who incarnates the Divine Word. From the standpoint of Muslim esotericism, he is the man who has searched for the Truth and who has been approved. He has reached knowledge because it is through the Word that it has been revealed. He is the "Connoisseur" par excellence. As for Jesus, peace be with him, he is called the "Spirit of God," for he highly incarnates the Divine Essence. And that is why Jesus, peace be with him, has decreed no laws, written no books, and has transmitted his message only in parables. His words and his acts puzzled the audience of his era, for these were pure spirit, whereas people abided by words.

All these prophet messengers have played a decisive role at very precise epochs of the human evolution. They appear when humanity passes through a serious rupture or when it falls prisoner to a message that does not allow it to evolve anymore. That is when it needs a new revelation, a new message, one fit for the new situation. These messages go through the prophet messengers (*russul*), while the mission of the prophets (*anbeya*) is simply to recall the contents of the messages of those who precede them. It is for this reason that, in the tradition of Tassawwuf, all these messengers are actually only a succession to this

source of Divine Light which reveals itself in every era according to the evolution, the maturity, and the spiritual understanding of people. In the Muslim esotericism, they all incarnate the same Spirit, which returns with a new face and new attributes, and which always appears when humanity needs it. There exists no contradiction between the first messenger and the last one, and the successive revelations are in total harmony and complement each other.

In fact, there is no contradiction among Judaism, Christianity, Islam, and all the religions which came before them. Muslim tradition counts approximately 180,000 prophets in the history of humanity, among whom 315 are messengers, and of the latter we know only a few. Mankind is ancient, and some messages lasted for many centuries. We always number the span of life of the message and not the terrestrial existence of the prophet.

Returning to the Islamic message, we notice that it has reached its zenith in the space of a century. Contrary to popular belief, this dazzling expansion is due to the novelty of the message more so than to the cutting edge of the sword, as the derogators sometimes try to make us believe. It was a liberating message.

The message revealed words of the absolute unity of God's worship, and the equality of all people in His Hands since there were no more mediators between man and God. It freed people from idolatry and gave them the sense of oneness. The Arabs worshipped 360 divinities inside the Kaaba. Every tribe had its own idol. Right after the Revelation, nobody could claim having a personal god. The base was and still is the One, the center of the circle; man was then directly connected to unity.

The Revelation showed thereafter this great freedom that men and women hold to be directly linked to God without having to go through sacerdotal castes. No more mediators, which meant no more churches, and consequently, no more priests. This cast out those who profited from their positions. For the Byzantines or the Egyptians, as an example, prayer could not be accepted if it did not go through a priest. For Christians, an ordinary person of faith could not celebrate mass.

After the Revelations, there were no more distinctions—neither social, nor racial, nor intellectual. When a person embraces Islam, he

or she is equal to the Prophet, peace be with him, who says in the matter, "Nobody is higher than the other. You are all equal, just like the teeth of a comb."[1] These notions seemed very revolutionary at that time when the world was divided into different social and sacerdotal groups.

That was the end of religious monopoly. Since then, the divine message was finally reflected in the holy and transcendent word contained in a book, *The Qur'an,* which was put in order and memorized during the time of the Prophet, peace be with him. Omar assembled it,[2] and Othman made the first copy which is the matrix of all the Qur'ans existing in the world. This matrix still exists today at the Topkapi museum in Istanbul.

The Golden Age

Islam then rapidly expanded, but, like every temporal thing, it encountered a crisis (*fitna*) on the political level. There were those caught in the trap of power and its connection to the economic and military expansion, as there were guardians of the tradition—those who awakened people's conscience, who ceaselessly reminded the community of their obligations, their duties, and mainly their attachment to the Source. At the very heart of the confusion, some schools appeared in different places in order to keep the tradition alive. In Iraq, there was Hassan Al Basri (642–728), Ja'far As'Sadeq (702–765), Rabee'aa (Al Adaweeya) (713–801), and Al Junaid too (?–910); in Morocco, Abdes'Salam Ben Mashish (about 1150); in Turkey, (Jalalu Deen) Rumi (1207–1273); in Andalusia, Ibnul Arabee (1165-1240), etc.

[1]Ad'Daylamee quotes Anas, bless them both, in a different *hadith* of the Prophet, peace be with him, about the same subject, "People are equal, like the teeth of a comb. None is above the other except through the level of faith in God."

[2]Zayd Ibnu Thabet is quoted by Al Bukharee as saying, "Abu Bakr called me to talk about the dead among the people of Al Yamama. Omar was then with him, and Abu Bakr said, Omar says that there was a lot of killing at the day of Al Yamama, and that those who died had *The Qur'an* memorized, and he fears that the killing would escalate, leaving no memories of *The Qur'an;* and so he wants me to put The Holy Book together.' I then told Omar, 'How can we do something the Prophet, peace be with him, never did?' Omar said then, 'By God, I swear, this is indeed something good.' And Omar kept talking me into it until the Lord opened my heart to it."

We can qualify this period, with the twelfth century as an axis, as the golden age of Islam. These guardians, anxious as they were to keep the tradition safe, had only one goal: to transmit the Supreme Name from one generation to another, so that humanity never closes this gate of knowledge, realization, and mercy. Historically speaking, this chain was never broken; it stayed alive through the transmission from masters to disciples.

We must know that in order to attain knowledge, we have no alternative but to reattach ourselves to one of the living spiritual chains. For the fruit to be good and of high quality, we must graft the tree. In the same way, through the attachment to an esoteric chain, we graft ourselves to the Source.

The Oath

Ever since the time of the Prophet, peace be with him, people become Muslim by declaring the *Shahada* (Proclamation of Unity), "There is no god but Allah, Mohammed is the Messenger of Allah," (*Lá eláha ella 'Lláh, Muhammadun Rassulul-Lláh*). From the same historical point of view, when the first disciples obtained their spiritual attachment, the Prophet, peace be with him, gave them his hand and they put theirs in his. "Verily those who pledge their faithfulness to thee do no less than plight their fealty to God; the Hand of God is over their hands. Then any one who violates his oath does so to the harm of his soul, and any one who fulfills what he has covenanted with God, God will soon grant him a great reward," (*sura* 48, verse 10). This oath, *ahd*, of fidelity and transmission took place under a tree. It goes back to the time when the Prophet, peace be with him, wanted to conquer Mecca, the place from which he was once driven out, in order to perform the pilgrimage. While being sufficiently powerful in artillery, he preferred to negotiate to avoid unnecessary bloodshed. The companions of the Prophet, peace be with him, were shocked and troubled by the reading of these negotiations. As a start, he, peace be with him, was treated as a simple man, without any recognition of spiritual qualification. Then, he was told that he could not enter Mecca to perform the pilgrimage that year, but the one after. He was also told that if a citizen

from Mecca ran away to go to Medina, he had to be returned to the Meccans; but on the other hand, if a Medinian left Medina to go to Mecca, he would not be returned to the Muslim community. All these measures were deemed humiliating by the comrades of the Prophet, peace be with him, and some among them were overcome by doubt. The community was then weakened and shaken; some thought the Prophet, peace be with him, knew what he was doing, and some decided they could not accept that compromise. It was at that time that the faithful showed their spiritual bondage to their leader. They were considered superior to the others, because they did not doubt. This means they possessed an internal excellence. We have the list of these companions. Still, among the thousands of people who were present that day, some have played an important role in Islam without having been spiritually tied to the Prophet, peace be with him—they were simply not ready yet.

It is from that day and in that precise place, famous to historians, that the oath of fidelity to the Prophet, peace be with him, began, an oath that symbolizes a person's attachment to another dimension, one much higher than the fact of belonging to the community. The spiritual oath is a total submission to the Prophet, peace be with him, who represents the Hand of God. *The Qur'an* says, "Those who plight fealty to thee, do no less than plight fealty to God," (*sura* 48, verse 10), of Whom the Prophet is simply a manifestation. Thus, any man or woman who takes this oath does not pledge fealty to the Sheikh, but through him and the Prophet, peace be with him, to God. The swearing of allegiance exists nowhere in the Muslim community but with the Sufis. This is the almost unknown history of the spiritual fealty that is still performed today.

The Universal Man

The education acquired through the master is based on *The Qur'an*. Its goal is simply the realization of the universal man, which means reuniting man with God so that he becomes His servant.

The universal man stands for the archetype of this spiritual being, perfectly divine, who came from paradise, an adamic creature before whom the angels prostrated when God declared that He wanted to

have a vicegerent on earth. There is a verse in *The Qur'an* where the angels ask God, "Behold, thy Lord said to the angels: 'I will create a vicegerent on earth.' They said: 'Will Thou place therein one who will make mischief and shed blood, while we do celebrate Thy praises and glorify Thy Holy Name?' He said: 'I know that which you do not.' And He taught Adam all the names; then He placed them before the angels, and said: 'Tell me the nature of these names if you are right.' They said: 'Glory be to Thee; of this knowledge we have none save what You have taught us. It is Thou Who are perfect in knowledge and wisdom," (*sura* 2, verses 30-32).

It is possible to think that God, in His great wisdom, wanted to create a being who holds a place between the angel and the demon; a being who holds a contradiction within himself—a negative pole and a positive pole. This adamic experience is unique. Before Adam, there were angels on one side—beings of light, whose sole purpose is nothing but the contemplation of the Divine, and who cannot therefore commit sins—and on the opposite side, the demon, always animated by a negative spirit, enslaved by pleasure, and living in darkness. Consequently, with the existence of these two aspects—positive and negative, the angelic universe and that of darkness—the world became perfectly balanced. But God wanted an intermediary world. He united these two worlds, these two polarities in the human being. If these two worlds interpenetrate, there is automatically a reaction, just like an electrical wire which can create a short circuit should the two wires, negative and positive, touch each other. Each world is perfect within its own entity, it is the encounter of the two that causes the reaction. Nevertheless, this encounter is necessary in man's case, the only intermediary in whom the transmutation of the two worlds was realized. The angel, being of light, and the demon, being of darkness, live in perfect harmony in their own worlds, while man carries inside all contradictions. The other beings on this planet do not possess this contradiction, this bipolarity. They cannot know, as the human does, love and hatred, joy and grief, certainty and doubt. Every creature is perfectly placed in its own world, even if the plant feeds on the mineral, the animal on the plant. The balance is perfect! The only exception is the human being

who incarnates, at the same time, balance and imbalance. Humans can sow, plant, and destroy the crops at the same time. Obviously, they can give life and take it away. It is their destiny. Man must accomplish it by trying to balance his nature.

When man understands and tests his two aspects, the negative and the positive, he can at last realize this dimension of the universal man that lies dormant in him. If this experience is successful, he becomes divine, in the sense that he incarnates a world where balance and imbalance are in harmony. He becomes God's vicegerent on earth. The Truth allows him to drop this opposition and become, under the effect of a transmutation, an exceptional being. He is then granted an extraordinary power which none before him has ever received. He becomes the witness, the messenger, the warning voice of the Absolute Truth.

For the Sufis, the negative and the positive are neither bad nor good, they are simply a reality. Thus, many acts that are consciously or even unconsciously committed, sins that may hinder our way, can, after all, push us in the right direction and indeed lead us toward God. In the Sufi education, we must also use the negative elements. If we are conscious of the fact that we have committed a negative act, it is positive in itself should we avoid doing it again. *The Qur'an* says, "By the soul, and the proportion and order given to it—thus inspiring it with its wrong and its right; truly he succeeds who purifies it, and fails who corrupts it," (*sura* 91, verses 7-10). As we see, negativity is part of our nature; it is the attribute that makes us unique. If we did not have this tendency, we would not be human, we would be something else. That is something we cannot help. Still, it is up to us to look for our internal truth. What is the eternal, divine, and true part that exists in me, and what is the temporal, material, disabling, and limited element which impedes the growth of my true nature? What is it that represents life in me, and what is it that represents death? The goal is not to avoid this shadowy dimension, but to find the middle path.

An Active Path

In order to reach this path, we need the assistance of those who have preceded us in the experience. They have marked the way, they can

even show us the dangers therein, they can lead us to the goal. The heart of the master is big enough to hold all human beings, with all their contradictions and all their ways, for every one goes toward God according to their own ability, their own determination, and their own will. It is in this context that Tassawwuf comes to be. This school or path emerges only through the second birth where man dissipates in the Divine. For this experience to be complete, it must be accomplished here, in this world, in an earthly pouch that holds its contradictions, its pleasures, its desires, its responsibilities. It must be accomplished through everything that characterizes us and makes of us beings of exception. Let's be very clear: we have been given this body to serve us, but the majority of people spend their time serving it. We cure it, dress it, cherish it, and it ends up enslaving us. We become prisoners to this envelope of flesh, when, in fact, it has been given to us only to serve the soul. Alas! We do the opposite. We impose on the soul servitude to the body, while realization is for one to understand that the real master is the soul and that the body exists only to serve it.

The distinguishing trait of the Sufi path is the fact that all its masters have experienced, at the same time, the tangible world and the spiritual one, and that they have always known how to harmonize the two in such a way that one is not overcome by the other. The spirit and the shape form a harmony. Let's not privilege the shape, for it limits our thinking; and let's not privilege the spirit, for we live in an earthly world. A certain equilibrium is necessary. Should we privilege the soul only, we will stay in the utopia of things, in the ideal. The function of the soul is to transform matter. We must then have our feet on the ground and our heads looking up toward the sky. The goal is to attain the balance between verticality and horizontality. It is one of the characteristics of Tassawwuf.

We can say that it is an active path, which means that for us to be worshipers, to meditate, or to seek God, we do not need to isolate ourselves from the world, unless it is for temporary spiritual retreats. We must carry out our duty toward society. That is why Tassawwuf preaches that one should simply live a normal life, get married, have progeny, etc. The Sufi education privileges all those who are not in

constant retreats and who *fight* in life. This is the major sense of *jihad,* holy war, the key to the gateway of the Islamic tradition which causes so many misconceptions.

Jihad, The Major Holy War

One day, the Prophet, peace be with him, while coming back from a battle, said: "We have come back from the small war, and we are now facing the big war." He was asked then, "But what is this big war?" He answered, "It is the war against the self."[1] Contrary to what is generally believed, the major holy war is not the spread of the Islamic faith through the injunctions of a tyrant. This major holy war, *Al Jihad Al Akbar,* the jihad of the souls, goes as far back as the origin of man himself. As soon as he had become conscious of what he had received from the Divine—the intelligence and knowledge which helped him recognize his responsibility, on one hand, and his ignorance vis-a-vis the universe he was related to, on the other hand—he realized that he had the power over his destiny, to choose between good and evil. It is in this perspective that the notion of Islamic jihad takes all its dimension and its involvement in daily life.

This major holy war, this major battle, is nothing but the combat of the human being against himself. The idea is to carry out a battle against the distorted ego, which is always fighting the phenomenal truth, thus generating some regrettable thoughts and reactions. We must not kill the ego, but only pacify it, appease it; killing and pacifying are indeed different. A person who loses his ego is a weak, imperfect, and a handicapped being. Only one who succeeds in pacifying the ego, that is, one who admits the evidence and supremacy of the Truth, and actually witnesses it, can establish oneself as a perfect being.

Thus, we can say that the Sufi path is an active one, a path which perfectly fits in life. We must work, keep up with the challenges, and

[1] This *hadith* was mentioned by Al Ghazalee in His book *Ehya Uloom Ad'Deen (The Revival of the Science of Religion).* Al Khateeb also quotes Jaber in the same *hadith* with these words, "The Prophet came back from a battle and said, 'You have returned from a blessed place and you have come from the small Jihad to face the big one.' And what is it?' They asked. 'Fighting one's desires,' he answered."

face problems, so that we can find solutions in a moderate way. Of course, this does not mean that we must throw ourselves, body and soul, into the material life to the point where we are trapped in its jaws. The Sufis say in reference to this subject, "Manipulate the material life with your hands only, never allow it in your heart, for the hands can be washed, but not the heart." These few words nicely sum up what an active path is. The Sufi lives the material life, but is also a worshipper, a meditating person, one who invokes the Supreme Name. He or she prays more than everybody else, tries to be more straight, more charitable, and more tolerant. In every domain, the Sufi must be ahead of others.

Today, however, it is very difficult to integrate all these aspects into the hectic life of our society where everything is linked to matter, to money, to profitability, and to revenue. Jihad is a spiritual combat difficult to lead, and has nothing to do with the false acclamations that some people give it nowadays for the sole purpose of spreading their own ideologies and politics.

Jihad is carried out in all domains, not only against one's self, but also in the material life: to fight against the economic crisis, against poverty, against the new diseases. This is the very notion of jihad; it is not war where weapons rule over all. The Prophet, peace be with him, says, "seek knowledge from the cradle to the tomb." I am sure that in the future there will be more and more Sufis among researchers, and that their discoveries will at last inspirit their character. Actually, most scientists have not yet grasped this inner mirror in order to transcend their sciences. They are prisoners to reasoning and remain in the world of the senses.

Disciples must not only fight this war inside themselves, being content therein, but must also serve humanity—witnessing the Truth everywhere. Their quest must be carried out at the very place where they operate. No matter what the disciple is, be it an educator, a doctor, or a politician, he must use his abilities and his power to the end. His realization is not only a matter of religious and spiritual endeavor, but is also a matter of community service; all occupations allow us to serve. We must totally integrate this notion in our quest and inner

search. There are not two ways, there is only one—one destiny, one path. There is no duality; it is unity.

Should the Sufi grasp this light, this guidance, he or she surely would not trade eternity for a temporal acquisition. Confronted with this choice, reasoning finds itself with no solid ground. The Sufi is not the only one involved in his choice; mankind in its entirety is implicated therein. The higher the human being is placed in the hierarchy, be it political, financial, military, scientific, or technological, the more concerned they are, for they assume the responsibility of all those who are behind them; they can lead toward peace or toward catastrophe.

We must ask ourselves about our jobs. What good do they do humankind? When we work for thirty or forty years of our lives, to whom do we give all this energy? Is it for the sake of money, a position, or is it for the well-being of the human race? If it is for the sake of people, then every single act turns into prayer. Every act is part of this effort, be it a smile to someone, a service, a personal quest for learning, an act of sharing, etc. We can no longer strive for spiritual strength only in a temple, a mosque, a church, an ashram,[1] or a monastery chamber. No! The sense of this endeavor, which is exposed in the word jihad, must be realized in every day of our lives, wherever we may be—in a laboratory, a school, a factory, etc. And so, we must develop vigilance and conscience. Day after day, the endeavor will grow, and we will be the first ones to harvest the fruits, for every tree is contained in its own seed. Still, we must labor and water this inner garden.

In reality, this combat goes on against every problem in life. The Sufi learning gives birth to an internal conscience which leads us to permanently ask ourselves, "How are we going to act in these particular circumstances?" For example, by taking a certain path, we can earn more money, gain more honor, more power, but if it is to the detriment of others, we move away from God. On the other hand, by choosing another path, we will perhaps be less rich, but we shall be appeased, and

[1] Ashram, a Westernized word coming directly from the Sanskrit." It is a dwelling of seclusion where the Hindu spiritual masters seclude themselves with their disciples to practice asceticism (meditation, yoga).

mainly closer to Him. I am, of course, simplifying things here to show that it is a continuous combat, fought every day and every instant. If someone wrongs you, what would be your reaction the day you have the possibility to make things even? Should that person have been malicious toward you, you can be malicious toward him or her, but this may hinder your way toward the Ultimate. On the other hand, should you adopt a responsible attitude by converting your desire to hurt into benevolence, you will strengthen your advancement on the path.[1] There must be a constant reminder deep in the heart, in every situation that life presents. Keeping one's self constantly reminded is one of the traditions of Tassawwuf. It is a way of life! If we choose this path, we must have both the qualities of a monk and those of a fighter. The Sufi is a worshipper and an enterprising person—a monk-warrior. It is through this apparent duality that the disciple advances and reaches self-realization. In every instant, then, there exists a permanent combat to ameliorate our way of thinking, talking, and behaving.

In our contemporary world, where matter gains more and more power, the combat is not even, for everything conspires to separate us from our selves and to delude us with an illusory well-being. In all domains, be they scientific, economic, or technological, we turn our backs to unity, heading for multiplicity, for growth. Of what?

Through their origins, their passions, and their desires, through all their weaknesses, humans still retain traces of animalism in them. And it is erroneous to say that the combat is against human nature, for our true nature is healthy. Corruption comes in fact from the education one receives or is subjected to. If a person understands his nature and the bounds to real happiness, he or she can advance, pursue their verticality, find their harmony and their place in creation again.

If we take a child and educate him in this path until he is an adult, his real nature will free itself. In order for the process of realization to

[1]Reference is to the *hadith* of the Prophet, peace be with him, "Let none of you be an imitator, one who says, 'I go along with people, should they engage in good, I do so myself; should they engage in evil, I do it too!' Be resolute instead, no matter what people do, always engage in good."

take place, he must feel all the negative stages, for without darkness, no one will know light.

This inner fight and endeavor manifest themselves also in prayer, through which we make our time sacred, something that is particularly difficult in our society, where time is not lived in its real dimension. We stop time by giving it the stamp of the Divine.[1] Only those who are really tenacious, courageous, and determined can succeed. An indolent person cannot choose this path; it is impossible. Even if this path does not require an intellectual competence, it does however ask for a continuous endeavor, carried out every day and every instant.

This combat relates also to love. I can assure you that a master cannot accept an apprentice in whom he does not see love before vigor. Without this energy, the vehicle cannot function. Those who seek knowledge with no love in their heart will never reach their goal. Even one who has faith and devotion, and does not have love, will not reach it either. The only energy that allows a person to enter this path and progress therein is love. God is love (in the words of Jesus, peace be with him, himself). "Follow me if you love God. God will love you and will forgive your sins," (sura 3, verse 31).

Also in this path, there is what we call excellence, which involves seeking and incarnating the most noble of characteristics in the human being and the nobleness of the combat. True pilgrims never put their arms down. If necessary, they use all their resources, up to the last spark of life, for the sake of this holy battle. They do not fight for themselves only, but also for the sake of the human race. The transcendent experience lived by the true pilgrim will allow others to live it someday in order to find again the archetype of the primordial ancestor: the man. This combat will ensure that the universal man never dies, that he is always present. This means that through the universal man, society holds hope, love, openness, and compassion. He is a light that illuminates thousands

[1] Reference is to the hadith of the Prophet, peace be with him, as related by Abu Hurayra, and which is reported by Muslim in his Saheeh, "Do not insult time, for time is God." The same hadith is also reported as the following, "Allah says, 'The son of Adam abuses Me by insulting time, and I am Time, I hold all things in My Hands, I cause the day and the night to rotate.' " Agreed upon by most scholars.

and millions of people, one that shows others they can overcome diffi-
culties and realize the perfect state of being—or the almost perfect.

As long as the universal man is present on earth, this world will make
sense. The human race was created and fashioned only to incarnate this
real inner dimension of man. This goal is accessible to all, with no ex-
ception, for the Spirit dwells in each one of us. But there are those who
take care of their gardens and those who neglect them. The first will
obtain roses or succulent fruits; the others rough prickly shrubs.

I think that if the Divine Will has established this spiritual message
as the last revelation to humankind, it is because the message is per-
fectly adapted to life and to the concerns of the modern individual. No
matter what people say, this exoteric and esoteric path of Islam is up-
to-date and will undoubtedly be, in the coming centuries, the path of
the elite among the community.

To my knowledge, ever since Mohammed, peace be with him, no
person has ever declared to be prophet or messenger who brought
along revelations in the form of a book. There were some people who
have interpreted some already existing texts, but they were not
prophets, in the sense that the contents of their message presented no
new elements. We must know that in the time of Mohammed, peace
be with him, the Revelation generated not only a true spiritual revolu-
tion, but also a cultural outburst, for the contents of The Book covered
all domains, be they of science, of philosophy, of law, and even of ar-
chitecture. It was a new page in spiritual and terrestrial history.

Jihad has always been the object of harsh criticism on the part of
the derogators of Islam who have hoped to see in this spiritual formu-
lation nothing but the expression of a warlike people, avid for con-
quests. Thus, some, due to lack of reflection, refuse to accept the
warlike aspect of the Prophet, peace be with him, and do not under-
stand it. They try to deny the fact that humans have this aspect in
them. If the Prophet, peace be with him, took the sword, it was that of
justice. This is what constitutes the uniqueness of Islam, which is an
active path. Jesus, peace be with him, said, "If they slap you on the
right cheek, give them the left one." The Prophet, peace be with him,
says, "Do not do unto others what you do not want others to do unto

you."[1] The message of Jesus, peace with him, spiritually most high as it is, was reserved for an elite group of men and women, submerged in the contemplation of the Divine and immersed in the Light—one must just refer to Christian mysticism. Islam, path of the middle, accepts the animal nature of human beings and perfects it. People need balance *and* the sword. They need, from time to time, to be put on the right track again. This sword is not that of violence, but that of justice, which separates truth from error. It is a reminder.

The Prophet, peace be with him, was not only a messenger, a herald, and a warning voice, but also a man who shows that there is truth on one side and error on the other side. We must help one who falls into error to be conscious of it. The Prophet, peace be with him, says, "Help your brother, be he oppressed or oppressor." His comrades answered, "We understand that we must help him who is wrongly accused, but how can we help the oppressor?" He said then, "By stopping his hand," (by impeding him from doing wrong).

We cannot deny the contradictory nature of the human being, this nature that contains the demon in it. Why have we fought against all the tyrants that the human race has known and why are we going to do the same with those to come? Why have millions of people died during all the wars that have taken place up to our time? Did we have to give the left cheek to Hitler, let him conquer the world, and turn two thirds of humanity into slaves under the pretext that the human race was composed of subhumans? Must we risk seeing humanity slide toward its destruction, or should we fight to shelter people from the animality that dwells in them? Those who dispute the use of the sword by Islam must refer to other civilizations. There is not a people who have not taken the sword, be it for defense or for conquest. Islam does not contest this animal nature of humans; it tells us that we must edu-

[1] This meaning can be found in two of the Prophet's *hadiths*. The first one as quoted by Anas is, "None of you shall be a true believer until he wishes for his brothers that which he wishes for himself." (Agreed upon by all scholars). The second is that of Jaber Ibnu Zayd, ". . . and to love for people that which you love for yourself, and to hate for others that which you hate for yourself." Quoted by Al Imam Ar'Rabee'ee.

cate them, awaken them; and should they, in spite of all of this, remain insensitive, then we must use an appropriate remedy for the sake of saving the human race.

Such is the nature of humanity, and one who denies this reality is either ignorant or blind, one who does not want to face the truth. The path of non-violence is not the path of passivity. Non-violence is not to be violent. Violence exists in us, and taming it is praiseworthy. Indeed, Islam tells us, "The punishment of a wrong is a wrong equal thereto, but he who forgives and mends his way will find his reward with God," (*sura* 42, verse 40). We always have the choice.

The Qur'anic Message

All acts, all reflections and attitudes of the Sufi are directly anchored in the Qur'anic message; this means that the Sufi does nothing that is not related to the Sacred Book.

The Qur'anic text can be read in different ways, according to people's maturity. We can read it textually, at a first level, or at a deeper level. It can be read in the past or in the present. Ali, may God be pleased with him, says, "If I wanted to, I could fill two camel-loads with commentaries on *Al Fatiha* alone."[1] And the Prophet, peace be with him, says, *The Qur'an* is the garden of the sages." Thus, people who know nothing about Islam and who attempt to read *The Qur'an* can be surprised after reading some translations, for they will often have access only to this first level. For example, the words which allude to fear of God can be misinterpreted. For the Sufi, however, fear of God is a reverential fear. A God whom no one fears is nonexistent. It is just like a child who loves and fears his father; this fear is not negative. For many people, fear of God is simply to avoid certain acts; they see it this way because of their first level of understanding. For instance, when we limit speed to ninety kilometers an hour on the roads, it is not a coercion, it is a law. If I am reasonable, I know that it is for my own well-being as well as that of others. At the first level of reading, *The Qur'an* can only be a code of conduct.

[1]*Fatiha:* The opening chapter of the holy book of *The Qur'an.*

For others, there exists a higher level. Knowing that God is mercy and love, they have surpassed the stage where they would need a stick to stay straight. In relation to this subject, we can refer to Rabee'aa[1] who was, in her young age, a girl of pleasure, and then led an exemplary life. One day, this great saint left her town with a bucket of water in one hand and a bundle of firewood in the other. She met one of the greatest masters of the time who asked her where she was going. She answered him, "With the bucket of water, I am going to extinguish hell and with the bundle of firewood, I am going to burn paradise, so that no one on earth adores The Lord because of fear of hell or because of hope for paradise; so that all may adore The Lord only because of love for Him." Who can attain this level of conscience? It is for this reason that *The Qur'an* addresses all levels of understanding.

Islam deals with human nature as it is. *The Qur'an* is not elitist. It addresses all people, regardless of their level of education, awareness, or conscience, and each person perceives and feels the message according to his level of evolution. It addresses those who do not like intellectual thinking and only wish to be told what they have to do. There are millions of people who live and function this way. They simply need a support, a crutch, a code of conduct; otherwise, they are lost and can behave in a dangerous way, for them and for others. The Holy Book also addresses those who have attained a degree of realization, of civilization, of education, which leads them to think before acting. And so, they do not need to read *The Qur'an* to know what they have to do, for they possess an expanded conscience. They read the Holy Book only to nourish and develop their souls, and to let its light inspire them and get them closer to God. "To be contented with what God gives you is deprivation," as the Prophet, peace be with him, says.[2] To act in consideration of paradise and hell is a limitation. Both

[1]Rabee'aa Al Adaweeya, Sufi woman, an eminent mystic figure in Islam.

[2]Al Baraz relates another *hadith* of the Prophet, peace be with him, in the same sense, "God does not give up until you give up." And Ash'Shaaranee, in his book— *Al Yawaqeet (The Rubies)*—adds these words to the same *hadith*, ". . . so move on somewhere else, or stay put next to your Lord."

premises are for purification, both are a great mercy. One who has not been purified on earth will be so in hell. But not everybody understands this.

In order to read *The Qur'an*, we need the help of a master. We cannot undertake the fields of algebra or chemistry without having been initiated into them. Our life is saturated with masters. There are those who have taught us how to speak, how to write, the art of singing . . . Why wouldn't we then be in need of a master to teach how us to read the Holy Book?[1] If we read it in an abrupt manner, without having any knowledge about this message or about the clear accounts of the great masters who have deciphered it and put it into practice, the subtle comprehension would be very difficult to attain. The assistance of someone who possesses this knowledge and who is close enough to us to allow us to enter into dialogue and ask the most contradictory questions is necessary to generate a debate from which the truth will spring. Just like the muddy water that we shake: the sludge settles at the bottom allowing the pure water to appear, for all that is heavy sinks and all that is light ascends.

All the great sages, the great masters, drew their knowledge from this source. My grandfather, Sidi Hadj Adda, used to say, "In this path of ours, we never eat stale bread." The bread is always baked daily, but only he who has attained a certain degree of realization and of conscientiousness can understand these words. *The Qur'an* is the greatest sacred book, a book that reveals the Divine Word, the Living Word, to all those who adopt this path.

There is also the problem of language in the reading of The Book. When we do not speak Arabic, we can have access only to translations which, whatever their quality, always remain translations. No human enterprise will be able to translate *The Qur'an* as it has been revealed in this sacred language, which is Arabic. Its content is not simply constituted

[1]The Prophet, peace be with him, says, "The best among you is he who learns *The Qur'an* and teaches it." Reported by Al Bukharee and At'Tarmedee, on behalf of Ali, the Prophet's cousin.

of a layout of sentences and meaningful words, but also of rhythms, music, vibration, and of poetry, all of which balances it in the best of fashions. This is the magic of the Arabic language. We take some Qur'anic verses and comment on them. This work of reflection allows us to pierce the barrier of language, to reach a level of comprehension way above the letter.

Moreover, constant effort is required on our part to understand The Book. We must adapt it to our time, an effort that is, at the same time, intellectual, rational, and spiritual, which allows us to find a solution to the problems today. In a world where people travel at a supersonic speed, where they explores the universe, where woman uses contraception and has become equal to man, or almost, and where—thanks to the media—the world has turned into a village in which every person knows the whole world and, at the same time, ignores it all, in this unprecedented complexity we must certainly find solutions to the arising problems. I am sure that these solutions exist and that we must sincerely make the effort to find them. The idea is not to turn them into an ideology, an instrument to gain power or subdue others, but simply to do it for God's sake, for our own well-being and that of the human race.

To close this chapter, I would like to answer this question that people sometimes ask me, "Who can be accepted in *tariqa?*" Everyone, with no exception. We start from the principle that we are all human beings and that all of us have the right to this knowledge, regardless of our nationalities, our occupations. And the fact that we have Westerners in our brotherhood is not a new phenomenon, nor is it, in the least, a style. Let me remind you that the presence of Islam in Europe is not exactly new. Islam was already implanted in Andalusia and in southern France many centuries ago. Gourdon, located under Bar-sur-Loup, was a Saracen citadel, and let's not forget Ramatuelle (*Rahmatu'llah*) where the emir resided. Islam and the West are so close to each other that it is impossible for them not to open up and enrich each other.

I can even say that, in the Middle Ages, there were more exchanges than today. Islam has contributed greatly in translating the works of the great Greek philosophers (Plato and Aristotle) through Averroés

(Ibnu Rush'd) and others; Al Gibr[1] in Baghdad contributed with his works in algebra; Ibnu Seena shared his works on medicine, etc. Islam had also fertile exchanges with the Jewish tradition of Maimonides.[2] There was also the mystic, Ibn Al Arabee, who was born in Andalusia and died in Damascus after having traveled all around the Maghreb. The emperor, Frederick II, was taught philosophy by the great Sufi, Ibn Sab'in of Murcia.

We must never forget that Islam was born from the same tradition of Abraham as Christianity or Judaism; it considers Abraham, peace be with him, or Jesus, peace be with him, part of the same line of descent as that of Mohammed, peace be with him. The texts which talk about Moses, peace be with him, and about other prophets, represent thirty or forty percent of *The Qur'an*. Whether this idea is accepted or not, the Qur'anic message is obviously part of the same perspective as Christianity or Judaism. They have the same roots, feeding at the same source. The trunk is the same, only the branches are different.[3]

> The Apostle believes in what has been revealed to him from his Lord, as do the men of faith: All believe in God, His angels, His books, and His apostles. "We make no distinction (they say) between one and another of His apostles." And they say, "We hear and we obey, (we seek) Thy forgiveness, our Lord, and to Thee is the end of all journeys," (*sura* 2, verse 285).

[1]Reference is to Jaber Ibnu Hayyan; among his writings is his book *Ar'Rahma (Mercy)* in which he shows the way of transforming minerals into gold.

[2]The outstanding medieval Jewish philosopher Maimonides (Moses Ben Maimon; or Rambam, from the initials of Rabbi Moses Ben Maimon), 1135–1204, was physician to the Sultan Saladin and communal leader of Egyptian Jewry, as well as an important figure in the codification of Jewish law. *The New Grolier Multimedia Encyclopedia.*

[3]Abu Hurayra, as quoted by Sheikhan and Abu Dawood, says, "The Prophet, peace be with him, says, 'I am far more worthy of the son of Mary than any man in this world and the hereafter, there are no prophets between him and me. And the prophets are brothers, sons of different mothers, but they all share the same religion.'"

The Master and
the Disciple

Heir of a Tradition

In the tradition of Tassawwuf, Prophet Mohammed, peace be with him, and his comrades are the models who head the whole spiritual chain of which the master is the descendant. He is the heir of the tradition and the trustee of a *baraka*[1] transmitted from one generation to another. This function makes of him the physical center through his body, and the spiritual center through his inner realization—his truth.

My great-grandfather, Sheikh Ahmed Al Alawee, used to say that the master is just like a lighted candle burning to illuminate others, until another candle comes to replace it. The master is before all a servant of God, and only one thing makes him different from the appren-

[1]"The Divine Trust" mentioned in God's Holy Words, "We did indeed offer The Trust to the Heavens and the Earth and the Mountains; but they refused to undertake it, being afraid thereof; but man undertook it . . ." Also, virtuous influence of a saint, dead or alive. Spiritual power of a master which he communicates when he initiates students in God's Way.

tice; he has experienced the path and the unity. That is why we must not restrict ourselves to the physical appearance, for the master is beyond that. Sometimes, he is the master, and others, he is the man. He is neither more intelligent nor stronger than any other person. He is even below others, for he has truly witnessed his weaknesses!

To illustrate this subject, we bring forth this story. When Moses, peace be with him, felt his end coming, he asked God, "May I go now? But who is going to replace me?" God answered, "Go! Gather all the tribes and tell them that each should elect the best man among them. Once they have chosen, gather those elected and ask them to choose the best man among them. Once the best is designated, ask him to go and choose the worst man of all the tribes gathered." Moses, peace be with him, did as told. The best left to look for the worst, and then came back. Moses asked him, "Did you find him?" And the best answered, "I went through all the tribes and found out that the worst of all is me." Finally, he who was elected as the best one of the community considered himself as being the lowest.

In our tradition, we say that the master is the servant of his disciples. A Sufi proverb says, "The Sheikh is the *faqeer* of the *fuqara,*[1]" and Sheikh Adda says in one of his odes, speaking about his *fuqara,* "You are my ritual obligations and my recommended prayers, you are my word and my action, my *qibla.*[2] O *qibla* of my prayer when I stand to pray!" See for yourselves, he who serves the others in this group or any other is the master and not the other way around. Those who will read these lines will think that it is a path of fools, where everything is reversed. It is all right, however. I can reassure you, it is a fruitful insanity dating back many centuries.

Succession

Before dying, although the master may sometimes allude to some followers concerning succession, he never designates his successor. As I

[1]*Faqeer,* singular; *fuqara,* plural. Literally "poor." Describes a disciple or disciples in the Sufi way.

[2]Direction of prayer—the holy site of Kaaba in Mecca, Saudi Arabia.

said before, it is up to the assembly of scholars to do so. The nomination is the result of meditation, dreams, visions, or what the common among mortals are used to calling supernatural phenomena—for us, these have no exceptionality whatsoever. This protocol does not last for years, the seat is immediately filled. Sometimes, some feel more or less worthy of succession. Human problems are always present, but in general, he who is designated, even if he is initially contested by some people, always ends up being accepted by all.

It may seem astonishing to see a very old person, connected to the brotherhood since an early age, come and ask for the spiritual bondage from someone who is much younger, less experienced, but acknowledged to be the most qualified to succeed. Bowing, he or she will kiss the hand of the master. Sometimes, some very aged and sick people delegate someone to renew the covenant, for it is very important that they, to the last spark of their lives, be connected to the latest link of the chain. But the fact remains that they really do not need to do so, for they sometimes end up knowing many masters in the brotherhood. Still, as a sign of respect, of discipline, and for the sake of the tradition which they must keep alive, they will renew the covenant. The meaning of this oath and its implications assure the perpetuity of the chain.

Inner Transformation

After this event—the divine and subtle inheritance of the true meaning of leadership—the character of the new master changes. He ends up seeing himself in every being who comes to him. He becomes one and many, and a constant exchange between him and the disciples is established. He is nurtured by them and they by him. He makes sure that the disciples do not lose their way. He takes back those stumbling, listens to the desperate. Thus, he is the confidant and the healer of the soul. Imagine all the problems that can arise given the weight of the community! Through the intervention of the master, and thanks to this relationship of trust, troubles are pacified. Each one knows, deep inside of themselves, that the master will find the solution.

As for me, I was very young when I was designated to succeed my father, and at first, I did not know why I was judged as being fit for

such a role, such an enormous burden. Having submitted to this decision, the four or five years that came after were lived in acceleration. The transformation of a man is not carried out through a flick of a magic wand. He has handicaps, shadowy zones that he must see and clarify; otherwise he will always remain in uncertainty and will be unable to assume the responsibility of such a mission.

The Role of the Master

When the Sheikh speaks, his word is definite, he never goes back on it. He does not speak according to his mood, one day dark, the other bright. What he says cannot be considered as the word of a common person, but as that of the master, the representative of the spiritual chain. Before making some decisions, he must concentrate, pray and meditate so that he can obtain as much enlightenment as he can regarding a situation. On the universal level, if unity is realized and the process which leads to it achieved, I thank God that I am able to leave this earth taking with me the Light that will lead me afterwards. Still, we must understand that the master does not possess all bodies of knowledge—relatively speaking. He does not decide on this or that orientation, nor make important decisions concerning domains he does not understand, be they domains of architecture or any exoteric science, without consulting with more competent people. As he is not the only one involved in the matter, and since he represents a community composed of thousands of followers, he must not only know how to answer properly, but also remain humble, for the more we know, the more we know that we do not know. And he who pretends to know it all is in error. Every individual is at the same time limited and unlimited. The community, however, always asks the Sheikh to have the last word. If somebody who is more experienced or older than the master offers his point of view, the community will not accept it if it does not have its origin in the Sheikh's word. The word of the master is fertile and procreative; it contains the germ of life, and there is nothing amazing about that. When he utters a word, things take another dimension.

The Sheikh's function is not only spiritual, it is also temporal. The community possesses goods over which he must watch. There exist,

for example, dilapidated buildings that must be demolished, schools to rebuild, people to educate, an entire social and cultural infrastructure to manage; and the Sheikh must increase this patrimony, not diminish it. He is the guardian of the community and he cannot avoid this responsibility saying, "I deal only with the spiritual side, you are on your own." This attitude does not conform with the tradition.

Action Versus No Action

Sometimes the Sheikh educates, other times he observes. He is at the same time in the framework of *action* and *no action*. It is a very important point. A master who acts instead of his disciple, or who aims at going against his or her nature, will end up breaking it. When there is need for an answer or an act, the master is the action; he has a definite mission to accomplish. But most often, he is only a mirror. If he sees somebody acting the wrong way he can let that person do so. He does not intervene systematically, for if he says, "No! Don't do that," the disciple will always carry doubt within: "If I had acted this or that way . . ." But if the disciple goes back to the master, strong from experiencing the consequences of the chosen act, he or she will perhaps be more ready to listen. Men and women are like children; it is not good to tell them, "Do not touch fire; you may get burned." The forbidden excites them.[1] As long as they are not burned, they will not conceive the danger. The best thing to do is to dissuade them by making them understand that they are also free. Only experience can indicate that which is good and that which is not. The master protects and observes, up to the point when he must reprimand.

When the Sheikh needs more information, he never answers by yes or no. There is always more than one possibility. For example, we reach an intersection where there are two possible roads, but one may be more risky to take than the other. In fact, there is always a way, a choice of the middle path which does not disrupt but preserves; a choice which leaves no trace that may disturb the process of realization and

[1] The Prophet, peace be with him, says, "If people were told not to break manure in pieces, they would actually do it and say, 'We indeed were told not to only because there is something (useful) in it.'" Al Ghazalee in his *Ehya*.

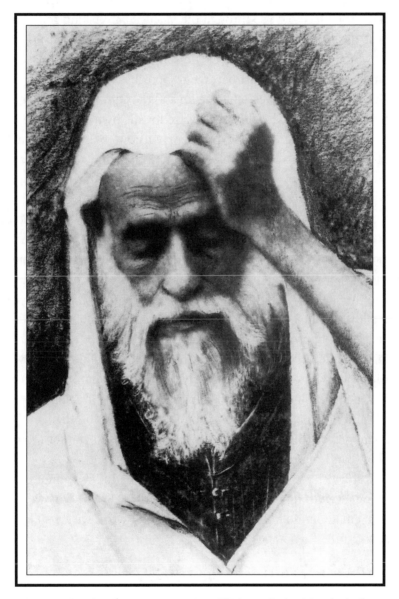

Sheikh Al 'Alawee, great-grandfather of Sheikh Khaled

the organization of life, for both are intimately linked, both are one. Of course, the *faqeer* must talk to the Sheikh about some things, even if sometimes he has to do so through the *muqaddam*.[1] Asking good questions is part of the essence of the educational system of *tariqa,* and those who ask questions that have no sense shows that they have not yet understood. People must become responsible.

The relationship between the Sheikh and the *faqeer* is based on complete trust. The Sheikh acts as if it were for his own sake—with distance, however. He sees the problem without being emotionally involved in it. In fact, the disciple comes to him mainly to be appeased, and the Sheikh immediately restores confidence and inner peace.

To better illustrate the master's way of responding, we bring forth this story. There was once a bandit who was running wild in the mountains of Kabylie, in Algeria. The *fuqara,* who knew of the visit of Sheikh Ahmed Al Alawee in the region, thought that the best way for them to get rid of that robber and his evil would be to capture him and bring him to the Sheikh. Deep inside of them, the *fuqara* were hoping that with a little chance, the thief would ask for spiritual bondage and become a *faqeer* himself once he had met the Sheikh. They ended up capturing him and bringing him to the Sheikh who then asked him what he did in life. Sincerely, the thief gave him the inventory of his evil acts. The Sheikh looked at his disciples and said, addressing the robber: "From now on, you will rob nobody except your brothers."

Dismayed by this verdict, the bandit thought: "If I cannot rob others, how can I rob my own brothers?"

This story shows that all is possible in this path. We cannot codify anything, everything is subtle, just like the Truth. That is why we must always remain humble and attentive. No matter what, we are still weak creatures, full of ignorance.

The Inner Revolution of the Disciple

In this spiritual path, the disciple must make a double effort, just like the earth which turns first around itself and which, together with other plan-

[1] Official in charge, spiritual director of a *zaweeya,* appointed by the *fuqara* and confirmed by the Sheikh.

ets, accomplishes also its revolution around the sun. Like the earth, we must accomplish a rotation around our own selves. This will allow us to improve by discovering our strengths and our weaknesses, and by acting right and wrong; and at the same time we take part in a universal education sealed with the stamp of brotherhood. Just like the earth which holds one side in the shade while the other is illuminated by the sun, there is always in us a part that is in light and another in darkness. For example, sometimes all is well on the material level which is in light, but not so on the sentimental level which is in darkness; other times, it is the opposite. There will always be a deficiency in man. The earth can never be illuminated for twenty-four hours, and it is the same for us. And this is a mercy. If we act, if we make an effort, it is possible for us to alternately lighten all the aspects of our selves, but never simultaneously. Night and day will stay forever. We always recommend patience; we must accept this alternation. If some aspects of our own selves are not yet ripe, they will take some time to become so. There is the impatience of the child to become an adult, and that of the adult who wants to rule over his or her own sphere, who wants to understand it all, possess it all, and have an absolute authority. This is impossible. If we accept our state by saying: "Right now, a part of me is illuminated and another is not," change will have a way to operate itself at a certain point in time. I will understand the part of me that was in gloom the day before and that is now in light. And should it go back into gloom the following day, it will hurt me less, for I have seen it, I know what it needs, I have identified it. I must then understand these desires that annoy me, these regrets, these weaknesses, these forces, and these passions.[1] If these aspects of our own selves do not reveal themselves, we will be unfortunate. Problems are provoked by the parts that have stayed in the shade and which we have not been able to know. If we do not understand something, it always means that there is doubt and turmoil, for knowledge is ease and peace. Those parts of mine which stay in darkness are the ones that prevent me from being at

[1] At'Tahawee reports the Prophet, peace be with him, saying in this respect, "The hearts are sometimes in delight and others in aversion; should they be in delight, engage in extra acts of worship; should they be in aversion, perform your obligatory acts of worship."

rest. Why am I agitated? One who does not accomplish this revolution around oneself ends up being sick. These are the ills of the soul.

To turn around oneself is to ennoble one's character, to see one's part of earth, one's part of water, one's part of fire, and one's part of air. All of this exists in man. That is why people must know who they are; they must know their qualities and also their defects, which bear heavily on them and make them stumble. The purer one gets, the purer his or her heart becomes and the more light it will reflect. Disciples must realize this knowledge. Nobody will be able to do that for them, not even the Sheikh. We call this the *inner revolution,* and one who cannot realize it, will not be able to continue the journey.

There is then a double revolution; the rotation around one's planet, and, at the same time, the revolution around the center of this source of Light in order to know the Absolute. This last revolution is ordered by seasons: spring, summer, fall, and winter. It starts with spring, the birth that is amazing. Then there is summer when we are tested by the heat, the hotness of the sun, which is very violent for some. This love, which was at the beginning of a phenomenal sweetness, becomes violent. Then there is fall: the fruits that have grown under the arduous fire of the sun of summer are ripe. And last, there is winter: things fade and stay within their own limits.

During this progression, the friend, the companion, the master is necessary. For if the first phase is that of knocking a few corners off and polishing, which sometimes requires the teachings of a number of masters, it is essential to understand that the second phase of realization, which is the path through excellence that leads to unity, can be accomplished only with the assistance, the *baraka,* of the proficient master in whose hands the disciple completely abandons himself.

The revolution around one's self and around the center is different and unique for each one of us. It can be achieved very slowly, or very quickly, just like the planets.

The Different Schools

Schools of philosophy that exist nowadays disagree on this second point: they propose a complete revolution around one's self only. But

in our tradition, we turn around ourselves and at the same time we continue to advance toward the Absolute that we may enlighten ourselves. In these philosophical schools, there are extraordinary exercises realized on the mental and physical levels which lead to an exceptional self-control through a multitude of methods. But why all this if I do not advance toward the source of the Light?

The following story on the conception of the Sheikh concerning the way to guide in the Path is enlightening in many respects. Salah Khelifa[1] says:

> I was going to meet a sheikh in Bougie, and I received from him the initiation after he had decreed, as a condition, the daily recitation of a considerable number of litanies. I had the perseverance to recite them regularly and, after a certain period of time, he ordained me to fast daily, eating—after sunset—nothing but barley bread dampened in water. I observed that rule too; then he passed on to me the seven Divine Names which are the ones specially used in prayer, *'dikr,* in this *tariqa* . . . After a few days, he ordered me to depart in order to serve as a guide to others. When I heard that, I was right away filled with discouragement and disappointment, for I knew that what I came to look for was not there. I had only gotten from him some vague indications of which I had grasped no sense, and when I told him about it, he severely forbid me to renew such a confession in his presence or that of my co-disciples, for fear that it should spark some doubts in them . . . I left that sheikh and started looking for another who would be worthy of my attachment to him, until the day when, with God's grace, I met the supreme master, Sheikh Sidi Ahmed Al Alawee, through one of his disciples. That *Muqaddam* prepared me by giving me the Sheikh's book, *Al Menah' Al Qudduseeya—Sacred Gifts of Revelation*—to read. Then, when the master himself came to

[1] A great modernistic Sufi of Mostaghanem: "Sheikh, Ahmed Al Alawee (1869–1934)," in *Cahiers du Gremano* no. 7, Laboratoire Tiers Monde, Université Paris VII, Paris, p. 113.

our province, Constantine, I renewed my initiatory pact of allegiance with him. He then authorized me the invocation of The Name as it was practiced by his disciples, and told me that I could practice it wherever I was, secretly by myself, or openly with others. He stayed thirteen days in our area, and during that time, almost two thousand people, men, women, and adolescents joined *tariqa*. When he returned to Mostaghanem, I went to see him; he put me in *khalwa* (spiritual retreat). Six days therein I stayed, and I obtained there that which I had wished for before.

Mankind has realized enormous progress in the knowledge of the self, the superego, the conscious and the unconscious, the subconscious, etc. But these new fields of knowledge lack the dimension of a wider vision. They lack the total revolution which is made out of seasons and which happens only through time. There is a time for every season, and those who want to live spring, summer, fall, and winter all at once will never be able to. It is Divine Wisdom that has decreed so. We can say that psychology is a fire, but with no flame. It is a fire because it produces heat, energy, but it gives no light. Light is revelation. We need it to realize ourselves, to love, to be. This revelation has been with man since the darkness of the caves. If we need to stick to theory and speculation only, psychology is more than enough. All these areas of knowledge are used in many schools—of psychology, of philosophy, etc., and they even allow business people to be more efficient. But certain people whom I have met in these schools are overcome by the doubt caused by the mental work they have accomplished.

My grandfather, Sheikh Adda Bentounès, used to say, "There are some ignorant people who take an onion and peel the first layer saying, 'This is the skin.' Then they take another layer and say, 'Look at this, another skin.' And by peeling layer after layer to find the heart of the onion, they end up finding nothing in their hands, there is no more onion." We are like the onion. The difficult part is the first skin, the one that is on the surface, the dirty one that we can remove. But let's keep the rest, which is a divine mystery, a protection, and a mercy.

Why strip ourselves to the point where—in the sense that nothing remains of us—we turn into a mere thinking carcass?

In our civilization, everything contributes to making man a thinking robot that we can repair, stimulate, cure. But this leads nowhere. Once we take off the first, the second, the twentieth layer, what remains? A person with no faith, no law, no love. There are even some people who ask themselves, "But what is love?" And we can hear this answer, "An ensemble of neurons, of synapses, of molecules . . . " We enter then an infernal process which, in my eyes, equals the description of hell, where all is nothing but chemical, electric, rational, logical processes, where words serve as drawers to classify them. For me, the human being is something else; he or she is the one who has received all the Divine Names with no exception.

Some schools end up with the conclusion that God is in us. In fact, God is everywhere, and even if He is also in us, we are nothing. In our tradition, we are only the shadow of what we think we are. These schools fall therefore into rationality; they want to trap God and localize Him. And they will soon find a remedy that causes some chemical reactions thus provoking a pseudo-mystic ecstasy. For us, all these ways are oblique paths, and when people have experienced all these possibilities, they will remain profoundly unsatisfied . . . miserable.

The Nature of the Master

To help people understand the nature of the experience the Sheikh lives, we can say that God is always present in him as He is in every other creature. But unlike others, the master is conscious of this Presence, and must answer to Him.

This Presence manifests Itself on him either spontaneously or because he desires It. He must take care of It as if It were a fire, and must be very vigilant. It is from It that he draws his *baraka*. He possesses nothing on his own, he cannot give anything but that which he has been given. In this matter, it is said that one day the Prophet, peace be with him, did not feel the Presence anymore, and this shook him so much that he wanted to throw himself from the top of a mountain. It was at that time that It came back to him, for God wanted to test him:

"By the glorious morning light, and by the night when it is still! Thy Guardian-Lord has not forsaken thee, nor has He hated thee," (*sura* 93, verse 1-3).[1]

We must understand well that we always put ourselves in situations where there is negligence, forgetfulness, and manifestation of false truths that create many veils masking the Presence, Who, for Her[2] part, is active day and night. For even in sleep we can receive an education, an answer, an exchange. In our path, there is an important traditional science concerning dreams.

As to my role in *tariqa,* my person therein is in itself secondary. The path needs a vicegerent, a master who perpetuates it, that's all. The physical body is an accessory; in a certain way, we no longer exist. Sometimes, some disciples say, "But Master, you are a man, we exhaust you . . . we take a lot of your time. . . you travel a lot . . . " Other times, the doctors advise me to pause, to make an evaluation of my health. To tell the truth, this is not important anymore. The day when this body will stop functioning, it will disappear, and this *baraka* will go to dwell in another body that is more befitting to serve Him. As Sheikh Al Buzaydee has so nicely put it, "I am but a tenant; when I die, I give the key back to the Owner who gives it to whom He wills."

The Encounter with the Master

The first encounter with the Sheikh is a question of personal destiny. The parental affiliation plays a considerable role in this. Some people have had members of their family attached to *tariqa,* and it is a great happiness for them to see one of their own retake the torch. But this does not raise any favoritism: it is a word that has no place in the community. There is a saying among *fuqara,* "The path pertains to him with

[1]Sheikh Sidi Muhyeddeen Ibnu Al Arabee, God bless him, says in his explanation of *sura* of *Dhuha, The Glorious Morning Light,* "There was a time when the Prophet, peace be with him, waited for a long time for revelation to the point where he climbed a mountain to throw himself. Out of exhaustion, he stopped… At that moment, God's Words, 'And verily the hereafter is better for thee than the present . . .,' were revealed."

[2]The station of the Divine Presence.

sincerity and not to him with seniority." It is also for this reason that the disciple is called the poor (*faqeer*). In *tariqa*, social success is not important. When disciples are among their brothers and sisters, they must have the attitude of the poor in God, the ones who ask for His help, for without it, no transformation is possible. This is the original sense of the word *faqeer*.[1] It is always a state of submission and aspiration leaving no way for pride or arrogance.

If the question, "How does the master recognize the disciple?" can be asked, so can this one be posed, "Does the disciple recognize the master?" It is in the heart of the disciple that discernment takes place when it comes to choice. As for the master, truly every creature is a disciple! He cannot favor one over the other, saying, "I will choose this one instead of that one." It is impossible. Since the master's concern is for the whole, even one who is not directly the disciple of the master will benefit from his spiritual influence, his *baraka*, which can be a simple word, a smile. . . , for every human being has a divine part in them. He is the relief; all people who come to him are welcome, even if they do not swear allegiance to *tariqa* or choose him as a guide. All will draw this *baraka*, this blessing, from him. Anyone can come to see him, regardless of their religion, be they an atheist or follower of another master.

The Disciple's Determination

When the encounter between the master and the disciple takes place, it may be a blessing for the disciple if the master approves him or her but delays the engagement. For example, some disciples come in groups: the master receives five of them and asks the sixth one to wait a little longer. As we say in *tariqa*, "You come in through the door. We drive you out. But if your desire is ardent enough, you come back through the window." This test is necessary, because I do not have the right to let somebody make a decision for which they are not yet prepared. Not to test this person would be a disloyal attitude, and I will

[1] Reference is to God's Holy Words, "Should they be in poverty, God will give them means out of His grace," (*sura* 24, verse 32).

always feel responsible for it. That is why I ask disciples to ripen well their choice and their engagement.

Affiliation to this path must be voluntary. It is a very important choice about which the future disciple must be perfectly decided. It is an inner battle where the enemy is nowhere else but inside![1] Aiming at driving you away from God, the enemy actually pushes you toward this quest. It is only much later that we discover that this enemy, once pacified, was in fact a precious ally.

The master or the guide is not a mediator; he is a companion, a safeguard. For the ego is so powerful that it can lead astray at any time, and one who intends to take on this path alone can easily get lost. We can climb up the mountain alone, but at our own risks and dangers. The attachment to the initiatory chain gives an insurance and a *baraka*— a word almost non-translatable—a fluid that passes from one heart to another, transmitted from master to master, from one generation to another, up to our present day. When this inner approach is engaged, it is important to feel appeased and composed. We must put ourselves to the test again, but without falling captive to doubt and hesitation. If there is an incident, we know that we are insured by the spiritual pledge.

This relationship between the master and the disciple is infinitely subtle. The master immediately recognizes the disciple, there is no doubt about it. But as for the disciple, it is up to him or her to feel deep inside whether the master is the right one. Should one attach oneself to appearances, and pledge allegiance to the master because the place is beautiful, the people friendly, the philosophical discussions interesting, he or she risks being disappointed and losing the way. Watch out for appearances. They are like snow: when it falls, everything is white, but the moment it melts away, beautiful things remain as such, and so do ugly sides of nature. Some people will spend their lives hopping from one place to another, practicing the *esotourism,* in the words of Lama Denis Teundroup. They would try a hundred

[1]Reference here is to the *hadith* of Anas, may God be pleased with him, as reported by Al Bayhaqee; the Prophet, peace be with, says, "The worst of your enemies is your ego."

masters, and still end up not finding the one they are looking for; their quest would be based on erroneous criteria. They are in fact disciples of their own selves. They consider spirituality a buffet; they scrape here and there without actually tasting the dish. In our era, this attitude has become a fashion, a new elegance of high society. To have a totally naked master in the Himalayas is more original and exotic than a Rolls Royce. We utilize spirituality the same way we shop at a supermarket. The disciple must show an exemplary discernment. He or she must focus on their research.

There are of course some affinities which are given priority when it comes to choosing a master. Generally speaking, any master can accept a disciple should the latter be indeed looking for the Truth. But the path chosen can be more or less adapted to a disciple's sensibility. Be that as it may, one who engages in a path must watch where he steps. I insist! If a path is not demanding right from the beginning, one must be careful. I cannot refrain from saying this, for if I deceive one single individual, all that I represent has no value.

When the disciple is in the presence of the master, he is in front of a mirror. If he is sincere in his quest, God will reveal to him that the place he is in is the right one. Should he be looking for a father or a crutch, the problem is different; but if a disciple's quest for God is true, he will not get lost. It may even be that a false master will be of use to him at a certain time, for there is always a part of truth in falsehood. *(See footnote 1, page 3.)* Contrary to what people usually think, God always takes care of His creatures. If the person who searches for God is sincere, and even if he or she is momentarily misled or lost, God in His mercy will guide that person. God gives people this test for the sole purpose of educating them. A master used to say, "There are blind people who write poems and books on the beauty of nature that the sighted are incapable of seeing."

There are two kinds of disciples on the path: the sympathizer and the journeyer. The first loves the master and participates in the meetings, but admits he cannot follow his way on the path or put the teachings to practice because they are too hard. Right from the beginning, the sympathizer's intentions are clear. As for the journeyer, he is strict and

ready to pay the price. The real disciple is thirsty, and the master immediately feels that spiritual fire animates his steps.

The Qualities of the Disciple

Disciples in this path must have three qualities. The master wants them first to be sincere. If disciples are not truthful with themselves, with their teacher, or people like them, if they always change faces, attitude, they are not fit for the task. Second, disciples must carry in them the germ of love without which no progression is possible. And finally, they must be spirited with a positive energy.

Right from the beginning, disciples are asked not to condemn things and to profit from every situation, even the most negative one. Thus, they will not find themselves isolated in a clan or a party. How can they reach universality if they deny a part of what composes it? It is impossible! If you say that things are misplaced, or that this or that matter is to be rectified, it is normal. But you are indeed in error should you spend your time condemning or destroying them. There are many times when an event regarded as being negative today is deemed positive and necessary tomorrow. Tierno Bokar, the sage from Bandiagara, Mali, used to say to his disciples that positive or negative thoughts are like white or black birds. If you express an idea, an intention, or a negative act toward someone, it is as if you release a black bird in his direction. The thought will have no effect if the person to whom you are sending it is not thinking the same way. The black bird can only nest in a black nest. It will turn around that person, and if it does not find that which it needs to nest—because there is no negative in him or her—it will go back to where it came from, toward its sender. Now, if you release a white bird, it will always find at some point a welcoming land.

Still, I do not deny that there may exist moments of legitimate deception. For example, how can we not ask ourselves about an act of murder with the idea of condemnation? Instantly, we hold a negative judgment on such an act, but we can also widen our vision and try to understand. It may be possible to get rid of a very hasty condemnation. Faced with all the manifestations of violence which exist around

us, we must ask ourselves, "Are we sure that we do not sometimes carry traces of this negative impulse inside us in a latent state?" If these problems exist in society, what is their source, and where is the remedy to be found? Condemnation does not resolve the problem. A society which neglects to give an awakening education about God can expect to reach such fatal extremes.

When a person asks to spiritually join *tariqa*, he or she must know and practice the five pillars of Islam which are: *shahada* (the declaration of faith), *salat* (prayer), *seyam* (fasting the month of Ramadan), *zakat* (alms), *hadj* (pilgrimage to Mecca). These obligatory practices must not be lived on an intellectual level, they must be experienced and integrated. Before committing to the path however, it is only reasonable that the disciple who is not born in the Muslim tradition fast Ramadan once, simply to know if he or she is able to perform it every year.

A Rigorous Form of Asceticism

When disciples swear allegiance to *tariqa*, it does not only mean that they have recognized the message of Islam, but that they have taken an initiatory path as well. It is a very demanding course that requires enormous efforts, the first of which is the daily recitation of *Al Weerd*[1] and the prayers which they will be assigned. Then, they must be ready to perform some spiritual retreats, *khalwa*, and follow a scrupulously straight conduct in their daily life. Those who are newcomers in the Muslim community will receive a new name which the Sheikh will give them or which they themselves will choose. This name determines the constant state that animates them, but we must not care too much about it. This change is part of the tradition, but it is not the essential

[1]*Dikr* of the *selseela*—The initial chain of transmission. Started with Al Imam Ash'shadeelee (died in 1258) and is still practiced today. Its goal is to link the disciple to this chain of spiritual mystic masters. It is composed of diverse formulas to recite, in the morning and in the evening, a certain number of times. *Dikr Al Khass* (the special or private *dikr*) is a Divine Name which the Sheikh grants a disciple of his to recite in private, according to his abilities and his merit therein, usually for a definite period of time.

thing. We can surely be nameless and become true disciples. The community will then embrace the newcomer by giving him or her a rosary, a *djellaba* (a long garment), etc.

In the master-disciple relationship, when we talk about disciples, we are not referring to the disciples of the master, but those of the path.

We can also be surprised by the meager results obtained by some individuals in comparison to the energy deployed by the master. These results can be explained through these words of Sheikh Al Alawee, "I spend fourteen years teaching a disciple in the path of God, and Satan takes him away from me in five minutes." The spiritual endeavor of many years can rapidly disappear should there be no repentance. The master is used to this situation despite the fact that it is not easy to experience. In fact, when he acts here, in this world, he does not do so to reach a goal. The successful outcome does not belong to the master, and his only function is to look after his disciples, to keep their flame. Were he to act for his own sake, he would, of course, be disappointed, for the mission he has assumed has borne no fruits. But because the result has no particular identity, who can be disappointed? Indeed it would be an illusion for the Sheikh to think that, through his endeavor, he can positively change the world, or that an individual can be inwardly transformed. The only thing asked of him is to serve, that is all. The Sheikh is but the servant of the *fuqara.*

One day, Sheikh Al Alawee met another sheikh who told him, "I have taken one of your students away from you." Sheikh Al Alawee responded then, "If you have taken him away and gotten him closer to God, you have then returned him to me, but if you have taken him away and driven him to yourself, then yes, you have taken him away from me." I recall the masters often telling us that the Sheikh must give the viaticum and let God take care of the rest.

Before the birth of Mohammed, peace be with him, when the Ethiopians invaded Arabia to demolish the Kaaba with the help of the famous elephant (Mahmoud), the grandfather of the Prophet, peace be with him, gathered the notables of Mecca in order to go and see the vassal of Negus, in this case the king of Yemen, the Christian Abyssin,

Abraha. His army had already started to invade Mecca and steal live-stock. When the Meccan delegation arrived to see him, the grandfa-ther, head of the delegation, demanded that all goods be returned to them. Quite astonished, Abraha said, "What? I come to destroy your temple, and you ask me to simply restore your herds to you!" The grandfather of the Prophet, peace be with him, answered him, "The goats, the horses, and the camels belong to us, but the Kaaba does not belong to us. It is God Who must save and preserve it. Deal with Him."

The Five Pillars
of Islam

In the Muslim world, practice plays an important role. It is a discipline in which real Muslims recognize themselves.

This practice is composed of five parts which are called the *five pillars of Islam*. First, there is the declaration of faith (*shahada*), which is the acknowledgment of God's uniqueness and of the message of Prophet Mohammed, peace be with him. Then, there are the five ritual prayers (*salat*), effectuated at the rhythm of the solar course. After that there is the fasting of Ramadan—a lunar month, (twenty-nine or thirty days)—which moves around the solar year, and after twenty-five years, it completes its turn around the four seasons. The fourth pillar is the alms (*zakat*), and the fifth one is the (*hadj*), the pilgrimage.

The Declaration of Faith

The first pillar is the acknowledgment of God's Oneness. For the Muslim, all rituals are based on this doctrine: "I declare there is no

god but Allah, and Mohammed is the messenger of Allah." *Shahada* is proclaimed throughout the whole life of the Muslim as a constant reminder.

The Sense of Prayer

The second pillar, prayer, is the axis or the essential element around which turn all the rest. In the *zaweeya,* the place where men and women meet to pray to God throughout the day, prayer orders the daily program. After *shahada,* prayer is the best tie *(selah)* between God and man, and man and God. It is for this reason that it is essential. It is the key to the right way; it purifies the heart so that it may reflect God's Light. One who does not pray cannot meet God.[1]

Prayer is a daily cycle in Islam. We start the day with the morning prayer *(subh'),* which symbolizes the beginning of life. Then there is the midday prayer *(duhr),* when the sun is at its zenith, when there is no more shade, and when one somehow finds oneself in one's culminating point, in one's verticality. After that comes the prayer of the middle part of the afternoon *(asr),* the prayer of the sages, and the path to wisdom. Then there is the sunset prayer *(maghreb),* at the time when the sun, in the process of fading, leaves behind a spot of light. It is the moment when a person's life gradually leaves this earth. Penetrating the night, we enter a parallel world which we do not know, and that is the time of the *esha* prayer, the fifth and last one which teaches us that prayer exits in the other world as well. This cycle is regulated so that every stage of our life is in contact with God, in constant communication with Him.

Muslim men and women are required to perform the five daily prayers. Since I declare that God is One and that the message which has been brought by Prophet Mohammed, peace be with him, is true, I make sure that this uniqueness remains constant and perpetual in my everyday life. Prayer is the means that will help me reach this goal.

[1] Ibnu Abbas, may God be pleased with him, quotes the Prophet, peace be with him, "The worshipper communicates intimately with his Lord, let him then be good at it." reported by Al Imam Ibnu Rabee.

It allows me to communicate with this uniqueness, and like *shahada*, it is the constant reminder of it. These five prayers, spread throughout the day, render time sacred, and fill the whole life of the Muslim. Of course, routine intervenes and gives prayer either its strength or its weakness. In fact, the effectiveness of prayer depends on the inner attitude of the individual. How is he or she going to pray? At what level? As a habit? With passion in the heart? By interest?

In the tradition of Tassawwuf, the role of prayer is to place us each time in front of God. The Prophet, peace be with him, says, "Pray to God as if you were seeing Him; and if you cannot see Him, know that He is." If we do not have this readiness, this intention, this force, and this perceptiveness to be able to see Him, then let us have the faith and the awareness that He is looking at us, and that all our acts, all our utterances, all our thoughts are uncovered before Him.

If such is our state of spirit, prayer then takes an extraordinary magnitude. It transports us from the temporal world of an everyday life, usually difficult to live, to a sacred encounter. It is a salutary moment during which man feels himself in the Holy Presence. For how can we be present with God if not through Him? This is what gives prayer this great importance and this considerable force. As Sheikh Sidi Al Hadj Adda has so nicely expressed it:

> Prayer is the indelible mirror
> Where God The Supreme reflects Himself.
> Each individual can see Him according to
> The clarity of his own heart;
> In the image of the moon when it appears in its
> First day of Ramadan.
> Those with keen vision distinguish it clearly
> While others remain in doubt.
> Ah! Doubt and its sad outcome;
> He who has not seen cannot
> Claim it exists not.

All that prayer stands for is revealed in these words of the Prophet, peace be with him, "Perform prayer [of farewell] as if you were performing it for

the last time."[1] This means that we must pray in as conscious a fashion as possible, far from routine. I make myself aware that I am in relation with the Absolute, in a dialogue with Him. Every time that I present myself in front of Him, I prostrate and submit myself. It is a constant reminder.

How are men and women going to use their time between prayers? What are they going to do to meet God or stay away from Him? What role would they play? What act would they commit? It becomes indeed difficult, between two prayers, to commit a disturbing act, one that erases or diminishes this energy, the intensity of this desire, of this communion. Every prayer allows men and women, in some way, to evaluate their conscience, their acts, up to the point where the evaluation becomes an essential diet. Actually, when we taste the flavor of prayer, we become perturbed if we cannot perform it; this creates a loss of balance; we do not feel well; our time is not regulated. The reverence of time transforms us; we do not live only to work or eat, but also to pray. Prayer is an integral part of our time.

Prayer is a means for the practicing individual to improve his or her inner side and to progress, because a discipline that is based on the desire to prostrate and to communicate with God elevates us and protects us from the abuses and the distractions which may be born in us.

Prayer is the mechanism for the spiritual transformation that is going to take place. It is a key for one to move from one stage to the next.[2] Just like the person who, with a chisel and a hammer, hits a

[1]Reference here is to the *hadith* of Abee Ayoub Al Ansaree as reported by Ahmed; "A man came to see the Prophet, peace be with him, and said, 'O messenger of Allah! Advise me and be brief.' The Prophet, peace be with him, said then, 'When you pray, do so as if it were the last time, and do not say words that would harm you the following day, and turn your back to what people hold in their hands.'"

[2]In one of His holy *hadiths,* the Lord says, "Not every performer of prayer prays. I only accept prayer from him who humbles himself to My glory, the one who engages not in sin, who feeds the hungry, covers the naked, who is merciful in calamities, who welcomes the stranger, all of this he does for Me, in the name of My glory, My sovereignty. Indeed his face is to Me more than the sun in radiance; I will turn his cruelty into clemency, and his darkness into light. I will answer all his prayers, and be by his side the whole time, and I will give him the protection of My angels. He is to Me just like the heaven of Al Ferdaws, whose fruits are untouched and whose state is unchangeable." Reported by Ad'Daylamee.

stone on a daily basis; no matter how hard the stone is, it will crack. And even if he cuts into it by just a few millimeters, he will create a passage and go to the other side. By the power of persuasion and discipline, he will obtain a result—a promise to experience a better state than the one he is in now. Human beings are not impotent, they are not blocked by a wall, at the mercy of the hazards of time. Through prayer, they can even provoke an energy to carry them further and awaken them more and more every day. This assiduity comes only through maturity. Actually, when one tastes the beneficial effect of prayer, it becomes a necessity. As we take time to stop all activities in order to eat, we must do the same to taste this delicate food of the soul.

Prayer also has other effects, visible and invisible. It affects hygiene, for at every prayer, we must perform ablutions. To wash with water refers also, on a symbolic level, to the removal of impure aspects in us. We remove negative things, frailties, so that we can stand before the Absolute.

In addition, it plays an important social role in the community. The rich, the poor, people of knowledge, ignorant and illiterate people, all find themselves on the same line. It is a fraternal exchange, since the faithful are called to meet five times a day. If there is somebody who is absent or sick, his brothers and sisters ask about him. If there is someone with problems, we are immediately informed.

In Islam, prayer is a tool for the Muslim community to live a sacred moment which brings the terrestrial world to this opening, this encounter with the celestial world. It is as if you were in the Sahara and, by looking at the horizon, you notice that the earth and the sky touch each other. It is through prayer that we may reach this perception of us and the Unknown, of us and the Divine. Through this act, something takes place, an emotion that we cannot name but simply feel, live. We are the witnesses of an experience, for ourselves and for others.

The place of practice is not that important. Since the Prophet, peace be with him, prayed while riding a horse or a camel,[1] we can perform

[1] Ibnu Omar, God bless him, says, "The Prophet, peace be with him, used to pray on his camel during his trips, no matter what direction it was facing." And At-'Tarmedee reports, "The Prophet, peace be with him, and his comrades came to a

it anytime and anywhere, even on a plane, or on a train, for it is the intention that counts. We can pray while seated. There is no need for body language: it can be symbolized by closing the eyes, and inclining the head slightly, as Sheikh Al Alawee said:

> Better be a prayer without prostration
> Than a prostration with no soul.
> The goal being farther than the means,
> Weep over those who
> Seek but the latter.

Prayers are always initiated by *fatiha,* which is called "the Mother of the Book." In our tradition, we say that the entire universe is contained in the four Holy Books, the four Holy Books in *The Qur'an,* which is itself contained in *fatiha,* itself contained in the invocation, the *basmala* (in the name of God, Most Gracious, Most Merciful), which is contained in the letter *ba*[1] (ﺏ),itself found in the dot under letter *ba.* We go from the universal, from the infinitely great to the infinitely small, from the macrocosm to the microcosm—the dot—which is the origin of all things. It is the dot that contains the whole universe.

Every prayer starts with the *sura* of *fatiha.* Its words are universal and can be said in all religions.

1. In the name of God;
 Most Gracious, Most Merciful.
2. Praise be to God,
 The Cherisher and Sustainer of The Worlds,
3. Most Gracious, Most Merciful.
4. Master of The Day of Judgment.
5. Thee do we worship, and Thy Aid we seek.
6. Show us the straight way:

strait . . . then it was time to pray. The Prophet, peace be with him, ordered the caller to call to prayer. Then he proceeded on his camel and led his comrades in prayer while sitting on it; the prostration was lower than the bowing," see Safar As'Saada by Ash'Sharazee.

[1]This letter refers to the word "In," in the part of invocation of every *sura* of *The Qur'an* with the exception of the *sura, Tawbah,* the chapter of Repentance.

7. The way of those on whom Thou
 Hast bestowed Your Grace,
 Not the way of those whose portion is Your wrath,
 Nor that of those who go astray.

After *fatiha,* we can choose a *sura,* or one of the verses of *The Qur'an,* according to time, to our perceptiveness, and our inner state. The chosen piece can thus affect us and increase our level of consciousness. These recitations are accompanied by three positions of the body: the standing position, the bowing position, and the prostration, each of which have their own symbolic meaning. We start with the standing position to reach the prostration, which symbolizes submission to the Divine Will—we accept to be what we actually are. Some Sufi people also say that through these corporal attitudes, all kingdoms are represented—the animal, the vegetable, and the mineral. It is all about the return to the Absolute; not only to that, but also to the origin, the earth. This ritual is closed by this sentence, "May peace be upon you," (*As'Salamu Alaykum*). We turn right and left, whether we are alone or in group. This movement is accomplished for the sake of the angels who accompany us and who are always close to us.

In the Muslim tradition, it is said that each person is accompanied by two angels, one on the right and the other on the left.[1] In a book, they register the good and the bad acts that will accompany us all our lives until the Day of Judgment. When we stand before God, we will be judged for all that we did in our lives. The book and the angels are symbols which help us to be conscious of the fact that every act in life counts; that it is noted down and will never be forgotten. I think that we carry these angels in us. I mean that every act is engraved somewhere in us, in our conscience, in our cells, in our genes. "On the day when their tongues, their hands, and their feet will bear witness against them as to their actions," (*sura* 24, verse 24). An act is eternal even if we forget it! Every time we do something, we must be aware of the consequences. Are they beneficial? Useful? Really unselfish?

[1] There are many references in this matter; "Verily, over you are appointed angels to protect you, kind and honorable, writing down your deeds; they are aware of all that you do," (*sura* 82, verses 10–12).

Prayer is done. Right after the salutations of peace, we can add other practices such as *dikr* with the rosary of ninety-nine beads (*tasbeeh*), and (*du'aa*), praying for guidance. There is, of course, besides the five ritual prayers, an entire range of prayers—that of Friday, that for the dead, for the drought, for feasts . . .—that we can adapt to circumstances. In each prayer, we are allowed to ask for something, for ourselves and for others. Prayer is a means to receive and to give. We receive the Divine since we recite His Word, and we stand before Him to declare His Uniqueness and submit to His Will. There is a constant exchange between the human being and the Absolute.

There is a difference of degree between the prayer of the common person and that of the disciple. The quality of prayer reveals the state of the being. The cleaner the mirror is and the purer, the more it will reflect the Divine Light. Besides practicing the prayers as do all Muslims, the Sufi realizes other things. There is a lot to say about prayer—we would need a whole book to deal with this subject in detail.

Fasting

Fasting has a role of purification, and it is also a form of worship. It is not only a matter of abstaining from eating, but also from everything that is superfluous in the relationship between the human and the Divine. There is the obligatory fasting of the month of Ramadan, and the recommended fasting that takes place, for example, at the time of retreats. Ramadan is also the month of Revelation and the Night of Destiny during which the gates of heaven open much more to the prayers of man.

On the physical level, fasting is quite healthy; it purifies the body from its excesses. When it is accompanied by a spiritual intention, some psychological elements are also eliminated. In general, during the fast, we worship a lot, we read The *Qur'an* more, and we pray more. These practices are essential in the retreats.

Zakat

Zakat is an economic practice. It means that if I consider myself fortunate or wealthy, it is a divine privilege for a period of time during which God becomes somehow my associate. *Zakat* represents the expression of gratitude that I have for God who has given me life, health, and the

possibility to enjoy the gifts of life. It is not charity, nor is it a donation—it is rather a duty, an obligation. Every year we make an assessment of our fortune and, when we fill out the fiscal declaration, we put the sum of benefits that we have gained aside to pay a 2.5 percent on it. This percentage can sometimes be evaluated in money or sometimes in kind (corn, cattle . . .) for the farmer or the breeder. There are some exemptions though. For example, if a woman has jewelry, she does not pay any tax on it since it is considered as personal adornment.[1] On the other hand, there is *zakat* on gold, on financial shares, and securities. When the Islamic institutions still existed, people gave their alms to the treasury which redistributed them. Today, the state does not receive these alms anymore. Governments impose taxes and we are obliged to give alms ourselves. We can grant them in full to somebody or we can divide them, but we must give them. I think *zakat* is one of the most demanding practices, for it touches a sensitive part of the human being. The attitude of men and women with regard to money is always very revealing of the degree of their faith. *Zakat* is a means to see if God is really an associate of ours, and whether we bow to His Will.

The Pilgrimage

For safety reasons, a woman must not do the pilgrimage unless she is accompanied by a male member of her close or distant family. It lasts for about a week.

In order to understand the symbolism of pilgrimage and to discover the extraordinary, incomparable force that emanates from within it, one must live it. While doing it myself, I felt an awakening to a dimension which I had intellectually dreamed of, but had never realized. The unity of being is fulfilled in this place.

We start by being almost naked, for the restrictions imposed allow no hiding. The only garment tolerated is composed of two fabric layers

[1]Among those who exempted women from paying alms on their personal jewelry are, A'esha, Asma, the daughter of Abee Baker As'Seddeq, Abdu Lah Ibnu Omar, Jaber Ibnu Abdeel Malek, Ahmed, Al Qasem Ibnu Mohammed, Malek, Ash-'Shaabee, Ishaq, Abu Ubayda, and many more.

that cover all but the head and the chest,[1] in spite of the heat that can reach forty-six degrees Celsius. While in our society, clothing makes of us what we think we are, in Mecca, we lose all identities; we are identical to all beings. We integrate ourselves into something else, and the bond between people comes out in an extremely powerful way, since it is experienced and shared by millions at the same time.

Pilgrimage starts with the seven circumambulations (*tawaf*) around the Kaaba which symbolizes the house of God. It is a hollow cube of stone which is about fifteen meters high, thirteen meters long, and twelve meters wide, covered with a black velvety layer on which are

[1] A woman wears a modest white dress and a scarf covering everything but her face.

Sheikh Khaled Bentounés (standing in the middle)
during his pilgrimage to Mecca in 1981

written, in golden letters, the Divine Names as well as Qur'anic verses. This empty cube symbolizes the unknown, the absolute mystery, the unfathomable.

During this period, I saw the entire human race in front of me in these millions of faithful who turn around, all at the same time, for twenty-four hours, praying and invoking God in different languages, thus creating a deep sound far beyond imagination. When I saw, felt, and heard this compact mass of human beings who revolved all at the same pace around this cube, just like a dense cloud where I could no longer distinguish men nor women, nor even individuals, the thought of a nebula crossed my mind. Adding to that, the heat, the feeling of suffocation, the lack of air, and the difficulty of walking, I felt my individuality as if crushed inside this mass. During the seven circumambulations that I accomplished, I felt more and more tired, to the point where I counted their number on my fingers each time I held my hands to salute the Kaaba.

Of course, as with all pilgrims, I was animated by the desire to get close to "the black stone." But nowhere else have I seen such a great number of people crowd around, squeezing each other with one single obsession: to touch the stone. To reach it, the pilgrims would do whatever it takes; they would give everything they have!

This black stone is located in one of the angles of the Kaaba. It is said that Adam brought this stone with him from paradise.[1] It stands for the pact between God and the human race. "When thy Lord drew forth from the children of Adam—from their loins—their descendants, and made them testify concerning themselves, (saying); 'Am I not your Lord?' They said: 'Yes, we testify,'" (*sura* 7, verse 172).

Pilgrimage allows us to climb back up to the source, to the origin. After *tawaf*, we go to the well of Zamzam, whose source sprang under the foot of Isma'eel, son of Abraham, peace be with them. It is at this fountain that many men come to drink, where many hearts are regen-

[1]Ibnu Abbas reports the Prophet, peace be with him, saying, "The black stone came down from Heaven whiter than milk, but the sins of the sons of Adam turned its color black."

erated, and many thirsts quenched. Being of a particular taste, a little bitter and salty, the water therein is so light that we can drink excessively, without ever feeling bloated.

The second phase of *hadj* takes place on the two hills of As'Safa and Al Marwa, which are today a part of the temple. The pilgrims must perform seven round trips between the two hills, slowly first, then hastily.[1] This trip symbolizes the trekking of Hagar, the second wife of Abraham and mother of Isma'eel, peace be with them all. Seeing her baby dying of thirst, she implored God for help, going from one hill to the other. The wife of Abraham represents here the thirsty soul—thirsty for life, for Truth, and for the Absolute; a soul which persistently looks for this miraculous water that regenerates and nourishes. During this crossing, the pilgrims pray God for help, for themselves and for mankind. This stage is particularly long and hard, for in the state of *ihram* (the state of sacredness), we can neither wash properly, nor brush our teeth, nor get a haircut or cut our nails, nor can we shave, and these conditions get even worse since we eat and sleep less. But a great joy will be the reward for these first tests.

The test that follows requires a trip by bus to a place outside Mecca called Arafat. Imagine thousands of small enclosures overflowing with giant tents facing each other. In each of the alleys that separate them, there is but one faucet of water and three or four bathrooms for hundreds of people. From all sides, over many kilometers, there is nothing but white tents which stretch farther than the eye can see, and a colossal crowd dressed in white. During this day, pilgrims find themselves standing in order to pray. There is no distinction of race, of wealth, or of knowledge; everybody is the same. There exists only one distinctive sign: the presence of the Divine Grace illuminating the faces of some, and others whose faces stay closed and dark. *Arafat* means "the encounter," the place where we meet. According to legend, it is at this spot that Adam and Eve found each other after having been thrown out

[1]The fast pace takes place between the two green signs near As'Safa on a distance of seventy-five meters. Back from As'Safa to Al Marwa, the fast pace takes place on a distance of 260 meters. And the whole distance between the hills is 405 meters.

of paradise. It is the encounter between the man and the woman, between the spirit and the soul. This sacred place of Arafat has been delimited by the Prophet, peace be with him, and today it is hardly able to hold all pilgrims. The pilgrimage is valid only if we can enter this boundless space before sunset and come out of it before the sundown of the next day.

The next step takes place the following day. It is a blessed day where all sins of men and women are erased, if indeed they accomplish the pilgrimage for God and uniquely for Him. The day is devoted to prayer, the reading of *The Qur'an,* and meditation, all of which are interrupted by some time of rest. At sunset, a roar is launched, as if coming from a single person, when the crowd starts praying loudly, with force and intensity. Each person gives his or her inspiration free reign to allow the heart to express itself. Even in cries, everyone calls their Lord in their own tongue and according to the level of their faith.

The same evening, this human cloud hurries toward the buses in order to go to the station of Meenan for the next stage of pilgrimage. This trip is taken meter by meter, for the number of vehicles is such that we cannot call it traffic anymore, but only fourteen kilometers of chaotic jam. Midway, people stop at Al Muzdaleefa to collect the *jamarat:* a lot of forty-nine small stones in the size of a broad bean, which are necessary for the stoning of Satan. This stoning ritual lasts about three days. It takes place at the three spots where Satan tried to tempt Abraham, peace be with him, by throwing doubt in his heart in an attempt to separate him from God and impede him from sacrificing his son, Isma'eel, peace be with him. After these three trials, Satan gave up, for he knew that no matter how hard he would try, it would be useless to continue. In another legend, it is said that it is in one of these three spots that the guide who led Abraha to destroy the Kaaba is buried.

At this stage, the pilgrimage is a flood of men and women, who, elbow to elbow, many kilometers long and many meters wide, head toward the same direction. Thousands and thousands of stones, thrown in the direction of "the one stoned," sting the air and then fall down with a piercing sound. Symbolically speaking, it is quite clear that we are stoning our own demons, we are stoning some of our own atti-

tudes that separate us from the Truth. One who makes this pilgrimage an intimate experience knows exactly what aspect of himself he is stoning. After this ritual, we feel the beneficial effect of deliverance.

Then, some people are chosen to carry on the act of the offering, the sacrifice of an animal. This ritual takes place at Meenan, after the stoning, in a special place reserved for this custom. Personally, I had no offerings to make,[1] but out of curiosity, I went to the scenes, and I regretted having done so. What I saw alarmed me, if not horrified me—all these men, each with a knife in the hand, and all these bleating animals that sense death on the bloody ground! It is a memory that tears the heart. Why all these animals that will be of use only to a minority? I had come to witness a sacrifice, I ended up watching a massacre. This sacrifice, which symbolizes the offering from the creature to the Creator, has a deep and true meaning. But, can it not be of use nowadays to those who really need it? Can we not avoid this waste which is unnecessarily perpetuated every year?

In the sacred atmosphere of the pilgrimage, you pay for every attack on life, however small it may be—animal or vegetable, voluntary or involuntary. It is true that you can eliminate a dangerous animal, but you must pay, either by giving a compensation to a poor person, or by effectuating an animal sacrifice.

Last, there is the return to Mecca to perform the last seven circumambulations of the Kaaba, *(Tawaf Al Efada),* and then we go back to our civilian clothing. In a state of happiness, we can finally wash abundantly, shave, cut our nails, put on some perfume, and from that

[1]The offering in pilgrimage is a must for him who combines his *umra* (a visit to Mecca that can be done anytime in the year, unlike *hadj,* which is performed at a specific time) and his *hadj* in one trip and with one single intention, *ihram;* on him who combines the acts of *al hadj* and *al umra* during the months of pilgrimage, in one single year, with two separate intentions, performing the acts of *al umra* first—At'Tamattu'—after which he is allowed to go back to his normal life: hair cutting, sexual intercourse with his wife. . . ; on him who commits a wrong act; on him who misses a pillar; and on him who bears the intent of making an offering to the Lord seeking His grace. As for the pilgrim who is in Mecca only for the reason of pilgrimage, and commits nothing of the above, he is exempt from the blood offering.

moment on, everything is allowed again. The final ritual is the return to Meenan to throw our last stones.

After resting one or two days, we put on one last time, and for a few hours only, the garments of *al ihram,* so that we may perform *al umra*—the small pilgrimage—which is carried out at night to avoid the heat and the crowding around the Kaaba. We leave the sacred boundaries of Mecca in order to go to a mosque[1] wherein we perform a two-prostration prayer through which we express the intention of *al umra.* Then we go toward the Kaaba where we perform the seven revolutions of *tawaf* and where we pray facing the spot of Al Multazam. Finally, we go down to the well of Zamzam to close the whole process by the walk between the two hills of As'Safa and Al Marwa.

Pilgrimage is a way of testing faith. How far can the faithful go for the sake of God? And I assure you that if you are capable of abandoning yourself to respond to His call, you will live some instants of blessings that can never be forgotten, moments which are rare in this material world where the place of the true man is more and more tenuous.

In conclusion: it is prayer that determines the Muslim. If we are sick or traveling, fasting can be abrogated, it can be done in a different month, or it can be compensated for by giving food to the poor. Alms, too, are given only when we possess a fortune, land, etc. And pilgrimage is carried out once in a lifetime, but only under some conditions: to be an adult, to be healthy, to be financially at ease with no debts and without borrowing money. Prayer, on the other hand, can always be performed, whatever the setting and the attitude, whether we are sick or paralyzed. We cannot compromise with it since it is the most excellent way to open the heart of man to God.

[1] The mosque of our Lady A'esha, Mother of the Believers, may God be pleased with her; it is located in at'Taneem.

V

The Three Levels of Evolution

The five pillars are practiced either superficially or deeply, according to the level of evolution of people. There are three levels of religion in Islam; submission *(islam)*, faith *(iman)*, and excellence *(eh'ssan)*.

Islam is the first state. It is about submission to God in all that He has decreed and desired for humanity. Since He has ordained prayer, I do it; *zakat* also is His command, and I give it without any discussion. I must realize the five pillars in a state of submission, accomplished in a strictly formal manner.

The second state, *iman* (faith), expresses the fact that the words we speak come form the heart. The first level can be experienced by anyone, but not the second. The believers who live in the state of *iman* do not limit themselves to the practice of the five pillars, they hold their reflection in the heart.

The last level is that of *eh'ssan* (excellence). The Prophet, peace be with him, has described it as such: "Pray to God as if you were seeing Him; and if you cannot see Him, know that He is." This state is that

of certitude and inner vision. We do not worship God because it is a duty, but because we see Him. In this ultimate stage, it is not enough to know, but to see. The Prophet, peace be with him, says, "As if you were seeing Him;" the word "if" indicates a line between those who see Him and those who will never reach this level. Therefore, it is neither faith nor daily practice that guide prayer, but certitude,[1] the inner vision, which is not the outcome of reason, much less the fruit of imagination.

These are the three levels of this spiritual practice. To sum up this fundamental aspect, we can say that the first stage will never be like the second which, itself, will never be like the third. There are those who accomplish the first stage and stay there, while others will try to move to the second. Rare are those who will reach the ultimate level and who will then be at the highest plane of realization. Not everyone is able to endure this final stage, and those who can must be prepared in advance to tolerate it, live it, and be its witnesses. In fact, this radiance can actually be seen through those who have been enlightened; we see that they have seen!

A New Perception of the World

Now, we know the real meaning of the obligatory practice. It is not static, but is always generated and revitalized by reflection. It is not enough to perform prayer, we must harvest the fruits therein. And the practicing men and women, being more or less satisfied with the results of practice, will then search for a state of more fertility and more perception. From this moment on, everything is in its place. They start to perceive that the sounds and everything around them are not accidental. Events take their place and turn into signs. Actually, something opens in them, like a sixth sense which allows them to capture these signs. A sensory and corporal awareness sees light. The senses become more astute, more receptive. They await the sign that corresponds to

[1]Sheikh Al Alawee, may God be pleased with him, says, "When certitude comes, nothing more exists; behold with the eye of faith the existence of the Truth in every direction and every place."

the inner state, to the needs. At this stage, there are no more words, and I cannot explain further.

In fact, it is all about God, and nothing else. We see the divine manifestation through His creation. This tree behind us is not inert, it is spirited. It is alive just like me, and it, too, declares this Truth, but common people cannot communicate with it, for they have has not reached this universal state that allows them to open up to the plenitude.

This exposure is like a light that we ignite; it allows us to be spectators of a new scene of which we knew some details but did not have the whole view. In fact, although the world is the same, it is different each time.

This level is not yet that of realization; it is a state that can be reached through practice. I am describing to you the way this practice may be lived for one who holds it in the heart, knowing that it will be different for one who lives it at a higher level. What I am saying is above intellectual or rational endeavor. It is an experience that cannot be grasped, unless it is lived. This new perception of the world becomes normal. It is as if we are rising to a higher level that already exists inside us, a hidden aspect to which we could no longer have access. Through practice, faith, and through the intense desire to get closer to God, our intelligence and reflection evolve a step ahead, allowing us to see and to hear differently, with no comparison to previous experiences. When someone addresses us anonymously on the street, even if this person utters a dull sentence, he or she says it for us and not for somebody else. We feel the words as being meant for us and, at the very instant, as responding to the question we were asking ourselves or to the desire we had in mind at that moment. There is correlation in here; it is not a matter of chance, nor is it a gratuitous outcome. I do not know what the scientists and psychologists think of this, but in Sufism it is part of the domain of the possible and daily life. It is an experience that exists! We can live it once, ten times; the hundredth time, we are convinced of its reality.

Practice is in fact a tool of purification, of meditation, of incitement, and of refinement. It allows us to go ahead, and to discover a field of conscience we did not know or had forgotten, as is already mentioned

in Genesis. It is a matter of rediscovering a part of us: the Self and its great possibilities. If we think with a restricted and limited mentality, we imprison ourselves; why do that when we have the possibility to broaden the conscience, to extend it to infinity? This openness allows us to see the world and the beings differently. Creation as a whole takes another dimension, and this also means that we do not think the same way anymore. The astronauts, for example, who have left the terrestrial sphere on their way to the moon, have described different states of mind. They have changed internally because they have escaped their habitual boundaries. The Prophet, peace be with him, says: "There is in man a spiritual energy high enough to draw the universe, should it so desire."[1] When my master, Sheikh Al Mehdi, taught us this *hadith,* he stressed the fact that the Prophet, peace be with him, addresses the human race in general, but puts more emphasis on the believer and the knower.

We can attain this level through practice. It means that we can escape the boundaries of our space, our education, and take a totally new look at ourselves. We move a step ahead then and start a new register. We can no longer say that we are rising up or that we are retreading, but are rather experiencing a change of frequency. In fact, we see people and things we love in a bigger, more universal world. We no longer perceive them as a matter of chance, a necessity, or as an obligation. We suffer no more. There is no more pressure; and even if it exists, it has a role to play.

Usually, our mind is entirely enslaved by material interests and diverse emotions such as love, grief, delight, suffering, fear, doubt, and discontent. This enslavement is an impediment that limits us in our field of action. We must undergo many tests to change our mind and prevent it from concentrating on things with such force and suffering.

[1] The Prophet, peace be with him, also says in the same sense, "Should knowledge hang from the stars, some people of Persia would have aspired to it," reported by Abee Hurayra, and quoted by Abu Na'eem in his book, *Al Helya;* also reported by Qays Ben Saad and quoted by Ash'Sharazee in his book, *Al Alqab.*

Little by little, practice brings forth relief. One becomes more serene, more thoughtful. The pacification of the mind brings one more softness.

For example, the disciple is freed from the fear of death, while it remains a dread for the person who lives in the sphere of rationality. The latter refuses to think about it, because he or she feels they will disappear, body and soul. For the disciple, however, death loses this image of the fatal exit and becomes a step in the process of the continuity of the spiritual progression. In fact, it is the goal sought. The Prophet, peace be with him, says, "Die before you die." To die before death means that this dread of the ego, this restrictive concept imprisoning us, disappears for good. Through this liberating death, we can experience a second birth that opens us to the universal, the eternal. It allows us to reach the possibility, which all of us have, to get out of the limited and closed world of our rationality, our intellect, in order to attain the spirit that is manifested in everything—the present eternal, the living eternal. We change values, judgment, and perception. We perceive things at another level.

In this case, we must not forget that our internal experience cannot be separated from what common people, who are still prisoners of their limitations, live. And so, we must adopt a double language, a double way of thinking. With those who have reached the same level, we can converse, for they are on the same wavelength. But we must never make the mistake of talking this way to someone who has not attained this inner state and who does not possess the same level of reflection or the same vision of things, for we can confuse and terrify him. *(See footnote 2, page 3.)*

This is a story which illustrates well what we are talking about: It rained in a town for nineteen days. The king had been warned in a dream that the rain was going to poison all the wells and the fountains of the country. He then ordered his wells to be covered in order to safeguard the drinkable water therein. Alas! He did not deem it necessary to cover the wells of the city and the country, thinking the pollution would be temporary and would not cause serious consequences for

people's health. When the rain stopped, people drank from the water and became crazy. They came to see the king on a daily basis so that he could dispense justice, and they talked to him about their problems in a different state of mind, different from that in which they lived before. The king, seeing all of that, ended up asking them to bring some of the water they drank from so that he could have a taste of it. As expected, he became mad like them, and he was able then to dispense justice.

This anecdote shows that we cannot communicate among ourselves unless we speak the same language.

According to Divine Will, people are bound to the experience of their individuality so that it may be accomplished in full, but they also remain aware that they are an element of the whole. If the enlightened, those who have reached the highest level of realization, were to lose their individuality, they would be rejected by their fellow creatures, and would have their place in a psychiatric asylum, since their reasoning would be different from that of the masses.

This state exists, there is no doubt about that, and I think that we cannot rationally explain it since it is an experience. It is as if three of us were by the sea, all watching the horizon, one with the naked eye, the second with glasses, and the third with binoculars. We are all looking in the same direction, but one sees farther than the other. We all have the same sight toward this reality that surrounds us, but one who sees with the naked eye sees reality according to the eyes, and one who sees with a more sophisticated instrument sees it accordingly. In fact, all three see reality, all are right. All visions are right. It is a question of perception and depth.

How can a person who is faced with the hectic necessities of our society of consumption discover this inner state? Such people work eight to nine hours per day, and sometimes more. They run from morning to evening. They endure the assaults of phone calls, of faxes, etc. For the common among mortals, this life represents the truth. Chained to this perception, how can people understand on their own, through their rationality, the truth of the world of the senses? It is very difficult! The only thing we can propose to them is to take the pilgrim staff and

start the journey, the experience—that's all! We cannot undertake the trip on their behalf. We cannot perceive things unless we live them ourselves. If one does not take the pilgrim staff, if one does not engage in practice with a feeling of urgency, he or she will live on a mental level, and it will be totally illusory. This is what asceticism is all about.

They are watered with the same water,
yet each gives fruits of different tastes
(*sura* 13, verse 4).

VI

Spiritual Discipline

In the tradition of Tassawwuf, the ego is divided into three levels. The first is that of the ego *(an'nafs al ammara)*, the hardest to tame. This ego loves obscure things and cherishes evil. The second level is that of an ego which is sometimes negative and other times positive *(an'nafs al'lawwama)*, it commits evil and then regrets it—remorse coming after the action. And the third level is the ego which is appeased, the peaceful one *(an'nafs al mutma'enna)*. These are the three natures of the ego,[1] but the latter remains always present. If it were to disappear totally, we would no longer exist.

In spirituality, when we talk about reaching a state of being with no ego, we actually refer to the fact of leaving this non-pacified, rebellious ego which cherishes evil and then regrets it after having committed it. In the state of realization, it becomes an enlightened ego which discov-

[1] "The ego holds of vice as much as the Lord holds of bounty," Sufi saying. And As'Sh-ablee, God bless his soul, was asked about the meaning of this *hadith,* "The ego does indeed feel fine when it gets its sustenance." He said, "Should it come to know the provider, it would feel fine," and then he read God's Holy Words, "And God has power over all things," *(sura* 4, verse 85). See the book *Allam'a* of At'Tawsee.

ers its evil side, and then submits itself—an ego which rediscovers its primordial origin. In fact, its origin was only veiled. The Prophet, peace be with him, says, "God has ninety thousand veils."[1] The only possibility for the ego is to exist through God and nothing else; the rest is but an illusion.

The Goal Behind the Spiritual Discipline

The objective of asceticism, of self-discipline, is to allow man to see his dark side. This allows one to calm the ego and rediscover the spiritual spark which is divine in essence. Through a combination of experiences, both purifying (on the level of the body) and purificatory (on the level of the soul), one will manage to dust and polish this inner mirror which will shine more and more, and which will reflect this divine light already present within.

The moment that man is able to reveal this light, it becomes useful for others. It is in this sense that we can say, "Man is in the image of God." He becomes then a living witness of this Truth.

I repeat, the transformation of man comes to pass the same way the earth revolves around the sun in a year and around itself in twenty-four hours. We are talking about an individual and universal transformation. Every day, there is a transformation that takes place; it is a revolution around oneself and, at the same time, a journey around all the stages of life. (*See footnote page 51.*) There are two parallel evolutions which are intrinsically linked; neither can be done without the other. We must experience it all—the cold, the hot, the cool, the warm . . . everything, and in all degrees! This is what realization is all about: the complete accomplishment of the vast revolution. It is not the revolution of the ego which is limited in time and in space. It is rather a transcendent, horizontal, and vertical revolution. If this complete revolution is realized without this individual transformation, it will lead nowhere, just like an experience lived in a dream without a perceptible reality that materializes it.

[1]The Prophet, peace be with, says, "His veil is His Light; should He unveil It, the radiance of His Holy Face would burn all that His Sight catches of His creatures." Reported by Muslim and Ibnu Maja. (See *Al Jame'* of As'Sayoutee.)

The Purification

In our tradition, when the master receives apprentices, he purifies and polishes the receptacle. He prepares them so that they may know, before anything else, what they are looking for. He shakes them in all ways to make the goal clear. What are they really looking for? This is the first stage. If apprentices have not yet defined the goal of their quest, there is no need to continue. They will not be ready to confront this path and fully live it. But if they know what they are looking for, they will then be helped. My grandfather, Sheikh Adda, says in the matter, "When the apprentice arrives, he is like a tree which has just been cut in the woods. He is rough, and from one stage to another, from the cutting to the polishing, he becomes the stick with which we pass the k'houl[1] between the two eyelids."

The apprentice cannot start this journey on the basis of an illusion. All those who seek knowledge for knowledge, enlightenment for enlightenment, or who look for powers and charisma, are excluded in this path. And even if these people remain in the path, they will get nowhere. Only those who come in total sincerity, animated by their desire for God, will be able to reach their goal in the quest. From the very beginning, the master sees the man or woman who looks for the truth and the one who is in confusion. Often, in an indirect manner, the master shows the disciple his or her weaknesses and illusions, but he can also show more firmness if necessary.

The master is like a mirror which places itself in front of the disciples, calls them, and asks them to look at themselves: "What are you really looking for? What face do you want to have? What is your real desire? Look at yourself! You cannot ask for the more subtle and the more precious of things in the state you are in now. It is impossible!"

It may also happen that the master puts the disciple in a waiting period. But if the disciple's quest is sincere, he will soon become distressed, and will decide to engage himself. On the other hand, if the disciple is not apt for the path and if he is satisfied with what he has, he will wait, although it is his duty to solicit the master.

[1]Cosmetic powder applied to the eyelid with a small, finely polished stick.

When the disciple is determined, the purification is carried on, for we cannot meet God if we are occupied by hatred, violence, corruption, envy, and lies. If we do not root out these flaws from within us, we cannot go farther. These are the many chains which the disciple must break in order to be freed. In fact, the idea is to remove all blindfolds. We lie to ourselves and to each other perpetually. How many lies to our own selves and to others do we tell, every day, to maintain a beautiful but false image that has no truth in it, and we know it. Most of us have two faces: one facing society, and the other hidden, shameful but real. We must stop this game and live our primordial and original nature in a simple way.

Sometimes, we are surprised to find a shepherd who leads a very simple life in the mountains and who possesses a philosophy of life, a wisdom, and a peace, when he has never read anything at all. In order to take on this journey which passes also through the desert—the spiritual path—we cannot hinder ourselves with useless things; we need but the essentials in life in order to survive and reach the goal. Weight is the enemy.

To Organize One's Life

We ask the apprentices to concentrate their energy, to organize their lives, and not to stay unsystematic, for God loves order. Everything in the universe is in order, only man is in chaos with himself. First, man is dispersed, divided among his intellect, his conscience, his sentimentality, etc. Just like the concentric circles, he must first depict his center, his core, for he cannot go toward the One while being inside the sphere of multiplicity. He must realize the unity within, know who he is and what he really wants. It is indispensable! Take the example of the big athletes: all their physical and mental strengths are brought together for the purpose of victory, be it only to win a tenth of a second. It is the same in the spiritual domain; we must concentrate our strengths, and leave behind some of the things that weigh on us and which keep us prisoners. Disorder causes weakness, and I think that this applies not only to this spiritual path but to everything else.

We must start by gathering our energy toward a definite goal. Why ask for this union with God? There are some people who do not need

it, who feel fine right where they are, in harmony with themselves. There is a Sufi anecdote concerning this theme:

> One day, a Sufi master arrives by the sea floating on a carpet. Once on the shore, he meets a fisherman who was mending his nets. Seeing the master on his floating carpet, the fisherman exclaims: "This is extraordinary! You are a saint! You must absolutely show me the way."

> Faced with this sudden motivation, the master initiates him and then goes back the way he came. Without wasting a moment, the fisherman starts his prayers. Alas! He suddenly forgets them, and starts to run on the water to catch up with the master, "Master, I have forgotten the formula, could you give it to me again?"

> The master answered, "You surely do not need it anymore since you have reached a station higher than mine. You walk on water while I still need a carpet."

This story shows how deeply our intellect, our mental thinking, complicates spirituality. It is true that there are practices, but they must be lived in simplicity. One who is united with oneself and who possesses a mind which is neither congested nor dissipated will waste less time than one whose mind is complicated. Besides, I reproach our society for nourishing people with a broth of superficial information which does nothing but disorient them and separate them from simplicity. How can we find this simplicity again? If one finds oneself, he or she will find the Lord. On the other hand, if one loses oneself, he or she will stray far away from God. The first barrier for the modern man or woman is their rationality, their lack of mental simplicity. They must always find words to explain things, justify themselves, to label. This occupies ninety percent of their energy, and only ten percent remains for them to discover that which they do not know. This is not much. However, I reassure you, I have seen some people get over this stage, but it is only through love that they have succeeded in crossing the barrier of the mind and accessing this divine energy.

There is no real difference between people of the East and those of the West, all have a chance to reach Unity; "To God belong the East and the West, wherever you turn, there is the Presence of God," (*sura* 2, verse, 115). However, this idea is difficult to realize for Westerners because of their education and the desecrated society in which they live. On the other hand, those who hear the call to prayer five times a day, or who see people pray and fast, are psychologically better prepared to respond to this call, which they find in their daily life. But, in counterargument, if this religious environment is not accompanied with an awakening education, it can turn, as some say, into "the opium of the people," which puts people to sleep and separates them from the Truth. Conversely, a desecrated society can sometimes give birth to a thirst for sacredness, an intense desire to live something exceptional. For all these reasons, I cannot say that some individuals are better placed than others, it is a matter of one's state of conscience. There are people who are sure of what they are looking for, and others who go around and around all their lives. Here lies the difference!

Work is Prayer

Spiritual practice includes all aspects of life. Thus, the energy spent in a professional activity is no longer unsystematic or wasted in the spiritual evolution if these two worlds do not separate. Our misfortune resides in the permanent division of things. If I invest myself in my work, it becomes a device of amelioration—as necessary as the invocation of the Divine. I do not separate work from prayer anymore, it is an integral part of my life, and helps in my evolution.

I must work to live, I must pray to be able to advance in the path, and all this is one. My worldly and spiritual activities point toward the same direction. It is much simpler and more effective—my work becomes a form of prayer. The Prophet, peace be with him, says, "Work in this world as if you were to live eternally, and work toward the other world as if you were to die tomorrow." I work consciously, knowing that work will be my asset in the other world. While accomplishing my duty and assuming my responsibility toward society, I give dignity to my work. I do not turn it into pressure, as is so often the case nowadays. I achieve

something great, something rich, that allows me to discern truth from falsehood, to help and to educate others, or to play a useful and positive role regarding society. Should each one of us make of their work a form of prayer, they would do their best and would not cheat, since it is, for them, a way to advance on the path, an evidence, and a heritage, which they will pass on to future generations. We are talking about a transmutation. My job is part of life, just as my children, my family, or prayer are.

One day, Abu Dharr Al Ghifaree, while upset, went to see the Prophet, peace be with him. Prophet Mohammed sensed his agitation and asked him, "What is it that bothers you, O Abu Dharr?"

He answered, "O messenger of Allah, the rich people have hoarded the rewards; they pray like us, fast like us, and on top of that they give alms with the surplus of their wealth."

The Prophet, peace be with him, answered, "What! God has not given you assets to use for alms? To say: 'Glory be to God,' is alms; 'God is Most Great,' is alms too; also: 'Thanks be to God,' and 'There is no other divinity but Allah.' Every time that you ordain good, alms it is, and every time that you impede evil, alms it is too. Every time that you satisfy your body needs, it is as if you give alms."

They all exclaimed then, "What! We would deserve a reward just by satisfying our physical appetites?"

The Prophet, peace be with him, answered, "Doesn't he who satisfies his appetites in an illicit manner get charged with a sin? By the same token, he who satisfies his needs in a licit way gets a reward."[1]

We often make the mistake of desiring God by isolating Him from everything else, while desiring God cannot be real unless there is desire to see things change and rise. God is present in every act of life. Nothing should escape one's conscience, the Presence. Of course, there are some desires that fade, and others, more essential, that endure. Sustained by a new source, they are regenerated and take a greater dimension. I discover that to love others is to love God, and is also to love oneself, for many people hate themselves; they do not accept what they

[1] Reported by Abee Dahrr, God bless his soul. *See* Sahih Muslim.

are. By doing so, they do not accept God, when that which He has made of me and what He has given me is true and right. As a creature, I must be aware of this fact and love what I am. We are not talking here about the love of the ego. Our individuality does exist, but in fact it integrates into the Ultimate Being and harmonizes itself with the whole, just like the grain of sand in the dune; unfortunately people usually live to care for this individualistic ego which seeks but its own interest and which breathes for no other reason but to satisfy its ephemeral needs.

The Tests

When we have the conviction that disciples know what they want and where they are going, we give them some instruments which will allow them to begin the journey, to discover new things, and to become enlightened.

When we reach the stage where a person is conscious, the stage where one knows, and where it is no longer a matter of chance, some tests are given, tests which will allow us to see whether all this work is well integrated. We ask this person then, "Are you capable of traversing the desert?" For after some time, he or she will face its agony. He or she will experience intense thirst, hunger, heat. It will not be a journey for pleasure, because men and women usually give importance only to things for which they pay a high price, and which they really desire.

Often, we may read in some books of new spiritualities, which have nothing to do with any tradition: "Practice relaxation, meditate, this will bring forth many beneficial outcomes." In the Sufi path, we do not engage in such things. It would be misleading, just like when we give children a toy to distract them. This would never be the transcendental Reality. The toy of the moment will perhaps satisfy them for one month, two months, ten years, or perhaps all their life. Still this will only be a false device for them to forget their suffering.

In the Sufi tradition, no one can improvise or build an education which possesses neither support, nor roots, nor Light of Revelation, nor this divine flow (*baraka*) transmitted from generation to generation, even if God, in His Great Benevolence, can sometimes give to any human being the joy and the science to know Him and to show

gratitude therein without any intervention from any person. But this gift is an intimate and unique experience which cannot be taught, for it lacks exoteric and esoteric supports passed on since the beginning of time.

If people want to reach realization, they must pay the price for it. They will be tested as were all their predecessors. And we know all the tests gone through by all the sages and the prophets: the one endured by Jesus, peace be with him, in the desert for forty days; that of Moses, peace be with him, on Mount Sinai; and that of Mohammed, peace be with him, in the cave of Heera in Jabal An'Nour. In order to obtain the most valuable thing that exists, one must sacrifice oneself; the harder the test, the finer the result.

Temptation will come in its own time. I did talk about Abraham, peace be with him, who was tempted three times by the devil in the desert. There will not be only one or two attempts against this dynamic of evolution; they will be numerous. Our desires, our passions, our egos will rebel; our environment will not understand us; many will be the difficulties. We will never be able to obtain enlightenment as easily as we buy a packaged meal, or as we reach some states by taking drugs. Never! Every atom of ours, every cell, must go through this transformation. It does not happen only on the level of the mind, on the psychological or intellectual level; it takes place also on the level of our bodies. Our being as a whole must go through this complete change. If the whole being is concerned, it is then a full test. On this path, one must expect everything! There will be fear, doubt, and suffering, up to the point where, from one stage to another, things are fine.

Then the disciple sees the oasis far ahead; little by little he or she advances toward it, and it becomes bigger and bigger. At last, he gets closer to this haven of peace. He reaches the source and quenches his thirst therein. Before seeing Him, before coming to know that He is here, the disciple takes up the path only by faith in the guides who lead him on this way. When he sees Him, it is the state of certitude that pushes him forth.

> Multiplicity distracts you until you visit the graves. No! . . .You shall soon know! Again, you will soon know! No! . . .Were you

to know with certainty of mind! You would surely see hell-fire! You shall see it with certainty of sight. Then, shall you be questioned that day about the joys you indulged in (*sura* 102).[1]

It is a crossing of the desert. I cannot describe this way differently. We can, of course, benefit from all practices that can help us and allow us to find the strength and energy in us.

To Love God

As I have already said, no master accepts an apprentice who does not have love;[2] it is impossible! Love is the essential energy that leads to progress when people have exhausted all kinds of arguments; when they are totally weak. Love is lived in the way of God—on the spiritual level—and is also lived on the physical level as a human being. We experience it with our children, with our partners. When we love people, we accept everything from them. We are ready to change our lives, to forsake everything. If we actually do this in regard to a human being, what should our attitude be toward the Divine? This quality of love will be decisive on the path, for man will fall, collapse, stand up again, slide another time, but he will always be back on his feet if his heart is full with love for his Creator.

The Sufi master arouses in the disciple this eagerness for love. The whole practice of Tassawwuf incites us to taste this divine love more and more, until the love for God becomes an absolute necessity.[3] But most of the time we rebel against the Divine, because we do not understand: "Why is it God who decides and not me?" When we are hit by destiny, we rebel against Him and we reject Him. We think that He does not exist, for if He does, why so much suffering, so much hunger,

[1] A'esha, may God be pleased with her, reports that the Prophet, peace be with him, said: "The essence of religion is the knowledge of God, confidence in Him, and a good mind."

[2] "Has no faith he who has no love," says the Prophet, peace be with him.

[3] At'Tarmedee and Ibnu Abbas, God bless them both, report this *hadith* of the Prophet, peace be with him, in reference to this subject, "Love God for what he bestows on you of His bounties, and love me for the love of God, and love my family for your love for me."

wars, diseases, accidents, suicides? The first stage consists of transforming this rebellion into submission; the second deals with changing this submission into love. We do not really submit ourselves except through the love that liberates. Rabee'aa Al Adaweeya says,

> In two ways I love You
> I love You because I do
> And I love You because You are worthy to be loved
> The love from my heart
> Is the remembrance that takes me away from
> All that is not You
> And the love You deserve
> Is the time when You remove Your veils
> That I may see You
> No thanks do I deserve either for one or the other
> My thanks be to You for the one and the other

The Divine Names

When a person is appeased and possesses a center that is spirited by the energy of love, we tell him: "Now, it is up to you to realize the Divine Names."[1] All names and all attributes exist in us, and in creation too, for one specific purpose. Everything is animated, invigorated by the Supreme Name, which contains all names and all attributes, and which we have not yet realized. It must be revealed to us. The revelation, the knowledge of this Name, makes it possible to direct all of that light on the other names, for all possess this matrix imprinted in them, in their conscience, in their soul. This is the actual goal of the quest.

God manifests Himself through His Names. For example, The Omniscient (*Al Aleem*) is the name that holds all the knowledge of the universes, and all men of wisdom and science are sustained by this Name.

[1] Abee Hurayra quotes the Prophet, peace be with him, "God has ninety-nine names, he who learns them by heart (ethically and with certitude that is), enters paradise," reported by At'Tarmedee and Ibnu Hebban.

But in order to reach unity, enlightenment, it is necessary to gather all names under the Supreme Name. Should we not acquire the revelation of the latter, all other divine attributes will remain limited.

All of us contain these names, with no exception. Without them, we would not be able to exist; we would be ineffective. They stand for the qualities of the Lord before being attributed to men. Everything is in us; we contain the original being, the adamic archetype, sealed and stamped in every one of us. We are all complete; we have all received this seal of the Divine in pre-eternity. We can rediscover all of the above, this reserve which resides in us eternally.

For this reason, there is, on this path, a part of us that journeys consciously and another unconsciously. One part of the way is conscious: the desire, the will, it is my own self who wants, desires, and who searches. But soon, we realize that there exists also another part, unconscious, which pushes us toward enlightenment. The two approaches are done simultaneously on the path, just like our two feet which alternate while walking—the right foot and the left one representing the conscious and unconscious parts. Of course, the ego traps us by desiring to evolve rapidly, thus causing us to stumble. But the important thing here is to know that we do not know; to act while knowing that we have no acts of our own. In unity, opposites meet, harmonize with each other, and then cancel each other.

The Retreat

As I said, it is the master who reveals the Supreme Name, and the disciple will receive the techniques to start the invocations during the retreats. From that moment on, it is emptiness and regeneration. One loses all except oneself: "He The First and The Last, The Outwardly Manifest and The Inwardly Hidden, He has knowledge of all things," (*sura* 57, verse 30). For when one finds himself in the desert and is thirsty, his only desire is to drink, nothing else occupies his mind. Knowledge, fortune, wisdom, family, everything disappears. Only water, which will regenerate his life, counts for him. This is how we come to know if the desire is real and the thirst true. In this sense, there is a

sentence from the *Bhagavad-Gita*,[1] the famous sacred Hindu text, which explains the above: "Among one thousand people, only one looks for Me, and among the thousand who look for Me, only one finds Me."

We are often distracted, even diverted, from the path by things that are not important. For example, some people get lost when they follow some spiritual paths in order to acquire power, know the future, or even to have some kind of superiority over others, or to cure those who are sick. It is perhaps acceptable, but in Sufism, it is a waste of time, for it is not the purpose. The only goal in this path is the realization in God, which needs this energy that is love, and a determination, a strong will to practice.

In connection to asceticism, this determination can also be strengthened by the retreat *(khalwa)*, which can traditionally last three to forty days, or even a whole life; and one must show a certain maturity and balance in order to confront this seclusion. By getting away from noise, from agitation, and by getting rid of the daily constraints, the retreat allows us to fully assess ourselves, face our ego, dive deep inside ourselves, and vitalize the being. It is then desirable that *khalwa* be effectuated at least once a year. However short it may be, the retreat is an absolute necessity for the disciple, so that he or she may revive the primordial tradition. All the Prophets, peace be with them, the sages and the saints too, all have used the retreat as a tool of detachment from the world and as a means of communication *(munajat)* with the Absolute.

It is always the master, or his representative, who decides on the length of *khalwa*. It must be carried out under his authority and his

[1] The *Bhagavad-Gita* (Sanskrit, "The Lord's Song") is one of the most widely studied sacred writings of Hinduism. Taken from Book VI of the Indian epic *Mahabharata,* the *Bhagavad Gita,* written as a poem, is Krishna's response to questions posed by Arjuna, a warrior prince, concerning his responsibility in good and evil as he is about to go into battle. Krishna, incarnated as Arjuna's charioteer, laid the cornerstone of Hindu philosophy by instructing Arjuna with the following principles: the world of matter and individual consciousness are grounded in the same spiritual reality; intuition can grasp the divine reality; human beings possess two natures, a divine self within a material being; and life is intended to lead people to unity with the Divine Spirit. *The New Grolier Mutimedia Encyclopedia.* Wadee'a Al Bustanee translated to Arabic some of this work.

benevolence, so that he may attentively watch over the reactions of the individual. In fact, some people, because of their psychological weaknesses, can be somewhat shaken.

The Spiritual Dance

The retreat can be a preparation for education, and can also assist the disciple to better savor the *emara* or *al hadra* which is a form of *dikr* and a spiritual dance. Dermenghem, in his book, *The Cult of Saints,* describes it perfectly.

> Standing, the eyes closed, holding tight to each other, the right hand in the left hand of the next person, the fingers intertwined, the brothers build a closed circle in whose center a *qutb, vertex,* marks the cadence, claps his hands, turns around himself, watches every single person and all at the same time, switches the place of this or that one so that the whole group stays balanced, stops when disorder threatens or when exhaustion overtakes. In the center of the circle, stand one or two *mussame'een* (singers) who sing mystic poems to the glory of God and to the praise of Prophet Mohammed, peace be with him. Inside every breast, with the rhythm getting faster and faster, The Name Allah becomes *Llah,* then *Ha,* then *H* coming out no longer from the lips but from the throat. It is the breath of the heart that wafts, while the bodies sway up and down with the feet stuck to the ground. The huge unanimous rale sounds like the vibration of a giant saw. The eyes are still closed, the faces tight in an expression which draws both on pain and on joy.[1]

[1] There are many *hadiths* in this respect; the Prophet, peace be with him, says, "Those who celebrate the Oneness of the Lord, whose bodies sway up and down, in their sessions of *dikr,* are way ahead; *dikr* relieves them of all their burdens, letting them come free on the day of judgment." Reported by At'Tarmedee and At'Tabaranee. And Sheikh Al Alawee, God bless his soul, says in the matter, "I do not say that dancing is an integral part of Sufism, it is rather the outcome of the Sufi's absorption in *dikr.* And he who is in disbelief, let him try it."

Sheikh Adda Bentounés (in the center),
grandfather of Sheikh Khaled

The purpose is to gradually become a blank page and to live the in-
tense immersion in the Name. Some moral qualities are required of the
disciple, but, paradoxically, physical qualities are not necessary. I know
some sturdy people who flee the *emara*. They have never dared to take
it on because they see it as too big a burden, and they are afraid. On
the other hand, we see those who are seventy years old, holding them-
selves up with a cane, become young people of twenty once they prac-
tice this dance. It is a unique tool of transcendence which gives a
sensation of lightness and openness, for our sensory faculties become
keener. After that, the sun shines differently; the air we breathe, the
beings we see, the words we hear, all take a new sense and a new di-
mension. "Thanks be to God Who has guided us to this. Certainly, we
could have never found guidance had it not been for the guidance of
God," (*sura* 7, verse 42). It is at this time, after the emara, that the mas-
ter chooses to transmit the teaching through parables (*muthakara*)
which gush out from his heart toward those of the disciples. Sheikh

Sidi Al Hadj Al Mehdi says, "*Muthakara* is the spirit of the reunion," (*Jam'a*). Finally, something that cannot be expressed in words occurs, and to talk about it is, in some way, a sort of betrayal.

In our path, we do not talk about our spiritual experiences, even if they are not secret. As I said earlier, there are no secrets in the brotherhood. Everything is secret without being so. Everyone can say the Divine Name, but how is one to pronounce it? Everything is visible, but where can one start? For example, a lesson is given by the Sheikh, or the *muqaddam,* and sometimes the audience understands absolutely nothing of what is being said. Why don't they understand when they know all the words? For others, the same lecture can be a revelation. Sometimes, some people who do not speak Arabic feel the teaching of the master, thus having their fill. Obviously, something else intervenes here. I can assure you that there exists nothing simpler and less elitist than this spiritual education. If a spiritual path is made up of secrets, there is a real problem, for God is as visible as the sun that rises every morning. The instruction of the master is clear and simple; however, it is accomplished in degrees.

In the Sufi path, pride is the greatest of follies—the pride of one who discovers the power of this knowledge and uses it for personal objectives. It is a great danger! For anyone who acquires this potential can enslave people and use them. Humility in this path is an obligation; with time, it becomes part of one's nature. The principal enemy of man is his ego. It is for this reason that the masters transmit this sort of education only to a small number of disciples, chosen for their humility, their generosity of soul, their submission to God, and their love for *tariqa.*

The Dangers of a Practice Without a Master

The Sufis say, "He who does not have a master has Satan as a master." The practices used in *tariqa* have been codified and tried for many centuries. When we guide someone, we never fall captive to our inspiration or our imagination by asking him or her to realize this or that practice. Instruction is linked to a chain, and the path is perfectly marked. Logically speaking, there are things to do and others to avoid.

Sometimes, because of ignorance, some people try to imitate a practice which they have read in a book or which they have heard about. For example, without any conditions, and without being directed, some perform the invocation. Alas! I know many who have psychologically disintegrated. I must be very clear: Do not play around with a dimension that is of another order and which you cannot attain except by crossing the doorway of a path marked by the guide. The teacher proposes a meticulous dosage that goes hand in hand with the capabilities of the disciple.

Of course, there are some activities that we share with everyone else, but there are also some tools which are personal for the intimate experience of each one of us, and that we cannot reveal. That is why I must not violate the secret of people's intimacy. What is good for one is not necessarily so for the other, and vice-versa. For example, some are tempted by the invocation, and the moment they indulge in it, they are troubled. We give them then another practice. People are like iron, copper, or gold.[1] Every mineral has a degree of fusion. Even if we are all physically composed of the same elements, we are different on the psychological level. This difference is part of the immense divine possibility, which, by the way, is not found only in man. There exists no drop of water, no leaf, no grain of sand that is identical to the other. This is amazing! Look at fingerprints. Each one is different. Each being is exceptional, unique; and here resides the danger of imitation. If we try to imitate somebody else, we risk losing our lives.

It would be vain and suicidal to go with someone to the mountains of the Great Jorasses[2] when this person, though desiring this ascension, is unable to take on a long climb that requires stamina and endurance. At the level of his psyche, man is very delicate and very fragile. One sad experience is more than enough for an individual to get lost in a labyrinth with no outlet. It is then extremely dangerous to

[1] Ibnu Abbas quotes the Prophet, peace be with him, as saying, "People are like minerals. Their ethnic characters are transmissible."
[2] Mountains in Algeria, south of Costantine. They are 2.300 km. long; most of the inhabitants are Berber, carrying the name, "Shaweeyoon."

play around with these practices, and it is for this reason that they are given in small doses and under supervision, and only to some disciples who have already realized a part of the path. The spiritual energy is a light, but it is also a fire which can be destructive if not controlled. In front of the master, disciples immediately betray themselves through their words and their behavior. They cannot hide their inner state. It is impossible. The role of the master is to be an inciter, but he must also stop uncoordinated impulses. At a certain level, divine drunkenness is desirable and even aspired for, but the receptacle must not be over-filled. Through his recommendations and his advice, the master limits these states; otherwise, the disciple, and others too, could be hurt.

Al Majadeeb

In Sufism, there exist some men or women whom we call *al majadeeb* (plural for *majdoob*), *enchanted by God,* people outside the norms of life, who live permanently in divine drunkenness. They cannot, by any means, guide others. When asked about them, Sheikh Hadj Adda said:

> A person drinks a cup of elixir and lets himself be seduced by its softness. He drinks a cup, then another. Another cup and still another; the more he drinks, the more he wants to drink. But at a certain moment, he notices that everything around him starts to turn and that he is happy; he stops. He is the Sufi tasting exhilaration without rolling over on the ground. It is he who, facing the screen of a movie theater, glances back at the projection light. The *majdoob*, on the other hand, drinks until the earth starts turning around, he drinks more, up to the point where he turns around with it. He is always drunk, and he staggers on the street, he lives drunken. Everything turns around and he does too, he gets lost in the movements of the earth, of the world, and he turns around with everything, and he sees how united he is with the whole, he sees himself in everything. The Sufi is sometimes in this state, but the *majdoob* is always in it. The first inebriates himself sometimes, the other all the time, always directed toward the light: with his back to the screen, he burns in the light.

Some of their stories can stun the minds of those not initiated in this esoteric language. But as it is mentioned in *The Qur'an*, "God disdains not to use the parable of a midge or something even smaller. Those who believe know that it is the truth from their Lord; but those who reject faith, say: What does God mean by this parable?" (*sura* 2, verse 26). This is a form of education, but totally puzzling. When these enchanted people reveal something, they do it with such a force that it shocks others. In this respect, we tell the story of a *majdoob* who was shouted at by somebody who accused him of being an atheist, for he kissed the hand of his master. Far from being offended, the *majdoob* showed joy, and hugged his opponent saying, "Thanks be to God. I do not know how to thank you, for you have just uplifted me to the rank of the angels who prostrated to Adam. As for you, you have just defined your place (that of Satan who refused to do so)."

Another *majdoob,* whom people asked why he felt very agitated when the name of the master was pronounced in front of him, said: "I am a victim of love. God has hunted me as game. He took a rifle named Mohammed, peace be with him, and He put a bullet named Sheikh Adda therein. Whenever I hear his name, I feel the impact of this bullet which struck my heart with the love of God."

These people have no more ties in this world—they have no homes, no children, they are everywhere and nowhere, and their words sound strange. They live at another level, and consequently, communication with them is very difficult. They can also be agitators by uncovering a secret, shamefully hidden by somebody who finds himself then speechless. Those who do not take them seriously call them, "the crazy men of God." They are hidden under a garment of madness, but they are perfectly anchored in the knowledge that we call the divine inebriation. But this inebriation goes over the limit sometimes, as is shown in this beautiful story of the *majdoob,* Abdel'Lah Al Faid (the servant overflowing from God). I transmit it to you the way it was to me, with its literal and spelling imperfections; a story which takes us back with subtlety to the premises of this constant combat between good and evil.

When Shaytan (Satan) was stripped out—of his angelic state— because of Adam, he gathered his strength in order to take re-

venge, and told Allah (God), "Because this one is the cause of my defeat, I will exterminate his offspring.

"So be it," answered Allah, you will have no effect on My servants!"

Shaytan succeeded with the race of Cain to produce the deluge and exterminate all beings on earth. One among them was just, Noah, along with his family. And so, Allah created Races in order to prevent Shaytan from corrupting anew creation. These races formed many and diverse groups, and Shaytan found himself confronting not only the race of Seth, father of the servants of God, but many other races, assemblies, mixed groups of servants of God and the devil's own followers. For most often when Shaytan believes he has one follower or more in a group, the servants of Allah in the same group keep, through love, the servants of Shaytan next to them. And the only difference between Sidna Mohammed and Shaytan is that Sidna Mohammed is love and Shaytan hatred. And so, love unifies and hatred separates. Shaytan, seeing the numerous groups composed of good and bad, took the initiative to divide in order to reign. But there was Sidna Noah, father of all human races and master of all animal and vegetable creatures.

"You have it all," said Allah to Noah and his sons, "but you shall not eat blood with its flesh, for the blood is the soul. And you will spread blood on earth, you will not eat it with the flesh. And I will ask again for the soul of every being."

Shaytan heard of the rule and incited his followers to feed on blood. It was the existing difference between the servants of God, non-bloody, and the servants of Shaytan, the bloody. It is then that a bloody weapon came to the profit of Shaytan, racism. "You are not from the same blood as I am!" But this weapon was soon to be turned against Shaytan. Among the racial divisions, love for one's own country, own family, and own brothers grew stronger. And even the servants of Allah revered The Patriarchs, The Wataneyeen, [a very rare term derived from the word, Watan, homeland, nation].

And so, Abraham was a patriarch (the supreme father of the three religions), on behalf of God of course, not only of the desert but also a universal one. Abraham Al Khaled! Abraham the Eternal! [God Says]: "I am The Eternal and you are My intimate friend! You will never be called Abram, desired Father! But Abraham, universal Father!"

Shaytan was confused by Abraham. "How can Abraham, a Hebrew of the race of Heber the Semite, be universal?"

And there is Islam, rising up from within The Eternal Divine Will, a way of life for all humans and their subordinates, animal and vegetable, and for Creation.

Here is another story about *al majadeeb* and their anchorage in the knowledge—this story about the Gospel [*Evangile*] in French.

Yesterday, while repeating the word [Divine Name] *Ya Lateef*,[1] I had a clear vision of an Adventist priest, dead for twenty years. He criticized me for this repetition as if relating himself to the *hadith* (word) of Jesus, "Do not imitate the pagans who pretend they are obtaining help from their deities by repeating words in great numbers!" But, I answered him, there is only one word, spiritually speaking: *Ya Lateef*. Now, I must explain myself as to the reason I have chosen this word. Its sense cannot be translated, it is the Divine Name which cleanses. Do you think that a window cleaner has in his two hands anything other than a scrubbing brush? And still, he can and actually does clean thousands of square-meters with only one brush. There are thousands of square-meters in the soul, millions and billions, but there is only one word that cleans, *Ya Lateef*. What is then this work which cleans the souls? This work is referred to as polishing, in Semite, Aramean, Hebrew or Arabic, *injala*, wherefrom came the word gospel [*evangile*]: which means to

[1] Translation, *O Subtle One*, one of the ninety-nine Divine Names repeated hundreds of times, even thousands of times in *dikr*.

polish in order to see through the soul. The Book which en-
lightens. And so, *Ya Lateef* is the scrubbing brush of the soul
that leads one to understand and unite himself with this say-
ing of Jesus, "I am the Light of the World!" This equals *ingéle,
evangile* (Gospel), luminous inspiration. At that point, the face
of the pastor paled and immersed in the name of *Lateef*.

What amazing beings these *majdoobs!* Free men and women, living
by God, testing the mortals through the dazzling brilliance which
destabilizes our argumentative rationality. Sheikh Hadj Adda said,

Every flower with its own scent
And every one with his own ability to smell.
He who denies that the flower emits a scent
Would be wiser to admit that
It is he who has no sense of smell.

Brotherhood in the Tariqa
The master is always available to help those in need of assistance. But
of course, they must ask for help. That is why *tariqa* exists, for even
when the master is not around, other managing members (*muqaddem*)
take over. Furthermore, we always find a brother or sister toward
whom we feel affinity. We are never alone. As for those who are far
away, we must assist them according to the atmosphere and the situa-
tion in which they are. It is true we should feel that we are close to the
master, but it may be enough to see him one or two times a year, and
seriously accomplish that which he asks of us.

The presence of the master is necessary when we are in our first re-
treat. But there are some disciples who are able to guide others up to a
certain step, even if they have not attained realization. It is fortunate
that they can assist the master, otherwise *tariqa* would be very difficult
to run, especially with the great number of disciples. One day cannot
be extended; what would happen then if all these people simply
saluted the master at the same time, not to exclude the possibility of
them asking him personal questions? In order for that to happen, there
are some special encounters where, during three days, the master re-

ceives. Those who want to see him about a personal problem or an intimate question can be received alone or in groups.

There are also some extended seminars concerning themes chosen from *The Qur'an, The Sunna*—the Prophet's sayings and deeds—or Sufism, as well as annual congregations *(I'htifal)*, expositions of books, archives, pictures, and publications, ecumenical meetings, and celebrations of the great Islamic feasts such as the *Mawled An'Nabawee* (the birth of the Prophet), *'Eed Al Fetr* (the breaking of the fast of Ramadan), *'Eed Al Kebir* (the feast of the lamb, celebrating the sacrifice of Abraham's son). We also commemorate the *mussems* (celebrations) of some great saints, such as Mulay Idriss Al Akbar near Volubilis—Roman ruins (in the vicinity of the mountains of Zarhoun, near Meknes) in Morocco.

The Man
and the Woman

In order to understand the true dimension of the couple in the Islamic tradition, it is necessary to go back to the origin of creation as described in *The Qur'an*.

The Primordial Couple

When God created Adam in pre-eternity—the non-manifested spiritual realm—and deposited in him His whole knowledge through all His Names, Adam was in the absolute immaterial unity, living through his contemplation of God. The Divine Will wanted to make of him His vicegerent on earth, *Khalifa*. This adamic archetype, who held in him all the genes of the future humanity, doubled, and God created, from his left side, his spouse. Thus, the process of creating mankind began.

> We had already, beforehand, given a mission to Adam, but he forgot. We found on his part no firm resolve. When We said to the angels, "Prostrate yourselves to Adam," they prostrated,

but not Iblis: he refused. Then We said, "O Adam! Verily, this is an enemy to you and to your wife, so let him not get you both out of the garden, otherwise in misery you will be. Therein, you will not go hungry, nor go naked; you will not go thirsty, nor suffer from the heat of the sun."

But Satan whispered evil to him; he said, "O Adam! Shall I lead you to The Tree of Eternity and to a kingdom that never decays?" They both ate from the tree, and so their nakedness appeared to them. They began to sew together, for their covering, leaves from the garden. Thus did Adam disobey his Lord, and allow himself to be seduced. But his Lord chose him for His Grace, He turned to him, and gave him guidance (*sura* 20, verses 115-122).

This primordial couple lived in paradise, the place of integral joy, where one knows no hunger, no thirst, and no nakedness, and where the soul enjoys an eternal gladness in the contemplation of the Absolute. But God's plans were—and still are—impenetrable even for the angels, beings of light, who wanted to know more about this unique couple, one that is different from everything else in creation.

Behold, thy Lord said to the angels, "I am going to establish a vicegerent on earth."

They said, "Will Thou place therein someone who would do evil and who would shed blood, when we celebrate Your praises, and glorify Thy Holy Name?!"

The Lord said, "I know what you know not" (*sura* 2, verse 30).

If the angels were able to see the obscure part of this creature, the one associated with evil, they were unable to see his lucid part. This aspect of light present in the adamic couple was known only to God, Knower of all things. Here is a being who, the moment he was created, provoked controversy. If all angels prostrated to Adam, thus symbolizing their submission to the Will of the Divine Who wanted this unique

being to be the receptacle of the Divine Mystery, one angel, Iblis,[1] refused to prostrate, believing his nature to be superior to Adam's. Right from that instant, a combat, an enmity, was to accompany the destiny of these two entities, Iblis and the adamic couple. Iblis vowed to drive this couple out of beatitude. He used against them craftiness and temptation. Adam and Eve, living in paradise, were beings of pure light, having committed no sin, and knowing no disobedience. And it is here that the tempter is to accomplish his work of art:

> But Satan whispered evil to him; he said, "O Adam! Shall I lead you to the Tree of Eternity and to a kingdom that never decays?" They both ate from the tree, and so their nakedness appeared to them. They began to sew together, for their covering, leaves from the garden. Thus did Adam disobey his Lord, and allow himself to be seduced. But his Lord chose him for His Grace, He turned to him, and gave him guidance (*sura* 20, verses 120–122).

The Disobedience

The couple will then commit the first act of disobedience by forgetting the pact made with their Lord. In this respect, their offspring are like them: oblivious of the divine conscience, they commit sin through the temptation and the pride of wanting to resemble the Lord by looking for immortality and the everlasting kingdom—things reserved for God. Iblis was then only the first veil that diverted the adamic couple from the light which guided them.

Adam and Eve, at loss, noticed their nudity: they discovered their limit, their weakness, and their precariousness. And they recognized the mercy and the benevolence of God upon them. The act of disobedience having been committed, Satan had accomplished his goal—to

[1] Iblis's name in the world of the above was Azazeel, which means the servant of God; his nature is that of jinns: The Lord says, "Behold! We said to the angels, 'Bow down to Adam,' they bowed down except Iblis. He was one of the *jinns* and he broke the command of his Lord," (*sura* 18, verse 50).

chase them out of paradise. This fall transformed them, from the state of pure light that they were, into material beings, on earth, prisoners of a body of clay which feels thirst, hunger, sickness, cold, heat, and conflict, but always remembers the heavenly bliss and seeks it throughout its life. Thus did God fulfill His Will which sought to have a vicegerent on earth.

We understand through this symbolic narration of the Sacred Revelation that the Divine plans are impenetrable. It is through disobedience and veiling that He sometimes accomplishes His decree. The Prophet, peace be with him, says: "Moses had an argument with Adam, peace be with them both, 'It is you, because of your mistake, who caused the beings to be chased out of paradise, thus causing them grief.'

Adam, peace be with him, replied, 'Moses, you whom God has chosen for His Messages and His Words, you blame me for an act which God had chosen for me before He even created me.'"[1]

If we talk about Adam's sin, we cannot avoid talking about repentance. When Adam sees himself naked, he tries in vain to hide, and asks forgiveness of God who, fortunately, grants it to him.

The Stages of Creation

Let's go back to the problem of man's creation. If we assume that the Adam of paradise was pure light, we remain faced with another enigma: that of knowing the origin of man on earth. This creature exists on two levels, one high and celestial, the other low and earthly—it

[1] Narrated by Abu Hurayra and reported by Muslim. (*Al Ihya,* volume 4, page 168). The same *hadith* is reported differently: "Moses and Adam, peace be with them both, argued in the presence of the Lord. Moses said, 'You Adam, whom God created with His own Hands and blew into you from His soul, and made His angels bow to you and let you dwell in His paradise, and then you caused people to go down to earth with your sin!' Adam replied, 'You Moses, whom the Lord has chosen for His message and His word, and gave the Tablets covering all subjects, and made His intimate, if I may ask, how long was *The Torah* already written before I was created?' Moses replied, 'forty years.' 'Did you find (this verse) in it, "Thus did Adam disobey his Lord, and allow himself to be seduced." 'Indeed,' said Moses. Adam said then, 'How can you blame me for an act which God had already decreed for me before I committed it, and forty years before He created me?' This is how Adam debated with Moses."

is linked to man as we know him, the corporal man. The first part is the unknown in us that we can call the essence of man.

There is no doubt that the physical man has his origins on earth; in the mineral, the vegetable, and in the animal. But, through his reasoning and conscience, he holds a position which totally differentiates him from his lowly origins. He is somehow the last link in the chain of creation; the most perfect in all ways, gifted in intelligence, in expression, in sentiment, and in will, all of which make of him a higher being.

The Qur'an describes the creation of life and, through it, the creation of man: "And He has created you in successive stages," (*sura* 71, verse 14), "Then We created him in a new creation," (*sura* 23, verse 14). God speaks here about successive stages and of a new creation. Which means that man, as we know him, has gone through the process of the chain of evolution. More explicit indeed in the matter is verse 17 of *sura* 71, "God has grown you from the earth as He did with plants." This vegetative state allows us to ask ourselves about the relation between the animal world and the vegetable one. It allows us to see that there is connection here, through the fact that the animal is nothing more than a vegetable which has been separated from the earth, and the vegetable nothing more than an animal entrenched in the earth: "God created all living beings from water" (*sura* 42, verse 45), or better yet: "We made from water every living thing" (*sura* 21, verse 30).

A legend says that Adam's clothing was made of scale. Born from clay and water, the essence of life is going to follow an ongoing process, directed and protected by a higher will, up to this terminus where the Divine Light occupies man's conscience and reunites him to the Spirit, origin of his origin. Thus does the cycle of creation find its last phase in the person of Adam, through the universal being. The realization, which we have often talked about, is in fact nothing but this transcendent process which causes us to undergo this transformation, from one stage to another, until the level of the dissipation, *al fana,* of the substance into the Spirit. All wisdoms, religions, and revelations since the beginning of time came to remind man of this fundamental truth. Our perfect creation, with all the experiences it underwent since the dawn of human life, makes of man a unique and complex being. If all this

energy and these potentials dwelling in us serve nothing more than to have us live like animals (drink, eat, and procreate), then our life makes no sense. Only this divine Desire which makes of man His vicegerent (*khalifa*) ennobles him and pushes him to jump ahead toward the unknown side of the self, connecting him to it first, then uniting him with the universal. This is how one can understand the symbolism of the crescent moon in Islam; its points stretch to connect themselves to each other in order to form the perfect circle, symbol of the realized being.

All human beings date back to Adam, and in this respect, no one can claim superiority over another. No race, no nation, is higher than any other, no matter what the opinions on this may be. Man can only be superior through his mind.[1] It is the mind that allows him to live in unity and in the permanent fear of the fall. All men and all women have the same chance to have access to unity, for they have been created in it. Still, there is a desire for God which allows some people to evolve more rapidly than others.

Life, a Divine Gift

When it is said in *The Qur'an,* "Reverence the wombs that bore you," (*sura* 4, verse 1), we understand that this refers to the respect we owe those who have given us life and who have allowed this process to perpetuate. Life is a divine gift which was entrusted to the first couple, and we simply transmit it. Adam is inside each one of us! Like him, we have all sojourned in paradise, which is this blessed moment of childhood when children live in utter innocence, indifference, and freedom—a time when they care not about eating, wearing clothes, loving or hating. They are under the care of those who love them. When children come to this world, they are in a heavenly state: they see and contemplate. From that moment, whose role is it to feed them? The parents'.

[1]Reference is to the *hadith* of the Prophet, peace be with him, which goes as follows, "The first thing that God created is the mind; it came to Him when God asked it to, and it went back when the Lord told it to. Then God said, "By My Glory and My Sovereignty, I have not created anything better than you, through you I grant glory and take it away, and grant bounty and take it away." Related by At'Tabaranee as quoted by Abee Omama, and by Abu Na'eem as quoted by A'esha, God bless her.

But children must leave this station of childhood, otherwise they will not be able to evolve. They are, with no doubt, pure, but this purity is *unconscious*. It is only at the age of adulthood that they will consciously choose right over wrong. It is through a responsible choice, by desire, by love, that we go back to God. Of course, the state in which children live at their birth is perfect, angelic, and with no stains. Their parents are for them the only reality, and somehow incarnate their God. However, they must emerge from this station, and for this to occur, they must go through some tests and periods of doubt. Besides, the first revolts of children are against their parents who tell them, "Do not touch this, or do not do that." For an instant, the child hesitates, then he or she commits the forbidden act, just like Adam. It is through this process that a child will improve and discover the world.

First Initiation

Children will be initiated to the message of uniqueness when they reach the state of puberty, the moment when they, in their turn, will be able to procreate. This is the case in all monotheistic religions. The divine message addresses the human being who gradually becomes responsible. He enters a cycle where he is held accountable for his acts and his words. From this moment on, everything he says or does is taken into account. That is why this passage from childhood to adulthood is a period of research, a time of doubts, intense questions, and rebellions. Alas! The world where adolescents grow often gives them no possibility to expand this research. They are immediately disappointed, deceived, and their faith is weakened. The atmosphere where they live has already excluded unity. Modern societies are very materialistic and traumatic.

In this context, the parents have two possibilities in the education of their children. They can either let them take their own path, with its risks and dangers, or they can safeguard them to protect them if they fall; but here, they must leave them free to act—knowing that they cannot permanently spare them life's difficulties. When the tests of life strike, men and women need to hold on to something solid. We must then acquaint them with the notions of divine Unity and the sense of their humanity, to which they can adhere in times of trial; otherwise they risk being uprooted at the first storm.

Because they have been disappointed by religious education, many parents left their faith behind, and have thus deprived their children of a religious learning. Even if religion is not well understood or well taught, it can provide children with some basics to which they can attach themselves some day. And here lies the responsibility of the parents. I disagree with those who seek to cut children from their religious sensibility, from the sense of sharing and tolerance for that which is sacred. The case is different, however, if these parents are themselves unable to provide their children with an education that allows them to experience a natural development, one that can lead them to search for unity.

When things lose their spiritual essence, people find themselves afflicted and confronted with inner problems, which they display in their outer appearance. The world we live in today is the result of what we go through internally. We live more and more in the state of multiplicity and complexity. We create more and more things, thinking that we thus satisfy the human need. We are lead by matter when it should be the opposite. It is a fundamental error! It is not by creating more and more cars, planes, refrigerators, gadgets, that we will answer to the vital need of the human being, which is love. It is only by looking for unity that we will find our balance, that the adamic being will find his origin. Unity reminds us of equality, of sharing, and it imposes a criterion of life that is simple but indeed effective: "Ordain good, denounce evil," in us and in society.

We will not be able to denounce evil, hatred, violence, murders, wars . . . all kinds of selfishness in the world, until this selfishness has no place left in our hearts. Before talking about peace, we must be, ourselves, in a state of peace. Is it not absurd to see two nations make war and then reach a negotiation, when they could avoid the ravages of a conflict by not engaging in war to begin with?

The Woman's Role

We have talked about creation, about the original couple, the child, and about education. This leads us to talk about the woman, the mother of society. Actually, the dilemma of women does not exist only in Islam but in all societies. The Qur'anic revelation addresses the being, be it man or

woman, and it contains no suggestion whatsoever that can lead us to think that the woman is inferior to man or that her soul is insignificant. Regarding this revelation, all beings are equal, for they are all God's creatures. In Islam, the woman is man's equal, not only on the level of creation, but also on the level of the being. Metaphysically speaking, there is no difference. The woman is as capable as man of reaching the highest of mystic stations, there is only a difference of nature.

In this respect, the story of Mary in *The Qur'an* is very revealing concerning the state where the woman communicates directly with the Absolute: "Relate the story of Mary in The Book when she withdrew from her family to a place in the East. She placed a screen to screen herself from them. Then We sent to her Our Spirit, and he appeared to her as a man in all respects," (*sura* 19, verses 16-17). Also the story of the mother of Moses, to whom God revealed the order to put Moses in a cradle on the Nile: "And indeed We conferred a favor on you a first time, when We revealed to your mother that which was revealed to her," (*sura* 20, verses 37-38).

It is true that every element in our world has a peculiarity. All these elements come from the same origin, still the fruit or the flower agree to play its role. It is the flower's duty to accept its own self and carry out its role in harmony with its original function: to produce the fruit. At the level of creation, the woman has been entrusted with regenerating life which is permanently present, for the souls are already here— spiritually that is. Since the body does not descend from heaven, it must be built through the woman, so that it can welcome the soul.

In his sessions with women, the Prophet, peace be with him, told them, "Each one of you who gives birth to three children puts a barrier between herself and hell." This means the sins of the woman would be forgiven if she gives birth to life, if she accepts her role with regard to creation. There is also a famous *hadith* which says, "Heaven is under the feet of the mothers," (and not under those of the father). The role and the rank of mothers is important here on earth as well as in the celestial world.

We can enjoy heaven through our mothers, by respecting them, loving them, and by getting their agreement or their benediction. He who

does not have it will not enter paradise. Through this last teaching, the Prophet, peace be with him, wants to ennoble the function of the mother who is highly considered by God, since she is said to have paradise under her feet. It is in her that life is created. Without her precious mediation, we would have stayed in the nonexistence. Those who have no love for their parents will not know the state of paradise, for those who cannot love their own parents, how can they love anybody else? After the love for our children comes that for our parents, especially, the mother. When it is said that the mother has paradise under her feet, it means she wishes for her child's happiness before anything else. This is what makes her happy. If she sees that he is sad, she will be sad too. In a family, it is always the mother who is the more sensitive and the more touched. That is why the Prophet, peace be with him, says, "Do not hurt your mothers,"[1] by creating situations which sadden them.

However, the parents do not have the right to block their child's way, regardless of the child's nature, for thus they impede him or her from experiencing life. It is said in *The Qur'an,* "We have enjoined on man kindness to his parents. But if they strive to force you to associate with Me that of which you have no knowledge, obey them not," (*sura* 29, verse 8).

The Guardian of the Tradition

The woman possesses the power *par excellence,* it is she who creates the nations. The woman is the guardian of the customs, of the traditions, and she represents the honor of the family. An Arab poet says, "The woman is the nation. If her character is degenerate, she perverts her nation; if her character is noble, she dignifies her people."

I think that the West has a caricatured view of the Muslim woman, for she does not conform to this appellation of the Occidental woman who is said to be "emancipated." Wrongly, the West thinks that there exists but one model of woman and that all others are erroneous. We

[1]The same meaning can be found in a different *hadith* by the Prophet, peace be with him, "God has forbidden you to disobey the mothers," agreed upon.

criticize the Muslim woman without offering a better alternative. We protest the fact that she does not work and stays home; but has the Western woman really found happiness and balance? Were it the case, we would be able to say, "There is an excellent social model, let's put it into action."

Let's go back to the life of the Prophet, peace be with him, who was, without any doubt, the most courteous, the most loving, and the most gallant of men toward women. It is he who said, "I was made to love three things of your world: perfume, women, and prayer." Look at the place he gave the woman—between the subtlety of perfume and the sublimity of adoration! It is through love that women give and that they receive. It is through love that it is possible for us to discover the secret of life and the depth of this relationship of universal love.

Long before our present time, the Islamic traditional society had recognized many rights of the woman and codified them. She was a being in the whole sense of the word, equal in all respects to man. She even represented the foundation on which society stood; it is through her that the transmission continued from the earliest of times. She incarnated the balance of the family and brought relief in times of distress. Through her sensibility, her adroitness, and sometimes her malice, problems were resolved and conflicts appeased. If I am talking about the traditional woman, it is because she is a reality in *tariqa*. Thus my grandmother, born in 1898, was, and still is, the kingpin of the *zaweeya* in Mostaghanem, a mother to all, receiving, organizing, looking after the daily comfort and well-being of more than one hundred people. She used to journey on horse with her father, Sheikh Al Alawee, who told her before dying: "Khayra, you will lack nothing. I leave you as a harbor where the boats come to find shelter."

It is true that we must not idealize, but the traditional woman that I am describing here has indeed existed, and still does as a matter of fact: a higher being who can give more than she receives. But the imbalance we are faced with concerning the woman, both in the Islamic society and society in general, has not ceased to waste ink in the matter. If the modern world has liberated the woman, it has not resolved her problem as to her essence and her real place in society. It is an open debate

Sheikh Khaled with his grandmother,
the daughter of Sheikh Al Alawee (1984)

which calls us all. Is she the object of the desires and fantasies of man, or is she the land of stability and fertility for the tranquillity of souls?

For me, the positive social effects of the woman's evolution are an illusion, a fantasy. We can simply say that this evolution is positive *vis-a-vis* a period of history where the woman was socially relegated and did not have the same rights as the man. But, in reality, when we talk about the evolution of the woman, we evoke a false problem, for we cannot divide the evolution of the human being. Either all beings progress together, or else we enter into a debate of sterile ideas where the woman criticizes the man and vice-versa. We had better become conscious of the fact that we are one, and that all beings must advance together toward a better comprehension of themselves, and toward freedom and a more harmonious world for all of us.

In the Islamic tradition, the woman is indeed prisoner of a social order, but so is man. We have been imprisoned by the local and ancestral customs, which go against the words of *The Qur'an*. It is important to denounce them and to come back to this sacred text which has the ability to liberate us and bring us a real joy of being, through our application of its rules. For a freedom that is based on words, desires, passions, and assumptions, does not represent the true freedom of the being

The Alif and the Ba

In the Muslim esotericism, we can understand the divine manifestation by evoking the first two letters of the Arabic alphabet, the *alif* (ا) and the *ba* (ب). The first is the masculine element or the spirit, the second is the feminine element or the creating soul. The *alif* possesses a vertical position which is transcendental, directed from low to high, and the *ba* is a letter laying down on its side as if the *alif* places itself in a horizontal position. Because of its independent and transcendental nature, The *alif* cannot be linked to other letters, but the *ba* can.[1]

[1]The meaning here is that the *alif* (ا) is never linked to letters if positioned at the beginning of words, but it can be so at their end; "And to your Lord is the final destination."

By laying down on his side, Adam—*Alif*—gave birth to Eve, *Ba*. And so, Adam contains the *Ba*—Eve—in him, his second nature that is feminine. However, one is predominant in relation to the other.[1] This means that when God created the first letter, the *alif,* Adam already had the *ba* in him. It is not a radical change then. There are not two elements. Duality was created later. In fact, there was simply a change of position which gave birth to the feminine element. There is really no rupture, only an element contained in another. There is a first and a second. There is Adam and Eve, and we cannot make them opposites; for so we would abolish the world and renounce it. It is by accepting these positions as they have manifested themselves that we obtain the conducting wire from which life starts. And life can only be created through the union of these two positions which the couple represents.

When we are able to challenge this debate—me and I, man or woman—and return to our unity, when the woman renounces being considered but a woman and the man but a man, when they consider themselves complementary beings forming an entity, we can then find the answer. Otherwise, as says a *majdoob:* "I threw a stone in the air, I followed its track. Before it fell down, I noticed that men were preoccupied with nothing but their bellies and that which is below."

In the history of humanity, the man and the woman have always looked for this primordial unity through love. This unity where they were contained in each other is found again when they become a couple. We cannot deny this natural and innate attraction of the man toward the woman, and vice-versa. This attraction allows them to rediscover, on the corporal, emotional, and spiritual levels, the unity where the two entities were contained in the One. When we talk about two entities, different through their contradictions, and we place them in front of each other as two opposites, we engender dissidence and move away from unity. On the other hand, when we try to harmonize these two entities, we rediscover unity. It is this encounter that is sym-

[1]Reference here is to God's Holy Words, "And men have a degree (of advantage) over them."

bolized during the pilgrimage to Mecca, when the faithful celebrate the encounter of Adam and Eve in unity, the day of Arafat.

The fusion of the *alif* and the *ba* is the creative force behind the childbearing of humanity. The masculine element and the feminine one represent the external appearance that every individual possesses. The *alif* as well as the ba are autonomous letters, each with its own function. Both of them contain the point: the *alif* (١) in itself, and the *ba* (ب) under itself. The truth addresses the essence, and the essence is the point which resides in us, and everything is contained in the point: the universe, the line, the circle, etc. It is the origin of the creative manifestation of the Absolute.[1] When we die, our masculine and feminine elements disappear; all that is left is the point.

The debate concerning the Qur'anic message is not about the confrontation between the masculine and feminine types, but assuming the responsibility that lies with us, as men or women, in a harmonious environment which allows us to advance toward unity. By undertaking the role of the *alif,* man, and the *ba,* woman, we somehow take on a mission, a well-defined role to accomplish in society; and both the man and the woman must accept themselves as they are. The most important thing for them is the quest for a return to the effective and real unity in every domain of everyday life. It is carried out in the framework of the harmony of the individual, the couple, the group, the nation, and humanity as a whole.

On this subject, in his eighth research of his book *Philosophical Researches,* Sheikh Al Alawee says,

> In this regard, the body parts and organs are very instructive. The activity of every one of them is more to the benefit of other parts of the body than to its own, and all of them unite for the well-being of the same body. For example, while the senses all

[1]Sheikh Al Alawee talks about the meaning of this point in his book *Al Unmoudaj Al Fareed (The Point is the Encompassing Secret),* "And Allah—in His knowledge—encompasses all things," (*sura* 4, verse 126). The Encompassing here relates to the essence of things not to their shape.

participate to increase the level of perception, the mind chooses that which is useful for the body. Even the mind does not act for itself, but for the whole body. By the same token, far from focusing on an egoistic profit, the activity of the organs, the senses, and the moral faculties focuses on the well-being of every part of the body. From this standpoint, it is easy to generalize the theory. What we are trying to say is that the human being must be considered in relation to society as the organ is in relation to the body, strictly speaking. He must then act for the good of everyone else rather than his own. Of course, he will get his share, for, by being a member of society, his happiness or unhappiness is determined by that of society itself. If the whole community decides to make this rule respected by all its members, no doubt it will, sooner or later, know happiness and prestige among nations. This should be the objective of every reformer, *musle'h*. One of the best references in this matter is the *hadith* of the Prophet, peace be with him, where he says: "The believers are like one body. If one of its organs is sick, the whole body is affected by insomnia and fever."[1]

A man (or a woman) who does not get along with his or her spouse, or who does not find company (or a companion), will be perturbed just as a country that does not get along with another. In the same way, when there is trouble between a couple, when harmony is broken, a great anxiety strikes them both, and the family is destabilized.

The Path of the True Middle Ground

Islam is the path of the true middle ground, for it undertakes human nature as it is. For example, unlike other religions, divorce has always been accepted in Islam. Is it something good? Or is it the opposite?

[1] Quoted by An'Nu'man Ibnu Basheer and reported by Ash'Shaykhan with the following words, "The similitude of the believers in their friendship and mercy toward each other is the same as that of one body . . ."

The Prophet, peace be with says, "The lawful thing most detested by God is divorce."[1] We can say that it is positive in some cases and negative in others. In Islam, we always prefer to live things in the open rather than hide them. We favor clear situations. For example, you have a wife, and you desire another, why not? If this desire is constant to the point where it becomes a problem, why not solve it, but clearly, in public, and before all, in front of your own wife. Why? Because Islam declares that marriage is a contract between two parties and not a lifelong sacred engagement, as is the case in other religions. In this contract, we can write whatever we want. If the woman wishes to remain the only wife, she has the right not to accept the presence of another, and her husband must respect her desire. If she accepts, for this or that reason, her husband can remarry, there is no restriction. Right from the beginning, the situation between the spouses is clear and with no ambiguity. Lies are often the cause of an unhealthy atmosphere that can lead to hazardous situations. Why then hide and lie?

Before Islam, in the Orient, men had the right to live with many women. It is Islam that has limited the number of spouses to four. Besides, if you have more than one wife, you must give to every single one of them the same rights, the same things. If you buy one a house, you must offer one to the other; if you buy one a very expensive robe, you cannot give the other one of a lesser value . . . and you must divide your nights between them in such a way that none should feel lessened. What man can live like this? Doing so would be to put oneself in a difficult situation! *The Qur'an* says, "Marry women of your choice, two, or three, or four; but if you fear that you shall not deal justly with them, then marry one," (*sura* 4, verse 3). This is the way things happened in the traditional communities, and if this is—before any real acquaintance with the subject—too difficult to understand for the people of the West, they themselves often act the same way, but secretly—doing so to protect their reputation, when they are nothing but pure hypocrites in the matter. And so, those who denigrate Islam

[1] Related by Ibnu 'Omar, Muhareb, and Al Bayhaqee.

do nothing but denigrate themselves. Often, Islam is criticized for the fact that the man can marry four women when the woman can marry only one man. This problem for the religion of Islam is, before all, a problem of responsibility and fatherhood. A man can in the same night make love to four women and have four babies with them. One woman can in the same night make love to many men, but she will be able to procreate only one child. Who will be the legal father? It is then a problem of rights which protect the individual in his person and his goods.

Islam wants us to take the veil off and live in harmony with this aspect of our own selves. When we read the books of the great masters on sexual education, we are surprised to notice that their lectures were given in crowds of thousands of people without any taboo or apprehension. That is why I say that Islam is a religion which responds to the problems of the modern man. Still, I do not deny that it had been fossilized, during many centuries, by those who have privileged the letter to the detriment of the spirit, through a blind conservatism.

Love

Human love, too, can be an opportunity for revelation, for it elevates us. Love is the most dynamic tool, the most powerful, the one that takes us back to the union. It is a love that we cannot seize, characterize, or rationalize; a love that already exists in us, and which transcends us. The couple is an experience decreed by God. Of course we can live alone and be in divine unity. However, the coupling of a man and a woman is an aid and an accomplishment; it is an order set by God for humanity to perpetuate. All of us have desires, sexual appetites, fortunately so. If we can totally satisfy our pleasures with a partner who shares the same values, the union is then total. It represents a balance and a satisfaction on the corporal as well as on the spiritual level, and it is a support. The partner becomes then a brother or a sister in the path. Many reasons can lead us to marriage, but we must do so also because of faith. And although the spiritual path is a personal accomplishment, matrimonial life becomes some sort of help. At those times when one partner weakens, the other gives him or her strength. It is enough to see the role of the first wife of the Prophet, peace be with

him, Khadija;[1] she helped him, protected him, and reinforced him—in his declarations. The woman represents a substantial force for the man, and vice-versa. There is a union if the two entities harmonize with each other and evolve internally as they do externally. To find harmony in oneself is also to discover it in the other party, in the couple. It is not a question of finding out what part of us is masculine or feminine, for if we start to divide ourselves, we do not advance. This part, be it masculine or feminine, we hold within us, but we do not have to define it; it exists, and that is all. The human being is one. It is the totality of the human being that progresses, not the one or the other. It is this experience of love lived on the terrestrial level that can allow us to move further into the universal one.

[1] A'esha, God bless her soul, says, "Although I had never seen her, I was more jealous of Khadija than I was of any of the Prophet's wives. He always talked about her; he would slaughter a sheep and give it away in her name. And I used to tell him, 'It almost seems like there is no other woman to be mentioned but Khadija!' He would reply, 'She was this and she was that, and I had children with her.' This he said when we were in our third year of marriage."

VIII

The Divine Time

We already know that prayer is one means of access to the Lord. He has chosen the word to address us and to allow us to communicate. The word is nothing but the vehicle of the idea, and it is man who gives it all its sense and its intensity. There are some empty words, and others truly deep. "If speech is silver, silence is gold,"[1] they say. True communication must be established in silence, for everything that is born already carries the germ of death in it. This is equally true for the word! To express love, the word is not useful. Love is in the non-duality, the lover and the one loved become one.

The Divine Presence

Tassawwuf is a path which leads man toward unity. God is at the same time the Whole, the Other, and the Unknown. It is man who has created duality by making himself a separate entity from the Lord. In fact,

[1] Related by Ibnu Abee Ad'Dunyaa in his book *As'Samt* as reported by Al Awza'ee. The latter says, "The saying belongs to Solomon, the son of David, peace be with them both."

128

He has never been separated from us, "And He is with you whereso-ever you may be," (*sura* 57, verse 4). It is our ignorance and our pride that cloud His Presence. But, little by little, worship will remove the veils, "On the earth are signs for those of assured faith, as also in your own selves; don't you see?" (*sura* 51, verses 20-21); "We [God] are closer to him [man] than his jugular vein," (*sura* 51, verse 16). Defi-nitely speaking, God has always been present in the heart of man. Not only has He always been there, but there is none but Him and nothing else but Him. He is both cause and consequence; He is All.

God is Eternity

God is Eternity, let's watch out for the traps of reason; if we try to ap-prehend this notion intellectually, it is as if we want to contain time in the instant. It is impossible! The minute cannot contain the hour. We are a part of the hour, a part of time. If we want to contain time—eternity in other words, for God is Eternity—the limits of individuality must disappear. A *hadith* says, "Do not insult time, time is eternity, God is eternity." Intellectually speaking, no one is capable of containing time, for we are limited. Even so, in every era, philosophers and thinkers have vainly tried to understand and speculate on the matter.

We do not deny the use of the intellect, and we are not asking those who possess elaborate thinking to stop rationalizing. We rather recom-mend that they stop getting lost in speculative reasoning. The Divine is order and mystery, and sterile and complicated reasoning has no place in this domain.

To sum up, the intellect and the body have a predominant impor-tance in the balance of our personality. They are tools put to the serv-ice of man to help him. It is through the intellect and its light that man is different from other creatures. Still, he remains limited, for his field of investigation is from the domain of the world of sense and reason. The moment he is faced with the apprehension of the universal truth, man is ineffective, as if paralyzed by the infinite where he finds no landmark. At such a time, the wise among us will know their limits and the arrogants will invent other truths, other religions, and new sects, where they get lost and lose those who follow them. "Haven't

you seen him who takes his passion as his god; God has knowingly left him astray," (*sura* 45, verse 23). Wanting to apprehend the spiritual life via the intellect alone is like wanting to plaster a wall with a spirit level. First, you use it only to see whether the wall is straight, but then other tools are necessary: a trowel, a wood float. At a certain moment, the research will have to be on another level, otherwise the intellect will become a hindrance to the understanding of the whole, of multiplicity and uniqueness.

The Original Human Being

When apprentices choose this spiritual path, we ask them to rediscover their primordial origin—which is neither intellectual, nor rational, nor corporal, but simply spiritual. He or she who comes back to this state no longer tries to find out if he or she is the One, the Whole.

Everything that is limited in time is illusory—it is the illusion of an instant, even if that lasts for centuries. What are the centuries in comparison to eternity? Even earth is limited, for it has a beginning, and it will disappear with everything that composes it. When we observe the earth's life at the level of time, the whole thing does not even represent a thousandth of a second. In our daily life, do we really attach any importance to something that lasts but a second? It is a *flash,* and we do not notice it. There are even some real events which we can experience for months, or years, and that we forget. Are we then simply living a dream?

There exists in Sufism an anthology of anecdotes and stories in the matter. One goes like this:

> A master asked his disciple, who had just finished spending some time with him, to undertake a pilgrimage to Mecca and Medina. A year after, the disciple comes back and knocks on the door of the master's house. The latter asks, "Who is it?"
>
> "It is I," answers the disciple.
>
> The master exclaims then, "There is no place here for two, go back to where you came from."

Confronted with this injunction, the disciple leaves again for another whole year and then comes back. The master inquires to know who the visitor is, and the disciple answers, "It is you—[master]." The master then allows him in.

Time Materialized

We can also find out that the Truth does not belong to a group of people, even less to our own selves, but that it is we who belong to it. Everybody is wrong and everybody is right. The Truth is everywhere, and no one can claim: "Me, I have the Truth." We are limited by time, while Truth is eternal. One minute can contain the seconds, but one second cannot contain a minute. The minute contains only one instant of the hour. How can all that is eternal be contained in a limited dimension? We can hold but a tiny part of the Truth.

This realization allows us to become less pretentious. A person can be right at a given moment, but if we perceive this same truth at the level of time, it becomes itself ephemeral and is no longer certain. I do not know whether this reflection can touch a materialist spirit, for our whole civilization lies in the opposite idea, that of materialized time, hence the expression: "Time is money." The materialists deify time and reduce it to an economic notion, a monetary value, while the time we are talking about has no beginning and no end. It is above this reduction which is to the image of man and not to that of the Lord. Enough it is to watch the spectacle offered to us by the stock exchanges where the value of money rises up and goes down, with all the damage that that causes. We see the exchange agents get more and more excited, going along with the pace of the quotations in the market. Why such a frenzy? With regard to the education which I received, there is a big problem for me here. One cannot imagine the disturbance that this game of stocks can generate. The whole world's economy is regulated by this speculative game. But perhaps I have not encountered a great master of the stock exchange to teach me the mysteries of this madness!

This phenomenon of the globalization of the economy, of finances, and mainly of information, worries a great number of specialists and scientists. In *The Diplomatic World* newspaper of August 28, 1995,

M. Paul Virilio writes: "For the first time, history will function in a uni-fied time, world's time. Up to now, history came down in local times, local spaces, regions, nations. And yet, in a certain way, globalization and virtuality establish a world time which prefigures a new type of tyranny." This anxiety is understandable, especially because men can be manipulated by information and disinformation, both of which forge opinions and legitimize some behaviors that serve the interests of powerful groups who hold the information and the means to diffuse it on the planetary level. "There is never information without disinfor-mation," continues Mr. Virilio. "And a disinformation of another type appears to be possible then, far from any deliberate censure. Here, the sense is asphyxiated and the mind loses control. There is another great risk for humanity provoked by technology and the media. This is ex-actly what Albert Einstein announced since the fifties when he talked about the second bomb, the bomb of computer technology, coming after the atomic one. A bomb where the interactivity in real time would be to information that which radioactivity is to energy, with the disin-tegration reaching not only the particles of matter but the people com-posing our societies."

For the Sufi, God is enough, "He is The First and The Last, The Out-wardly Manifest and The Inwardly Hidden," (*sura* 57, verse 3), The External and The Internal; He is in me but also outside of me, for I am but an instant in time. How can an instant contain eternity? It is not possible, unless the instant dissolves in it, just like the drop of water which loses its individuality and rediscovers the immensity of the ocean. If we cannot understand this notion, we cannot then conceive nor imagine the path and the logic of the Sufi.

There are living beings that live but an hour, others, twenty-four hours or ten years, and man lives between sixty to a hundred years. But what is a hundred years in time? And what do centuries, thou-sands or even millions of centuries represent in time? Nothing! If we go back to the Absolute, we notice that He is the One Who acts, the Omniscient. It is He Who inspires us, Who provides for us, and Who feeds us. It is also He Who shapes us by making us live and die. We come from Him and to Him we return. It is like time—where does the

instant die? In time, which absorbs the whole and which gives birth to the perpetual miracle of creation. "Even as We undertook the first creation, so shall We undertake it another time. It is a promise on Our part, truly We will fulfill it," (*sura* 21, verse 104).

Every civilization has come out of time. If some deny the Lord, can they deny time? It is impossible, for people experience it every day. In front of the mirror, who looks at whom? What do we commemorate by celebrating anniversaries or birthdays? "I celebrate my forty years!" Forty years of what? Of the time that has been allocated to me. To renounce the Divine is to deny time, and no one can deny it, for it affects us. Time gives us the innocence of childhood, the strength of the adult, the intelligence of the man—adult and mature. It gives us youth, wisdom, and old age, and through the wrinkles, we see it affect us every single day. We cannot dispute it, or stop it. We cannot fight. Fight against what? Against God?

This spiritual tradition tells us the following, "Men insult time, when I am Time, the One Who holds in My power the night and the day."[1] Every experience is but an instant of time to live, one that we must live as positively as possible. Time is to be lived without pride and with no pretentiousness, by appeasing the ego and by serving the straight path, the path of good and peace, for us and for others.

The Circle and the Center

We are not pure spirits, and existence demands that we respond to a number of material obligations, so simple that I symbolize them by a circle. This circle represents the exoteric life, that of every day, with its contradictions, its material and emotional problems. It is the spot where man suffers the most. When we have an infection in the finger, the whole body suffers, and little does it care about God. It is this circle also which generates rebellion and duality. Daily life is the circle, and we very often keep turning around, hardly thinking about going

[1] "Allah says, 'The son of Adam abuses Me by insulting time, and I am Time, I hold all things in My Hands, I cause the day and the night to rotate.'" Related by Al Bukharee, Muslim and others, all quoting Abu Hurayra.

back toward our center. The truth is that every minute that passes in the forgetfulness of God, that keeps us far and separates us from Him, raises our suffering which expresses itself through our body and our mind. The remembrance of the Lord is the constant reminder to our immutable and infinite center which is the image of the Creator. "He has created Adam in His Image." The return to the center through prayer, reflection, *dikr,* contemplation, is a return to oneself, a journey that uncovers our contradictions and our sufferings, which themselves become then positive and healthy tests, and not chains that hold us prisoners and make us vulnerable to the events of life.

Basmala

In the daily life of the Muslim, every act starts with *Basmala (Bismi l'Lahee Ar'Rahamani Ar'Raheem),* which means: "In the name of God, Most Gracious, Most Merciful." This formula sanctifies and elevates the act. The performer becomes the instrument of the Divine Will. The ego is erased and the performer is none but God through us. To drink, to eat, to plant, etc., all the acts of life are directly linked to this creative and sovereign source. Is it not true that men borrow this formula from God when they impose laws and judge others "in the name of the King, the President, the People, the Republic?" The Sufis accomplish all their actions "in the name of God." For them, any thing that is not accomplished in His Name is cut from the source,[1] and the act becomes then ephemeral, profane, and limited, for the laws and the decrees of humans always end up perishing.

This invocation gives the act its verticality, it represents a connecting point between the terrestrial world and the celestial one, just like the letter *ba*—first letter of invocation—which extends itself horizontally while stretching out vertically. To say *Bismi l'Lahee,* means that the ego is annihilated and that every act is accomplished in the name of God.

[1] Reference to the *hadith* of the Prophet, peace be with him, as quoted by Abu Huraira, God bless him, "Any act that does not start with *Bismi l'Lahee Ar'Rahmani Ar'Raheem* is defective—lacking in *baraka.*

Every act finds its way back to unity, and the *fuqara* intensify in themselves the resonance of *Bismi l'Lahee* through the conscience, which becomes more and more powerful and vast. This expansion of the conscience anchors in the mind of the disciple through faith in God, in unity. This faith gradually turns into certitude.

Every knowledge, every truth, is contained in the ultimate Truth, which is itself contained in the power of *Bismi l'Lahee Ar'Rahmani Ar'Raheem*. We tirelessly go back to this ultimate Truth. It is through Its will and Its power that we live. In Christianity, we find these words, "In the name of the Father, Thy will be done," which means: May Your divine will come to be and not my human will.

The Inner Life

Tariqa helps us live the instant in God. The world is a reflection of our inner states. That is why when we live moments of joy, our environment seems beautiful, harmonious, and all difficulties fade. But when our inner world is upset, life seems violent, incoherent, and contradictory. In fact, it is our inner experience that colors our exterior world. By transforming our inner world, we modify the environment that surrounds us. For the awareness that we live produces a radiance around us. If we act with mercy, tenderness, compassion, and joy, we spread around us an energy of well-being. This is surely hard to conceive for those who are not attached to unity.

But this reality is never held. It comes and goes; it is never imprisoned. It is a permanent quest. Thus God tests us and allows us to resist this pride of the self which glorifies itself the moment it feels it has some kind of superiority, that of having realized this unity. We are given these tests for the purpose of an inner purification, a growth. The tests allow us to mature; without them, our inner side stagnates. At the same time, purification is a removal of the veil, for it eliminates all that is unnecessary, all the dross found within this precious metal—the being. By purifying themselves, men and women see themselves getting better. If we think we are enlightened and have reached the goal, we actually stop; as long as we are in this world, we should allow this interior

Presence to flourish through a continuous to and fro motion, just like the waves which succeed each other, disappear, and come to life again, while the volume of the ocean remains the same. God says, in a *hadith qudssee,* as reported by prophet Mohammed, peace be with him:

> Should My servant remember Me in himself, I will remember him in Me; should he mention Me in a group, I will mention him in a group far better than his; should he draw nigh unto Me by a span, I will draw nigh unto him by a cubit; should he draw nigh unto Me by a cubit, I will draw nigh unto him by a fathom; should he advance toward Me at a slow pace, I will run toward him.

The Instant of Truth

E ver since the origin of Islam, texts have told us about the victory over physical death. The turbans that the companions of the Prophet, peace be with him, had on their heads, were their shrouds, for the companions were always ready to go to the other side of life.

The Passage

Today, thanks to the intensive care units, which are more and more effective, we possess precious testimonies on the personal experiences of the nearly dead. The descriptions given by people who have gone through this tunnel are not far from the description given by the spiritual texts of all the great traditions. In the Islamic tradition, it is said that the human being passes to the other world by going though a door, a passage (*serat*), which is also referred to as a line, as wide as the universe and as narrow as the width of a hair.[1] It is an obligatory passage. For those who have pre-

[1] Abee Sa'eed Al Khudree, may the Lord bless him, says, "I heard that the passage is thinner than a hair and sharper than a sword, full of hooks; with one of these it pulls many people," Al Qurtobee in his *Ta'dkera, The Reminder.* And Anas quotes the Prophet, peace be with him, as saying "The *serat* (passage) is the same as a sword—in its sharpness, and a hair in its thinness." reported by Al Bayhaqee.

pared themselves for it and who have accomplished themselves in this world, it will be a boulevard which they will cross with no fear. On the other hand, those who have not prepared themselves will dread this instant. For these, it will be like crossing a chasm on a hair as sharp as a blade. This is of course a symbolic image which shows that it is the sum of our actions that will determine our ease in this test.

We can see that death in the West is an inhuman phenomenon; it is considered as bad company. At the time of death, people are more and more lonely, abandoned in a sanitized home where no one hears them, and from whom everybody flees so as not to be concerned.

For Prophet Mohammed, peace be with him, the death of a man or woman is the result of a whole life, and each one will be sent to the other world according to the last act, to the last thought.[1] It is then at this precise moment that the conscience must be the purest it has ever been, saturated with love, with forgiveness, with detachment, and facing the ultimate encounter, long awaited. For this reason, death must be totally accepted.

The Preparation for Death

Death must not, in any case, be experienced as a tragedy, even if there is a rupture. It is for this reason that we help the dying person to live this precious and delicate moment. We prepare the person to die and we assist the family. If all of them accept death and perceive it as a natural accomplishment of life, departure will be much easier. On the other hand, if the family members are sad or anxious, the dying senses death as a hindrance and suffers from it.

The body is a garment, and it is by changing the envelope that the soul will taste death, for the spirit does not die. During our life, the soul remains prisoner to the body. In the book of Genesis, the soul, free as it was, refused to enter Adam's body. God then called on the angels and asked them to charm the soul by playing music. The soul accepted to enter Adam's body only because it was drunk from music.

[1]The Prophet, peace be with him, says, "People are resurrected bearing the last act of their lives." Quoted by Jaber, God bless him; reported by Muslim and Ibnu Maja.

That is why inspired music has always been beneficial to us, by giving back to the soul this recollection of drunkenness lived in pre-eternity.

For us, the human being is sacred! And so, whether one is a member of *tariqa* or not, the dying is assisted and helped in the same way, as this story shows it.

> Sheikh Hadj Adda, during his stay in a big city, was heading the assembly of the brothers, when people knocked on the door. A prostitute had just died in a red-light zone, and no *Imam* wanted to go there. Immediately the Sheikh went to the place where the body was in order to remove it. He accompanied it to the cemetery, performed the last prayers, and declared that perhaps the Lord had made him come that day only to pray for that unfortunate woman.

When people die, they lose all identities. They are no longer Black or Asian, Jewish or Muslim, since they go back to their origin carrying in them the whole adamic inheritance. One day, while the Prophet, peace be with him, was sitting with a group of companions, a funeral procession passed by, and the Prophet, peace be with him, stood up. One of the comrades said, "Those are the remains of a Jew!" The Prophet, peace be with him, answered, "Stand up [to honor the son of Adam] when you see a funeral procession."[1]

At the time of death, every individual must receive the help he or she needs; be it a natural death or an accidental one. For one who commits suicide, this act is, before all, that of a person diminished and submissive to despair. From the point of view of Sufism, being a way of submission, we can say that one who commits suicide refuses his destiny. It is a sort of rebellion which says, internally, "I, myself, put an end to this unacceptable situation." One more time, it is the ego expressing itself! This shows us the extent to which the ego can take us: to a destruction, not only spiritual but also physical. Sufism neither judges nor condemns suicide, for it is only God who knows. We have

[1]Related by Al Bukharee and Muslim as quoted by Jaber. (*See* the book *Ar'Rasf* of Al Aqoolee, volume 1/416.)

only the power to prevent it. Today, when we see more and more young people committing suicide, we can only ask ourselves about the kind of education they have received. What has been their spiritual nourishment? How have we invigorated their being? We must understand that the reason for our coming to this world is not to develop the body only, but also the soul. Developing the soul is the very goal of this spiritual path, whose door of hope is always open. In the traditional Muslim world, suicide is very rare.

It is said in the Islamic tradition, "We help a dying person,"[1] as if we were taking some steps with him or her [toward the other world]. We can give that person a taste of the ultimate life by explaining that he or she does not end, even if the body—the garment—returns to its origin, and the spirit to its own. The Prophet, peace be with him, says, "You are all from Adam, and Adam is from dust."[2]

Some deaths are very difficult and others seem to be much easier; this can be noticed on the body itself, especially on the face. For some people, the body remains tense, for the release is painful, while for others, a sensation of peace and light emanates from the corpse. Even after the last breath, the face is clear, and an amazing radiance remains. We can be under the impression that they are asleep. In Mostaghanem, I have assisted a great disciple who was dying. He was blind and deaf, but in the last moments of his life, he seemed to see and hear just as when he was young. For him, it was no longer a question of death, but of a journey during which he was going to convey some news to the world of the above. He had become a connection between the living and the dead. Thus, death can also be a revealing tool of an extreme joy; and I did see some people die in joy, however astonishing this may seem.

[1] The Prophet, peace be with him, says, "All creatures are God's children; and His most loved among them are the most helpful towards His children." Quoted by Anas, reported by Abu Ya'ala and Al Baraz. The same *hadith* is also related by At'Tabaranee as quoted by Ibnu Mas'ood. In another version, "He who helps his brother (religious brotherhood), God will come to his rescue, and Allah is surely a helping hand to a servant as long as the latter comes to the help of his brother."

[2] Part of the last speech given by Prophet Mohammed, peace be with him.

The **Ultimate Journey**

One who is about to die is taken in charge by his or her family and, if attached to one of the Sufi ways, the brotherhood takes care of everything.

In this case, there are some special recitations for the dying and some specific gestures, like laying the hand on some parts of the body, allowing the harmonization of the energy therein and facilitating the departure of the soul. We call the dying person by the mother's name, simply because it is she who has given him or her life, and because, juridically speaking, we are sure of the identity of the mother but not that of the father.[1] The ultimate recitation is then a prayer of life, Lá eláha ella 'Lláh, "There is no god but Allah,"[2] for it is the first prayer in life that was whispered in the person's ear at birth, and it is the last sentence he or she will say, or hear being said, at the last breath of life. At the very instant of death, there must be a union, a harmony between the physical energy and the spiritual one.

The **Last Word**

In the course of the agony, Islam defines many phases (*sakarat al mawt*). The dying will live anger, regret . . . but also heat, cold . . . These sensations are explained in the tradition as being connected to the departure of the soul from the body. It is the heat that leaves it first to give way to cold. The sensation starts at the very end of the feet, and then progressively escalates toward the top of the head until the last breath. But this description does not apply to the Islamic tradition alone. It exists, identically, in other traditions.

The moment the disciple enters this state of loss of consciousness, the moment the body starts to get heavy, and to the last breath, we say the *shahada* with the dying, calling him or her by the mother's name. Even if the disciple is very weak, we try our best so that he or she can

[1] Ibnu Abbas, God bless him, quotes the Prophet, peace be with him, as saying, "God summons people on the day of judgment by their mothers' names in order to conceal their identity." Reported by At'Tabaranee.

[2] "He whose last words are *Lá eláha ella 'Lláh* enters Paradise," says the Prophet, peace be with him.

recite with us this code of conscience. The person will thus leave with the word of *uniqueness* on the lips, which will facilitate the passage. The whole summary of the disciple's life will rest on this moment. The tiny bit of consciousness that remains must be put in the One. That is why it is better to avoid drugs—the massive doses of sleeping drugs or analgesics. Of course, in some cases of painful diseases, we can appease the suffering through an appropriate substance. But I insist: the disciple must be as conscious as possible. That is what is most important at this time! They must not fear, but be very attentive to the preparation of this passage during which he or she forgets that he or she is in the process of dying—thus being able to go to the world of the above. It is not an end, it is a departure.

When the death of a disciple approaches, there are some heralding signs which do not deceive, but which the person's family perceives not as clearly as one who is experienced in the field. For the family always refuses, more or less, the death of one of its members. If the master is present, it is a privilege and a great chance for both of them, and death takes a good course. I have seen some people die while drinking a cup of water or tea, and leave this world very smoothly. But before reaching and living this noble state, words of conversation as well as reminders are exchanged between the master and the disciple, for their relationship is at this moment very intimate. It is a time when we cannot cheat. We are not unveiling a secret when we say that when a disciple is about to die, the master and some *fuqara* sometimes foresee it through a dream or an intuition, even if no external sign alludes to a near end. Internally, the master is never surprised, a thing that allows him to subtly help the person to live this delicate situation. Unlike the parent who does not know and will go through the effect of surprise, the master will be again more available at the time of death, for no thought, no emotion, will come to interfere in this exchange.

We must understand that the above cannot stop the heart from expressing itself. Of course, the departure of a loved one is a real agony, but it must remain within limits, and must not become a tragedy which takes many years to heal. In our tradition, we know that it is an obligatory passage, sometimes smooth, others violent. It is not an irreparable

moment, since this body is nothing but a garment, which is first used, then tears and deteriorates.

May I also add that it is necessary not to hide the truth from one who is about to die, so that he or she may not be taken by surprise when leaving this world, and may not remain captive to an illusion. Truth makes this transition quick and painless. In our tradition, when the process of death appears, we privilege this moment by elevating the person to a level of consciousness that allows him or her to confront this ultimate test and not turn away from it. We do this so that the person may say, "I am here and I am ready to leave," instead of refusing and clinging to ephemerality. The more the acceptance is absolute, the more the liberation is facilitated!

Spiritual Death

Actually, Sufism considers the death of the ego, "me-I," far more important than that of the body, which it ranks in the order of things. Again, we do not deny that the physical death is a rupture, almost as if we were to pull the skin off an animal. But this separation from those we love will be more or less painful by virtue of our ability to accept their departure. Death for us is not an end but an access, the door which allows us to continue in the invisible world where we are sure to meet again those we have loved. "And say not of those who have been slain in the way of God: 'They are dead!' No! They are alive, though you perceive it not," (*sura* 2, verse 154).

As for the spiritual death of the ego, it represents a second birth. However, we use this terminology because all the animal instincts, the negative instincts that man holds inside of him, must be thrown out. The human being must keep in him the quintessence of the most noble of ethics, which make of him the vicegerent of God on earth. The Prophet, peace be with him, says, "I was sent to complete the most noble of ethics [of man]."[1]

This preparation for the death of the ego is in fact the most important event for the disciple, for he or she must die within to be able to

[1]See Al Muwata' of Al Imam Malek.

live in the Absolute, thus realizing unity with the Divine. A man or woman who has not transcended egocentrism during existence has spiritually missed the target. It is the only thing that counts! The whole work performed during the life of a disciple consists of having access to this death of the ego.

I think that if realization is a goal which is seriously sought by the disciple and is not attained, he or she will put therein his or her whole conscience, whole energy, so that the moment of the big departure becomes the occasion to tear that veil and enter, through physical death, to the realm of unity. Death becomes then the extraordinary tool to have access to unity.

To Him Alone Belongs Our Destiny

God's Saving Hand, may I add, is close to every individual; there are no magic formulas or pre-determined settings. We always act in the faith that the Lord will accept our actions, but He is the only One to decide on our destiny. There are no laws, even if men and women finish their lives while in retreats, in prayers . . . this will perhaps not be taken into account for the peace of their souls. While on the other hand, those who have lived a dissolute life will perhaps be saved at the very last instant.

In a *hadith,* the Prophet, peace be with him, says: "One day, a person saw a dog which was so thirsty that it ate moist soil. The man took then his ankle boot and used it to put water in it and gave it to the dog. He repeated this action until the animal appeased its thirst. God was grateful to this man, He allowed him into paradise."[1] On the other hand, in another *hadith,* the Messenger of Allah says: "Another person had tortured a cat by locking it in and letting it die of hunger. Because of that, the person went to hell." And he added, "If I am not mistaken, [God] told the person: 'you have not fed the cat, nor given it water when you locked it up, and you have not let it go look for its own food.' "

[1]Related by Muslim as quoted by Abu Hurayra. And the ending of the *hadith* goes as follows, "Do we really get rewarded by being nice to these animals, O Messenger of Allah?" "In every soft liver—anything that is alive—there is a reward," he responded.

The dead person is buried as soon as possible so that peace and mercy (*ra'hma*) come upon the hearts of the relatives, and also to give the idea that he or she does not belong to this world anymore. The dead person's family, in his or her memory and for the peace of the soul, will celebrate the seventh day of his or her death, (the fourth day for some), through recitation of some appropriate *suras* of *The Qur'an,* some funeral chants, and through the distribution of alms.

The Barzakh, Heaven and Hell

It is said that, after death, the soul will sojourn for a period of time in the *barzakh,* the intermediary world. At that very instant, the soul frees itself of every negative aspect received in this life, for we cannot enter into the world of the above except by being pure conscience.

It is at this stage that the symbolic notions of heaven and hell intervene; the two are in fact nothing but stages leading to the ultimate reality. Paradise is accomplished above, which means that the souls of those who have lived on the straight, honorable, and virtuous path, will complete in paradise their task of reaching the complete realization, that of contemplating the face of the Divine.[1] The other, hell, takes place below;[2] it concerns the souls who, in the terrestrial life, have lived in disregard of the Lord, and in the frenetic pleasures of the senses to the detriment of the spirit which animates them. It is by the purifying fire that these souls will realize that "There is no god but God." Despite all of this, and according to the experience and the words of the great men and women of wisdom, it is said that hell is peace, just as paradise is. We find this idea in the following *hadith* of the Prophet, peace be with him, "The people of paradise moan just as those of hell

[1] Abu Dawood quotes Abee Razeen, God bless him, saying: I said, "O Messenger of Allah! Do we all see Allah privately on the day of judgment?" "Yes," he said. Then I asked, "How does this apply to us on earth?" He answered, "Don't all of you see the moon privately when the sky is clear?" "Of course," I said. Then the Prophet said, "The moon is but a creature of the Lord, and God is greater than all things."

[2] This is revealed in God's Holy Words, "And the companions of hell will call to the companions of heaven, 'Pour down to us water or anything that God has provided for you,'" (*sura* 7, verse 50).

do."[1] This alludes to the idea that the soul feels the torment of being separated from Him, whether it is in heaven or in hell. This means that paradise remains a stage and a limitation if the soul has not found the Absolute, the Divine. In the minds of many people, hell is terrifying, but in fact, it does exist only for the purpose of purifying and purging the negative thoughts which crowd the soul. Actually, these two stages are simply a great mercy from the Creator to the creatures.

If I take the example of a fetus which lives perfectly in its world and to which I explain that it will leave its womb and see the sun, the sea, the animals . . . , it is impossible for it to apprehend this dimension. How can it conceive the world where it will grow, since its prenatal world is perfect? From this example, imagine our situation before dying. Is it not identical to that of the fetus in its mother's womb? How can one find an appropriate language to describe this world of the above that we have not experienced in all fairness? That is why the spiritual traditions tackle it through images and symbols, which are helping tools in the matter.

People of this world pray intensely for the deceased so as to send them a lot of energy and positive thoughts. Pity, sadness, and all sorts of intrusive thoughts are useless and conform not with the attitude of the believer. If a member of the family is sad, it is important that he or she allow pain to erupt so that it may stop and dissipate. Once the dead is buried, we cease to mourn his or her absence.[2] We must allow the soul to pass to the other world with absolutely no regrets. If there is acceptance of the death by the members of the family, it only adds to that of

[1]Abu Yazeed Al Beztamee, God bless him, says, "God has some special servants who would run away from heaven and its bounties—the way those who suffer in hell cry for help—should the Lord veil them therein from seeing Him." See *Jawhar At'Tawheed, The Pearl of Oneness,* page 117.

[2]Anas, may God bless his soul, says, "The Prophet, peace be with him, entered the room where his son Ibraheem, God bless his soul, was in his moments of death; the eyes of the Prophet started tearing. Abdu Rahman Ibnu Awf told him, "You! O Messenger of God (referring to the fact that he was sad to the point where he had tears in his eyes)! Then the Prophet, peace be with him, said, "These tears are a mercy, the eye tears and the heart saddens, and we only say that which pleases our Lord; we really mourn your departure, O Ibraheem." Al Bukharee and Muslim.

the deceased, thus rendering his voyage far easier. Even the belongings of the deceased remain a hindrance, and it is better to give them away.

The thought of impermanence—death—acts as a barometer showing us the precariousness of that which we think we are. We become aware that we are limited, ephemeral, and mainly that time is precious; for a day, a month, or a year that go by never come back. It is an evidence that may seem banal, but if we give it enough thought, it gives us fear, which pushes us to find out what we desire most of all, and more importantly where we are going. Unfortunately, we are often so occupied by futile matters of which we are slaves. Whether we are rich, poor, powerful, weak . . . , ninety percent, if not a hundred percent, of our energy is dedicated to things which will come to an end with us, at our death. It is regrettable! In Tassawwuf, the simple reminder of death allows us to rediscover this momentum, which stimulates the real desire for the Absolute. A sentence of the Prophet, peace be with him, expresses this awareness of impermanence: "Live in this life as if you were to live eternally," which means, work for this life on earth as if you were to live eternally, "and work, at the same time, towards the other life as if you were to die tomorrow."

Man must thus accomplish all of his acts as if he were eternal. Every action must be realized as justly as possible and as conscientiously as possible. Each person will be responsible for every act and will have to answer for it on the Day of Judgment.

Reincarnation

Unlike Hinduism and Buddhism, Islam leaves the question of reincarnation in suspense. In the whole Islamic tradition, I have never seen reincarnation being dealt with, and neither have I heard that it does not exist. The debate remains open! *The Qur'an* indicates that our origins are physical, be they mineral, vegetable, or animal. At the time of death, all the constituents of the body return to their origin. From this standpoint, why not admit an eventual reincarnation of a part of our body? If we take the cycle of life as reference, we bury dead people on whom the earth feeds; the latter itself nourishes plants to feed animals on which humans feed. Nothing is lost, and nothing is gained; every-

thing changes.[1] Actually, this process is related only to the nature of the physical body, for that of the spirit is absolutely free. The spirit dwells in the body until the day it no longer functions, then it leaves the body and returns to its origin. And God knows best.

Fear of Death

I think that it is a good thing to fear death before dying. In the path that I am talking about, at a given time, we obligately go through this test. In order to get rid of something, one must live it! When we have lived the worst of experiences, we become free from them. I, myself, have twice lived this fear of death in all its dimension. And twice I told myself, "That's it! I am going to die." There is nothing extraordinary about this, and I am sure that a great number of individuals, no matter what religion they are, have been able to live this test. Having been in close contact with death, the latter becomes a natural phenomenon. It is now seen differently, for the root of fear has been uprooted and the shadowy zone has been erased.

In order for one to realize oneself, he or she must go through all stages; otherwise, the experience on earth will remain incomplete. Everything must be clarified; otherwise, the fear of the unknown remains. It is clear that we cannot talk about pain or joy unless we have lived them, the rest is but words. It is as if we describe the savor of an orange without having tasted it. The human being is a living laboratory where one is at the same time the guinea pig and the experimenter. It is at the time of these intense fears that the disciple becomes aware of the foundation of practice and its landmarks. For in such situations, we could ask ourselves where these fears could lead. At these exceptional moments, it is fortunate that there exists this immense Divine Mercy to which we attach ourselves. Ali, the Prophet's cousin, says, "People are asleep. Once dead, they awake."

[1]Al Imam Ash'Shaarawee says in his book of *Fatawee,* "It is amazing to see that when we put the dead person inside the earth (and cover him), there is no smell that comes up; not so, however, if we put him in any other place. And after a long period of time, the remains of man dissipate to be of use to other components of life."

Conclusion

We are living in an era that is at the same time difficult and meaningful for future mankind, for it is marked by change. Everything is reevaluated. Today, the only urgency is that humanity does not reach the point of no-return. We must stop causing damage to nature and must stop destroying ourselves. Nowadays, humanity chooses circuitous ways, but sooner or later, it will become aware that its happiness can only be found in the return to the Absolute, the True Eternal, the Merciful. Mankind is like one human being who goes through tests to become mature and understand his role. Humanity will never cease to change, for so is the destiny of man.

The book of Genesis says that Adam and Eve were kicked out of paradise, and in our tradition, the *majdoobs* say, "When Adam and Eve started to eat, they began to defecate. That caused a smell so bad that they were thrown out of paradise." They say that today the situation on earth is similar: the air that stinks and poisons, the sea polluted, the savage deforestation, the nuclear tests . . . If humans continue, they will be kicked out again. But where will they go? It is urgent that we be reasonable and at least go back to what makes us normal beings, superior and happy,

149

and truly responsible. Human beings easily say that they are the superior animal, but what allows them to affirm this superiority?

The Qur'an says, "The most honored of you in the sight of God are the most righteous among you," (*sura* 49, verse 13). Let us get closer to the center, to this spiritual particle which is in each one of us. It is urgent that each person excavate in order to find the source. To find water, we must dig a well by removing stones and dirt. Let men and women gradually stop wanting, at whatever cost, to profit, possess, control . . . so that they can live a more simple and reasonable life.

The human being has but the illusion of possession, since everything comes from the Lord. When Adam lived in paradise, everything came to him. Since the loss of this heavenly state, he strives to survive.

In our present world, there is a lot of bloodshed; there are a lot of wars; there is much intolerance, injustice, inequality, misery and opulence. If our society considers itself modern, what is the sense of this modernity? If it has brought us scientific, medical, and technological progress, it has on the other hand brought no change to the problem of humans in their relations, either with themselves or with his their fellow humans. To be civilized is an art of living in harmony with oneself and with others. It is a noble attribute, a fineness of spirit, a continuous sincerity, and a struggle against the blind obscurantism of the ego and against the ignorance of this spiritual particle inside us. Faith, wisdom, and knowledge are but one and the same path. Because humanity has forgotten this rule, it is suffering, and will suffer.

One harvests only that which one plants, and this is also true for nations and civilizations. If they seed anger, violence, and depravation, sooner or later they harvest the very same thing. How does the life of dictators end? Very often in blood! How does the life of those who have preached good and reconciliation end? Even if they were assassinated, like Gandhi or Martin Luther King, we no longer remember the names of their assassins, but theirs stay engraved in our collective memory for eternity. Today, we still talk about Buddha, about Jesus, Abraham, Moses . . . peace be with them all. Their messages are still alive, for they have seeded the love of neighbor. We honor them, while we care very little to honor Attila or Hitler.

Nowadays, our duty is to humbly respond to the problems of humanity. If I introduce solutions dating back to the Middle Ages, they will not adapt to my era. It is our duty to find that which will allow people to live in harmony, and not in contradiction, with their time. It is very easy to reject society and to become withdrawn, but I do not think that this can be constructive. What is the use of locking oneself up in an ideology, a philosophy, a sectarian religion which block and freeze all kinds of evolution? One who stagnates, who follows not the movement of life, never finds answers which adapt to the present. All the current movements, be they fundamentalism, terrorism, or fanaticism, are but the mark of refusal, of deadlock, of a stagnation of mentalities, and the mark of humanity's fear of its uncertain future.

All cultures have contributed their stone to the construction of the happiness of the human race, as has our modern civilization. The latter represents the secular inheritance of the civilizations which have preceded it: Chinese, Indian, Egyptian, Roman, Greek, or American-Indian. As for the Islamic civilization, it contains them all. From this perspective, it is neither better nor worse than any of them. With this assessment, and for the good of humanity, are we able, through a sincere reflection, to find common ground and answers to the evil we create, and which attacks us and wears us out?

If the human race does not redress its approach on all levels—scientific, philosophical, social, military, economic—it is doomed to catastrophe. It is our survival that is at stake, for the planet has never been this populated and this polluted.

Pollution is not only ecological. It also develops at the level of the heart. We must stop nourishing people with illusion, for we clearly see that it leads to deadlock. Even so, we persist in error. To the individuals, growing bigger and bigger in number, who are interested in spirituality, I would say: *Care not about spirituality but about humanity!* The danger is so real today that we must care about humanity, the universal man. If spirituality assists us therein, so much the better, but if it becomes a handicap, a hindrance, or an egotistic self-contentment, let us abandon it!

With the appearance of AIDS, the human race is, for the first time in history, threatened in its reproduction, in its survival. The act of

love has become an act of death. Before, the individual could well be affected with plague, with cholera . . . but without being handicapped and obliged to take precautions to engender.

And then there is the problem between the rich and the poor. It has always existed, and it would be utopian to say that this problem can be resolved for good. But we can reduce it considerably. How can we spend billions to make war, to build artillery, or to ruin ourselves in games or gambling, and find ourselves, at the same time, unable to re-solve problems such as famine, misery, or exclusion, when we actually have the means to do so? How can tragedies like Rwanda, Yugoslavia, or Tibet not be resolved, when the Gulf War blew like a wave of mad-ness? A third world war was talked about then with an incredible media turmoil. Why? For oil needs!

Until we condition our children to think that war is a calamity, an absurdity, and a curse on humanity, and that the true warriors are the ones who represent and defend, through the sacrifice of their lives, the weak and the oppressed as well as the human and universal values of peace and harmony—in the ways of the knights, the samurais, and the *mujahedeen*—and until we understand that the production and the sell-ing of terrifying and destructive weapons is a crime,[1] we cannot say that our civilization is modern and advanced. In fact, our civilization relies on force to the detriment of the weak and the human race. And its modernity is nothing but a technological lure that hides its anar-chist, over-excited nature; one that is devoid of love for fellow humans.

I would like to add that those who contribute to creating a gap be-tween Islam and the West are committing a great mistake, for they are in the process of nurturing, on both sides, hatred, wrath, and revenge. No one can deny that there are in the Muslim world more than one billion human beings with their economic, social, cultural, and politi-cal problems. The Muslim world needs to be helped in finding its sta-bility and its balance; its path of the middle ground. To push it back or show no interest in it is nonsense, for the future of all people depends

[1]Reference here is to the *hadith,* "The Prophet, peace be with him, forbid the selling of artillery in periods of turmoil." Reported by At'Tabaranee.

on its stability and its growth. It is by way of dialogue, mutual aid, and through the universal brotherhood that the human race will come to be, or will not.

Islam deals with people as they are, in their contradiction. Being neutral, I conceive the fact that a man or a state defends his or its interests. But, and without wanting to moralize, I would simply say: Let us be more human and let us learn to better know ourselves, so that we can turn back a little more toward the archetype of the universal man. From now on, our politicians, our sociologists, our philosophers . . . must inspire themselves from this human dimension, in the true sense of the word, and must better understand it for the well-being of all. We must stop pouring oil on the fire. If there is a problem in Algeria, Yugoslavia, Tibet, or somewhere else, it concerns us all, for the despair of some does not make for the happiness of others. Otherwise, we only create a happiness and a peace that are artificial, and last but an instant; and we must not be surprised if, sooner or later, the despair of some re-emerges on others. For example, the tragic problem of drugs in the West is a return swing of the pendulum of the colonial and warlike attitudes displayed against China and other countries of Asia.

It is urgent to adopt a responsible human behavior, with ourselves as well as with our children, our neighbors, and our enemies. We must try to embody the universal values so as to transmit and defend them, for they are in jeopardy. Fundamentalism exists not only in the Muslim world, but also in other societies. It denotes fear, ignorance, and a loss of sense. By isolating themselves, these ways of fundamentalism hope to be able to survive and stay away from the agonies of the world. I think that we cannot deny this phenomenon in the world, but, unlike the media which cares only about what to feed its audience, I believe that we must minimize this call for seclusion and confrontation by going back as often as possible to the positive values of the universal man.

With regard to its scientific, technological development, we pretend that our modern civilization is the most brilliant. In what sense, if it is not able to realize this dimension of the universal man? Will it be more brilliant by denying the actual problems of men and women and by becoming incapable of nourishing them on all levels? What character-

izes a civilization? The aircraft? The computer? It is the duty of a civilization to be able to nourish people and to answer to their material and spiritual needs, to their essential inquiries, so that they may see some sense in their lives. If this is not the case, then it is very late; it is the decline! When the mind is no longer present in the community, wisdom soon leaves; then conscience weakens and reason loses its trail. (*See footnote page 114*).

Even spirituality has become a business, with its marketing; this book is proof of it! You go into a store and you find all the spiritualities —in videos, books, cassettes . . . Of course, books have their role to play, but things must stay within their limits. A book is no more or no less than a map. It gives you some explanations, but there must be practice after that. Theory is nothing but wind if it is not followed by serious and constant practice. Spirituality will never be found in books. Never! It is almost like a person who, hoping to get to the United States, contents himself with buying and studying a map of the country. He will be able to locate Washington and know different routes from the east to the west, but he will never take on the journey because he is lazy or afraid of the idea of confronting the vicissitudes inherent in the trip. On the other hand, someone who does not know how to read a map will decide to cross the country. Who among the two has accomplished the trip and can talk about it? Here resides the difference!

People who read books and learn techniques thinking that one day they will discover this inner dwelling are wrong. Some moan in their suffering, but they have never spent one night making at least a step ahead toward the quest for the truth outside themselves and their small world. How can we discover this truth? By living it everywhere, and at the same time, by ceasing to deny it through our aggression and lying to other people and ourselves.

Truth consists, first of all, in harmonizing ourselves with all our contradictions and in taking the staff of the pilgrim. Spirituality is nothing but the expression of simplicity. We find it everywhere: in a child, an old person, an ignorant, a savant . . . We must not think that Sufism is a school which awards diplomas of expertise in spirituality or in eso-

tericism to high-thinking heads. Tassawwuf consists simply in transforming ourselves inwardly, and in reflecting this transformation.

The master is happy only when the disciple goes beyond him. Tassawwuf is not a school where the knowledge, the faith, and the ideology of men and women are forged, but a place where people are prepared to be spiritually awakened so that they understand, on their own, their truth. If this concept, this school, has been able to make it through time and reach us intact, this does not mean that it has not been fought against and denigrated. On the contrary, and many Sufis have been tortured by tyrannous doubting powers, by scholars full of their knowledge, by sanctimonious people who render the world to the image they make of it, by hypocrite monks who give away their souls to one who pays more, and by ignorants who pay highly for false truths. Tassawwuf needs neither followers, nor to be defended, and even less to be glorified. It is the path of "Those who walk on earth with humility, and who answer 'Peace' to the ignorants who address them," (*sura* 25, verse 63). There are those who are concerned and those who are not. And the Prophet, peace be with him, says, "It is being a good Muslim for one not to occupy himself with that which regards him not."[1]

In the Cartesian[2] society, the pending problem is their belief that knowledge can be acquired through the intellect alone—by reading, analyzing, and storing as much information as possible. On this path, such a conception leads nowhere! The return to the original simplicity is possible only by learning to relinquish that which we know. It is a question of dusting and reviving the simple and universal values which are the fundamental characteristics of man's heart.

These values are brought to life again by the Sufi tradition and, at a given time, it is indispensable to choose one of them. It is the pride and the blindness of the nations that cause these values to perish.

It is always because of pride and pretentiousness that one ends up boasting, using words such as, "I am far better than everybody else

[1] Reported by Abee Hurayra. *See Az'Zuhd* of At'Tarmedee.
[2] Of or relating to René Descartes and his philosophy.

and I possess the truth . . . I have a better spiritual teacher, a better prophet, a better religion . . . " There exists only one "best," it is the Divine, indefinable and unknown. And it is toward Him that we all must head. If I am attached to a tradition, I must first try to find whether there is still somebody capable of teaching it to me. I can also act like the bee which gathers pollen and makes no distinction among flowers, for the most important thing is to find the pollen, the nectar. This means that men and women must start their quest to find their way, without depriving themselves of quenching their thirst in the common spiritual heritage of mankind.

When I choose a path, I must not declare that it is the unique one, and that outside of it there is absolutely no peace, for the Truth is everywhere. Those who adopt such an attitude shut the door of divine mercy. They will go around in circles all their lives, prisoners of their passions and their fantasies. The only one who will advance on this path is one who is humble and aspires to nothing but the desire to love, to be accepted by God, and to serve Him throughout life. Whether I eat, sleep, or work, I perform every daily activity in the name of the Lord. Every gesture reveals this Presence. Realization is to become more and more enlightened by Him.

In Sufism, we call on the Divine that He may dwell in our conscience and our hearts which are terribly saturated with our passions and our desires. For Him to reside therein, the abode must be empty, cleared of all the impurities linked to what we think we know. God is by the side of those who are in need of Him.

Prayer is an essential tool in this process; one that can help us a great deal.[1] Despite our differences—which are not a malediction, as some think, but a benediction—prayer leads us to find ourselves in God, and trust each other. By becoming aware of the oneness, we become aware of ourselves and others. I do not believe in luck, I believe in Divine will. Every one has his or her own faith, his or her own belief. It is by God's will and not by chance that different religions connect.

[1]Reference here is to the Lord's holy words, "Prayer restrains from shameful and un-just deeds," (*sura* 29, verse 45).

Thus explains *The Qur'an,* "O ye people! We have created you from a male and a female. We have made you into nations and tribes that you may know each other. Verily, the most honored of you in the sight of God is the most righteous of you," (*sura* 49, verse 13). Different indeed, not for the purpose of fighting each other, but to know each other, that we may reflect each other and enrich ourselves with our differences.

Mankind has reached a threshold. Either it becomes aware of itself and chooses to turn back toward unity or it heads for its destruction. As humans, if we change internally, and tolerance inspires our encounter with each other, we can change the critical end toward which humanity is heading. The West as well as the East must cease to believe that their cultures are unique, for there are other models which are part of the spiritual and cultural heritage of humanity. If we condemn other religions, cultures, and races in the name of a sacrosanct truth, it would be an irreparable damage for all of us. Truth is nobody's monopoly. It is not human, but divine. Every day, it must be intensely sought, revived, and glorified by all of us, for we need it to guide us.

I, myself, have known some aspects of Islam through others, by approaching non-Muslims, like the Muslim and the Christian who were praying in the desert, each according to their own tradition. Both have admitted that there is no creator but He, that there is no truth but the Truth. Then, in the soundless immensity, one exclamation was enough: "God is Most Great!" (*Allahu Akbar*). He is greater than all of us, above all of us: laborer or president, black or white, Jewish or Muslim. I invite each person to make a step toward the other, as in Mecca where the pilgrims turn around the Kaaba, around unity, prostrating to each other.

If I may pray, let the prayer be that God guide our steps and render us more tolerant, that He take hatred away from our hearts and replace it with love. That He take wrath away and replace it with His wisdom so as to render us more conscious of ourselves and of others, and to allow us to share this gift that we have received, life.

To conclude, I would say that everything we have evoked here has no value for one who contents oneself with reading it. This testimony

is of no worth unless it allows the reader to engage in the path of the Truth. No matter what the chosen tradition is, the most important thing resides in the fact that the quest for God, for the Absolute, be done in total sincerity and with no pretension. Otherwise, this quest has no foundation and no objective, and is nothing but words. This text has no value unless it sparks acts, accomplishments which will give life to all that is nothing but theory. Each individual must effectuate his or her own journey, for God reveals Himself to each one of us in a different manner, just like the Prophets, peace be with them, who were each the witness of a different manifestation of the Truth.

Thus, the path leading to the true God is a path of hope, of tolerance, one that carries the germ of life, of a renewed mankind which awaits the savior, the Messiah,[1] the time when truth will triumph over error, when good will triumph over evil, when generosity will triumph over egoism, when sanctity will triumph over perversion, and, last, when humanness will triumph over animalism. All religions announce and await these messianic times. But who among us will recognize him and will follow him? In this respect, Sheikh Adda used to say: "The group prepared to receive the Messiah will have excluded from itself the idea of its ego! They will not be able to say, 'our family, our root, our religion.' They will be the group of the saints, the *mutah-harun* [purified]."

Finally, I say do not trust masters,[2] starting with myself. Caution must continue until the time when the relationship (with the master) is based on frankness, loyalty, friendship, devotion, and absolute love. If we have not attained this level, there is still no master. The master is nothing but a mirror, thanks to which disciples contemplate their ugliness and their

[1] The Prophet, peace be with him, says, "Jesus will surely come (down from heaven), powerful and just; he will surely destroy the cross, he will surely remove levy . . . Hatred and envy will surely cease to be, and no one will care about money anymore." Related by Muslim.

[2] Reference is to the *hadith* of the Prophet, peace be with him, "People are about to enter an era in which Islam will remain but a word, *The Qur'an* but a shape; their mosques will be full but hollow in faith; their men of knowledge, the most wicked of all that is under the sky. Those with them will boast corruption."

beauty. And do get closer to the master who says, "I know that I do not know."[1] And God knows best. And to Him is our return.

"Religion is sincerity," the Prophet, peace be with him, says. This book wants neither to convince nor to convert. It is simply the testimony of a man whom destiny has placed where he has never asked to be; a man of faith, a servant, one submissive to His Will, with no merit nor claim therein.

I ask God the Merciful to forgive the errors of my imperfect language in describing His hallowed path; I ask the reader whom I might unwillingly have hurt, and my brothers and sisters, who believe in the One, to forgive me for my ignorance. Amen.

[1]Reference is to the hadith of the Prophet, peace be with him, "A people will appear who will read The Qur'an and say,'No one knows how to read the holy book the way we do, and there is no one better than us in matters of religion." Then the Prophet asked his comrades, "Is there any good in these people?" "Only God and His Messenger know," they responded. The Prophet, peace be with him, then said, "Those are the fuel of hell." Related by Omar, may God bless him, and reported by At'Tabaranee in his *Awssat* and also by Abu Ya'ala.

EXTRACTS FROM

The Deewan
of Skeikh Al Alawee

The poems that have been composed to the glory of God and the Prophet, sung with or without instrumental music, have made it possible, throughout the centuries of decadence, to save the Islamic identity of the *maghreb* (West) and the *mashreq* (East).

Sheikh Ahmed Ben Mustapha Al Alawee (1934–1869), whose monumental works have just started to be known in the West, has written more than three thousand verses illustrating this inner quest where the passion of the divine love and of the mystic states incites us to realize this superior ideal.

"To those who believe not in the hereafter applies the similitude of evil; to God applies the highest similitude; for He is exalted in power, The Wise."[1]

When we become aware of the important role that these poems play in the sessions of *dikr* of the Sufis—sessions of invocation to God—

[1]"To God is the supreme ideal," (*Qur'an, sura* 16, verse 60).

through the force of the word that is incarnated in the Arabic language, through the hidden allegories which penetrate the heart of the soul, through the rhythm, the measure and the voice with which they are sung, then a celestial harmony emerges, an atmosphere where every participant tastes some moments of inebriation and Divine Presence in which all one's being is drowned.

> Succeeor of Sheikhy Al Buzaydee, who was an affliliate to the spiritual chain Derqaweeya-Shadeleeya, Sheikh Ahmed Ben Mustapha Al Alawee established a new spiritual branch which holds his name. The sanctity of Master Al Alawee caused many disciples, from almost all the countries of Islam, come to him. His word had a considerable impact, not only through masterly attacks on modernism but also through the dazzling audacity of treatises and poems which provoked the admiration and the gratitude of some, and the indignation of others.
>
> —*Extracts of Traditional Studies, 43rd year, 1938, p. 292*

The reading of these few poems, extracts of his *Deewan,* and of some of his wise sayings will make it possible to imagine the diverse reactions to which the writings of the Master gave birth.

Although no translation would be able to reflect the beauty of these poems of Sheikh Al Alawee, the following have been translated for the first time to French by The Friends of Islam, known today as Terre d'Europe, and then to English to pay tribute to him.

■ Vessels of Love

Vessels of love pass among the masters
Annihilating them gradually

O noble men, I said, do you accept me?
Young man, they replied
You must be empty, that is the condition!

I hear you well, o noble ones
Still, I implore you, have mercy on me!

The truth is, there is but pain in me
And feeble are my deeds!

Compared to you I am nothing
It is on you that my hopes rest

The mention of your names
Is wine to my soul,
And your love is my fortune!

I have a burning passion for you
O that it may last!

O days lost in senseless matters . . .

Had this been my only aspiration
I would certainly have left all else behind

And wandered as prey to my passion
Welcomed by The True One

There is no blame in loving you
And any other blame I welcome

If only I possessed among you
This sublime station

■ O You Who Interrogate Me

O you who interrogate me, you will be responsible
For whatever damage our answer may cause!

Here is a detailed answer for you
Revealing the secrets of the inebriated

For every thing an access, a way
For every essence a sign, a mark

Every truth demands a proof
And each sincerity holds a firm constancy

For every lover a beloved
For every servant a master

My condition is indeed unique
I see it bewilders you

Whatever you see of us is pure illusion
For you know not my essence
It is far beyond you

As long as you believe that I am the one talking
About any of Attributes of Allah

All exaltation of us is feeble
And to compare us to others is to belittle us

All you know of me is that I am beautiful
When It is on Al Alawee that The Essence
Has marked Its Print

Great is the distance between us
As between the living and the dead

I am a mystery to you, still inaccessible
And it is safe for you to esteem it

All knowledge of us remains limited
For many are the flaws of the brain!

■ You Who Dwell in Me

You who dwell in me
In God's name, hasten not
O generous ones, treat gently your dwelling

Welcome, welcome o you
In whom my heart and mind are lost

May love leave me with no way out
That I may see none but you in the world

For is he not in error who sees other than you!
And surely to commit such a sin is not our intent

We only want to forsake everything
And see no space for anyone else but for you

This, my friend, is for those who have achieved Unity
For they are the vagrant
Those who have annihilated the world

Their families and their ties they left behind
once they realized the essence of all creatures

They realized that every manifestation
Is identical to its root
For the wave is no longer seen
In the immensity of the ocean

When the sun comes up all the stars fade
The moon is seen only in obscurity

So it is for the sages when LAYLA appears
For them all illusion in the two worlds fade

Her appearance requires them to isolate
From the elite as well as from the common

Their station is way beyond stain
And their state needs no explanation

And when they pray all is their Qibla
Wherever they go their desire is met

It is in all clarity that they contemplate The True One
And their closeness to Him is everlasting

When they drink the bitter becomes sweet
And their language is ambrosial and conclusive

Everything bows to their power
In their presence The True One perpetuates

May they rejoice for they have obtained
God's superabundant favor
They live in joy drawing profit from everything

Since The Perfect One has called unto them
And they have responded appropriately

■ O *Seeker of the Secret, Surrender*

O you, seeker of the secret, surrender
Do not disapprove of us

Leave behind your knowledge and come forth
That you may learn from us

Had you known before coming across me
You would not have needed us

By God! our knowledge is priceless
Far it is from having no worth for us

If you say you are a resolute seeker
That which you are looking for is truly in us

But if you think others might have this power
Turn to them, it will lighten our burden!

Certainly and by God I swear!
He will favor us who has savored the secret

In it I am indeed far ahead of all
Truly the glory therein is ours!

I reveal nothing nor hide anything
That is how it is between them and me

We give wisdom and we do not deprive
Him who has a share in us

Through this path we hope to find peace
And may God spare us

The evil of the Nafs[1] the way He knows
That it may have no influence on us

May Your Grace O Lord and Your Peace
Be on the spirit of our Prophet

And every venerable man
Among the people of Medina

[1] The self, the ego, the "carnal soul."

■ *The Song of Illumination*

The veils vanished
When my Beloved One appeared
O lovers of The Precious One
Time for Contemplation and Awakening

Let him who desires to partake
In our hidden secret
Come forth and learn
He will bathe in lore
What an excellent beverage!
Its cup bearer calls
O lovers of The Precious One
Time for Contemplation and Awakening

It is through this subtle wine[1] that those
Gifted with discernment became conscious
They have tasted this beverage
From its holder who has filled the vessels
Of this ancient and rich drink
That plunges the lover into bliss
 O lovers of The Precious One
Time for Contemplation and Awakening

The master of this wine poured a round
Among the inebriated
Hence the veils have fallen
But what can he understand who is veiled?
The poor one, nothing but pain has he given me
He does not know what this is about!
O lovers of The Precious One
Time for Contemplation and Awakening

[1]Wine mentioned in *The Qur'an* (*sura* 47, verse 15). By "drink," "wine," the
Sufis mean the Divine Love.

■ *Enslaved by Love*

The beauty of Layla
Has enslaved me

And the heart is lost
With the lovely one

And the eyes tear
Cesselessly down my face

Her arrows pierced me
They made me sick

With no goal in mind!
I lean toward none but her

And in the world
She has none like me

O young man, said she
Slowly! come . . .

Approach me with respect
And heal yourself from your ardent thirst!

Her discourse increased
My confusion

And had it not been for the glass of wine
That allows union . . .

I understood her words
I was quick in grasping them

Through an allusion, a smile
With no need of proof

We profited greatly
And we stayed together

Between sobriety and inebriation
For a long time

I kept the veil
That was hiding my intimate one

For fear the disgraceful
Should approach with his venom

On You be Peace, said I
O Layla

And on the assembly of the noble ones
Who have allowed me this matrimony

O Source of Peace
Gracefully bless

Him who is a light in the darkness:
Taha, our guarantor

■ O *Loved Ones*

O loved ones, your satisfaction is all I seek
My love for you increases ceaselessly
And has possessed me
You are my dearly beloved
Your spirit has made me drunk
And my heart refuses to forget your encounter
You have conquered my heart, and that is my offering
The sleepless nights you have left me
Bears witness to my love
You are my ideal, my desire, my elixir, my inebriation
You who hold my love
Who else could I have other than you?
You are my sustenance, my refuge
My goal, my support
You who are worthy of attachment
Rejoice! Rejoice!
How abundant is the radiance
That surrounds you during Dikr!
When the melodist sings The Name of your Master!
Answer to this Dikr! Let me see you
Inebriated and immersed
He who calls has called you
You tenderly aspire to The Truth with a
Momentum that suits you
You have forsaken all that perishes
And abandoned everything else
In the tumult of life The Lord has preserved you
In The Sublime Presence, you have unfurled your flag
Thank The Lord without end
And may He protect you
O you who hold the Secret, my heart loves you!
All along my journey
I have loved with passion none but you
Your absolute satisfaction is my sole ambition in life

■ These Men Who Have Vanished

These men who have vanished in The Divine Presence
By God they have melted like snow

Amazed in their contemplation of God you see them
Truly inebriated therein

You see them bathing drunk at the mention of Allah
The Divine Presence shines upon them

Influenced by the Beauty of God the singer chants
Zealously, they right away stand to glorify Him

Their breath is a breeze from God
Their life subsists with the very Life of God

They are hearts swirling around in God's Mercy
Truly overflowing secrets

Masterminds captured by The Divine Dominion
Humble souls in their quest for God

They are the fortunate through their bondage to God
They are the most fearful

He who sees them has witnessed those
Who act through none but Him
They are divine sources among men

May God's Mercy and His Bliss be upon them
May a scent of His Presence be with them

■ *Dikr is the Source of All Good Things*

 Dikr is the source of all good things
So reckless was I and a great deal of time did I waste
Those are forever gone; what to do now?
From now on, I must take advantage of my time
And sincerely mention God
And be present through my heart
And through my mind
Dikr is far better than trade
Ah! If I told you what it is worth
It is worth more than royalty and its ministry
But people, in their ignorance, neglect it
This whole world is a waste
It has invaded the just as well as the unjust
May God protect us from its heat

I fear lest my soul become a mount for this world
And in its hands I remain captive
After Divine Assistance and good virtues
 Dikr is the source of all good things
O Lord! Calamities have spread everywhere
And Dikr has become a heavy burden on the tongues
People have embraced strange ways
Their conditions, too, are multiple and different
The One Sought is hidden in the quests
For sincerity is so rare
People's hearts are hard
Advice is vain to the lords of evil
I can take it no more
What are my words
Compared to those of the Prophets?
 Dikr is the source of all good things
The sleepy can be awakened
But he who is dead is insensible

Preaching to a dead soul makes no sense
I am building my foundation on sand
People's behavior may lead to insanity
They are after God's wrath, their own failure
A mighty judgment awaits them

Judgment Day, what a tragedy!
If only you knew what will happen
If I told you, you would turn away from sin
 Dikr is the source of all good things
O brothers, let us repent
And together mention God in prayer!
In the other world, that is all we will find
And time is so valuable
Let's not waste it!
The damned one will have God as his judge
Refusing advice
He does not want to obey
He disobeys his Lord by committing great sins
Reminders to the believer are useful and healing
They strengthen both his heart and conscience
Thus will he bathe in honor
After going through the disgrace of sins
 Dikr is the source of all good things

O Lord! Help our community do good and seek virtue
Abrogate evil acts with good ones
Grant Your servants Your Pardon
For us and all Your living creatures
Your Clemency is essential
For we are all malicious
O Almighty One, I would like to repent!
So many evil acts did I perpetrate
In public and in secrecy

And people think I am fine
Had Your Grace not overwhelmed me
And manifested itself on me...
 Dikr is the source of all good things

You have made our words facts
They are now recorded in books
They manifest themselves on people like a zephyr
They capture the hearts and the souls
Every honest man craves them
O My God, conceal our blemishes
Al Alawee has hope
My God! Come to our rescue at the time of death
In the name of The Truthful One, Bearer of good news
To mine, to that of people here present
And those with good intention
 Dikr is the source of all good things

■ O *Mohammed,* **God** *Has* **Chosen** *You*

O Mohammed, God has chosen you
With my heart I praise you
For my tongue is unable to do so
Indeed describing the Beloved is way beyond me

I would like to glorify you, O Taha[1]
But no words can describe you
Certain praises do not attain, in the least
Your true worth
You are beyond description
Just like the stars in the sky
My feeble sight cannot reach you
 And from afar, you appear to my eyes

Elevated like galaxies, you are a twinkling star
O Mohammed, God has chosen you
With my heart I praise you
For my tongue is unable to do so
Indeed describing the Beloved is way beyond me
If only this community knew you
They would devote their lives
To your praise (Dikr)
In you there is wealth without striving
Misled is he who chooses other than you
The entire earth and the sky
The Throne and The Qalam[2]
All are from your light
 Here, my logic is impotent

[1]Taha and Abul Qassem: Two names of the Prophet.
[2]The plume.

What can I say about him who has
Ascended to the Heavens?
O Mohammed, God has chosen you
With my heart I praise you
For my tongue is unable to do so
Indeed describing my Beloved is beyond me

God's Light is incomparable
Incompetence in describing it is true wisdom
Presumptuous it would be if I dared to do so
Still, I can say a word
He has surpassed everything, root and branch
He was sent as a Mercy to all
 I trust him, and God is my witness therein

Humble, submissive, and in need
O Mohammed, God has chosen you
With my heart I praise you
For my tongue is unable to do so
Indeed describing my Beloved is beyond me

Lying does not increase courage
Without you, I would have never
Known the Almighty
Nor religion, nor prayer, nor direction
Your grace has manifestly submerged us
Through it I have gained might and fame
On earth as in the heavens, I bathe in pride
 I am in love with you, forever

My heart throbs, my tears flow
O Mohammed, God has chosen you
With my heart I praise you
For my tongue is unable to do so
Indeed describing my Beloved is beyond me
The Lord of creation has blessed you
O master of all masters
I desire you with fervor
This praise is my plea
I hope to have a happy ending the day of my death
And that of the resurrection
For my entire family also
And the poor in God
 The believers too have hope in your grace

My heart is so weak and fears torment
O Mohammed, God has chosen you
With my heart I praise you
For my tongue is unable to do so
Indeed describing my beloved is way above me
Where would be my dwelling?
How would I be received?
After separation, God knows
O Abul Qassem! I fear that confusion
Should overwhelm me on the terrible day
Forgive me, O Imam of messengers!
God forbid that you should forsake the weak

I trust you will accept my apology
Old age has afflicted me and
Times have become bitter
O Mohammed, God has chosen you
With my heart I praise you
For my tongue is unable to do so
Indeed describing my Beloved is beyond me

I trust you so much
Impossible that you would desert me!
Still the burden of my sins frightens me
For many did I commit!
O God have mercy on Ben Aleewa[1]
Deliver him from the grief of this world
At every instant the unexpected appears.

I cannot trust this unpredictable heart of mine
O Mohammed, God has chosen you
With my heart I praise you
For my tongue is unable to do so
Indeed describing my Beloved is beyond me.

[1]Ben Aleewa: name of Sheikh Al Alawee, founder of Tariqa Al Alaweeya, was born in 1869, and died in 1934 in Mostaghanem (Algeria).

■ My Tears Flow in Abundance

My tears flow in abundance
They weary my eyes

O soft evening breeze!
Carry my greetings to Taha . . .

Transmit to him my salutation, O breeze of union!
Mention to him the overwhelming unrest
His love has caused . . .

Enchanted by him!
I am unable to endure the impossible separation . . .

Presence of His Splendor!

O soft evening breeze!
Carry my greetings to Taha . . .

The light of the beloved, O lover
Attracts you to its bosom with no way out!
Should he with a fine intelligence perceive it
Let him be swept away and be delighted

Indescribable marvel!
He will know It he who attains it

He will grasp its sense
Who achieves this union!

O soft evening breeze!
Carry my greetings to Taha . . .

Follow then this Path, O you
Who desires to get closer to him!

Follow the guide who will lead you
Towards The Presence of The Prophet

Be aware not to deviate
From the path of Love

You will taste a sweet beverage
This wine which you will be served!

O soft evening breeze!
Carry my greetings to Taha . . .

He who serves wine in The Holy Presence
Is none but Taha, Al Imam

He will make you forget even the wine he offers you!
Do not blame me at all if I say

That he is the vessel itself!
The Light of Beauty covering all things . . .

O soft evening breeze!
Carry my greetings to Taha . . .

Splendor of The Essence, Mohammed Al Hadi
Radiance of The Divine Attributes

My treasure, my sustenance
My comfort and support at the time of death

On the day of Judgment
He is the only savior!

O soft evening breeze!
Carry my greetings to Taha . . .

He will indeed intercede
In favor of my followers!

This is my conviction
Total is my trust

In The Essence, who is my fortress
On the day of Judgment

I pray for The Mercy of The Lord

O soft evening breeze!
Carry my greetings to Taha . . .

I have none but Him! At the time of the test
In Him alone rest my hopes

What a glorious position his is!
Mohammed is my entire Hoard!

My heart is in love with Him
And that is a life commitment!

His grace ceases not
To cover all men

O soft evening breeze!
Carry my greetings to Taha . . .

■ O Disciple Victory is Yours!

O disciple victory is yours!
Hurry, go toward the One you love

If you desire to annihilate yourself in Him
Do not listen to anyone but Him

Let your heart be present in His Name
Visualize It and understand Its secret

Direct your face to none but His
Since for Him you quiver with desire

Cast down your eyes in His Presence
And look within yourself and you will see Him

You are far from His Beauty
And yet you are none but Him!

Should they ask: who are you referring to?
Openly declare: Him, Allah!

I am annihilated in Him and by Him
He sees me just as I do Him

None can take His place
Lovers have lost themselves in Him

Inebriated and amazed in Him
They reveal and speak about Him

He is my goal and that is no mystery
My heart never forgets Him

At times He dissolves me in Him
And through me He emerges with His full splendor

Other times He perpetuates me through Him
"I" says I, then, not "He"

He! He! My desire is in Him
My essence and my spirit love Him with passion

Allah! Allah! I mention none other than Him
All my words are His Splendor

My Beloved! My Beloved! I hide Him
For I fear the day I meet Him . . .

He is my secret! I will not give Him away
Except to him who knows what He is

He is my destination for Whom I forsake all things
He took my mind away from all that is not He!

It is by His Command that I speak
When I do it is by Him and for Him

I send a prayer that pleases Him
To the one He has favored and chosen

To his family and heirs
And the ones who seek refuge in him

Al Alawee is annihilated in Him
He only desires His bliss

Mohammed, I know what is in him
He contains all beauty

O Lord bless him
A blessing worthy of his essence!

■ My Eyes Were Overwhelmed

My eyes were overwhelmed
The day He clearly revealed Himself
The irresistible violence of my Beloved
Is enough for me as an excuse
A troubling matter that dazzles the minds
I came to know Him when He appeared in me

Thank God for that which my eye has seen

It is a hidden secret disabling all but me
Many are His Aspects! Who is to know
That He actually can reveal Himself
As the heat of the embers?
Glory to Allah! He no longer hides from me!

Thank God for that which my eye has seen

The spirits evolve in The Holy Presence
If only you could see, O my friend
What is behind the garment
It is like a lamp in the niche of the sensible world
Its intimate sense expresses itself in all forms

Thank God for that which my eye has seen

I declared my love loudly I spread it among people
I said O noble ones
The beloved One I have found Him!
Yet all men deeply asleep
None to say he has seen Him
By God I swear He is never out of sight!

Thank God for that which my eye has seen

All words are vanity
Except those of The Beloved One
An impossibility they are devoid of any existence
All things are illusion that realization annihilates

Except The Face of Allah Which is
Enough for him who is sighted

Thank God for that which my eye has seen

O you who is sighted if you are not that dazzled
Ask yourself and contemplate
Who then manifests himself through creation?
If you answer: Allah The Well-Informed
We will tell you: Conceal this secret
And that which you hear as coming from me
Know that it is from Allah Himself

Thank God for that which my eye has seen

Truly I am wise in these skills I am gifted
Eternally unique I have no challenger among people
I care less about the detractor incapable of grasping
Unmindful of God my art is beyond him

Thank God for that which my eye has seen

If only he could wake up from the torpor
Of the world of the senses
And take a companion towards The Holy Presence
Like me worthy of trust in this Cradle of Intimacy
And by being sincere in Allah
He would perceive my words
Thank God for that which my eye has seen

Certainly among the sciences
There are some which prove
That I am unique in this sublime station
Know O disciple my name and speak and guide
Ibn Aleewa has power over me

Thank God for that which my eye has seen

■ Wise Sayings

He who contemplates God through creatures
loses sight of them
by disappearing in Him
and only The Divine remains for him

The knowledge of Unity is like fire
it enflames every single thing
it comes upon and by the very act purifies it

Do not forsake your soul (Nafs) nor be its enemy
be its companion instead and try to know
what it holds within.

There is not a single atom in the universe that
carries not in it one of the Names of The One Adored.

Tree of Ancestry in At'Tariqa Al'Alaweeya

Mohammed

'Ali Ibnu Abee Taleb

Abu Bakr As'Seddeq

Salman Al Faressee

Al Qassem Ibn
Mohammed Ibn Abee Bakr

Anas Ibnu Malek
Mohammed Ibnu Serene

Habeeb Al'Ajamee

Dawood At'Ta-ee

Al Hassan Al Basree

Ja'afar As'Sadeq
Moossa 'Reda
'Ali Ibn Moossa
Ma'aroof Al Karkhee
Saree As'Sqqat
Abu Al Qassem Al Junaid

Abul Hassan 'Ali An Nouree
Abu Bish'r Al Jawharee
'Abdellah Ben Abee Bish'r
'Abdel Jaleel Ibn Waihalan
Mohammed Bennour
Ayyoob Ibn Sa'eed
Abu Ya'aza Ben Maynoon
Al Gharb

Al Hassan As'Sebt
Abu Mohammed Jaber
Sa'eed Al Ghazwanee
Fat'h As'Su'ud

Al Hussein As'Sebt
Zain Al'Abedeen
Mohammed Al Baker

Abu Yazeed Al Beztamee

Abu Nas'r Al Karshanee

Sa'ad

Abu Mohammed Sa'eed

Ahmed Al Marwanee
Ibraheem Al Basree
Zain Ad'Deen Al Qazweenee
Mohammed Shams Ad'Deen
Mohammed Taj Ad'Deen
Nour Ad'Deen Abul Hassan 'Ali
Fakhr Ad'Deen
Taqey' Ad'Deen Al Fuqair

Abu Bakr Ibn Jahdar Ash'Sheblee
Abul-Faraj'Abd Al Wahhab At'Tameemee
Abul Faraj At'Tarasussi
Abu'Ali Al Hassan Ibn Yussuf
Said Al Mubarak
'Abdel Qader Al Jelanee

Abu Ya'aqoob Es'haq An'Nahrajure
Abu Sa'eed Al Maghrebee

Ash'Shashee
Shu'aib Abu Median
Abu Mohammed Saleh Ibn Bensar
Mohammed Ibn Harazem

'Abder'Rahman Al'Attar Az'Aeyyat
'Abdes'Salam Ibn Masheesh

Abu Al Hassan Ash'Shadelee

Abu Al'Abbas Al Mursee

Ahmed Ibnu'Ata-eel-Lah Al Eskandaree

Dawood Ibn Bakhelee

Mohammed Wafa Bahr As'Safa

'Ali Ibn Wafa

Ya'hya Al Qaderee

Ahmed Al Hadramee

Ahmed Zerrooq

Ibraheem Al Fah'ham

'Ali As'Senhajee Ad'Dawwar

'Abd Ar'Rahman Al Majdoob

Youssef Al Fassi

'Abd Ar'Rahman Al Fassi

Mohammed Ibn 'Abdellah

Qassem Al Khessasse

Ahmed Ibn 'Abdellah

Al'Arbee Ibn 'Abdellah

'Ali Al Jamal

Al 'Arbee Ibn Ahmed Ad'Derqawee

Abu Ya'aza Al Mahajee

Mohammed Ibn 'Abdel Qader

Mohammed Ben Qaddoor Al Wakelee

Mohammed Ben Habeeb Al Buzeedee

Ahmed Ben Mustapha Al'Alawee

'Adda Bentounès

Al Mehdi Bentounès

Khaled Bentounès

Glossary

Abu Dahrr Al Ghifaree *See* Ghifaree.

Abdes'Salam Ibn Mashish Morocco (around 1150). Eminent Sufi, master of Ash'Shadeelee and leader of Djebala (people of the mountains).

Abdel Qader Algerian hero, Akbarian mystic of the Tariqa Qadereeya, died in Damascus in 1883, author of *Kitab Al Mawaqef* (*The Book of the Stands*).

Abu Said Ibn Al Khair Maghreb, died in 995.

Adda Mostaghanem (1898–1952). Successor of and son-in-law of Ahmed Al Alawee. Poet and a grammarian.

Al Alawee Ahmed Successor of Sheikh Al Buzaydee of the Derqaweeya Shadeleeya spiritual chain. He established a new initiatory branch which holds his name. He was born in Mostaghanem (Tidjdit) in 1869, died in 1934. He published many writings, one of which is *Al Menah Al Quddusseyah, Sacred Gifts of Revelation.* He was a great reformer, a modernizer, a true bridge between the *Maghreb* (Northern Africa—Morocco, Algeria, Tunisia) and Europe.

Al Hadj Al Mehdi *See* Mehdi.

Arafat Plain in Saudi Arabia where, according to tradition, Adam and Eve found each other after having been thrown out of paradise. One of the stations of pilgrimage.

Ba Second letter of the Arabic alphabet.

Baraka Virtuous influence of a saint, dead or alive. Spiritual power of a master which he communicates when he initiates students in God's way.

Barzakh Barrier between two worlds.

Basmala Opening words in invocations—*Bismi l'Lahee Ar'Rahamani Ar'Raheem* (In the Name of God, Most Gracious, Most Merciful). Always pronounced before action and, actually, sanctifies it.

Basri (Hassan Al Basri) Born in 641, died in 728. Son of Oum Salama. He was brought up in the house of the Prophet.

Bismi l'Lahee Ar'Rahamani Ar'Raheem In the Name of God, Most Gracious (for the creature) Most Merciful (for all creation).

Bokar Tierno Malian, born in Ségou in 1875, in the heart of Africa, in the region of the ancient empire of Mecina. Known as the sage of Bandiagara, he died in 1940.

Buzaydee Mostaghanem. Died in 1909. Master of the brotherhood of Ad'Deerqaweeya—which was initiated by Sheikh Al Wakeelee. Master of Sheikh Al Alawee .

Dikr Invocations, prayers in which God's Holy Names are repeated.

Du'aa Mandatory prayer of invocation and special requests toward the Lord.

Eh'ssan The best of acts, the excellence of faith.

Emara Literally, presence. Ecstatic mystic dance.

Fana The state of extinction in the Divine to the point of total annihilation.

Faqeer Literally, poor. The word used to refer to a disciple in the Sufi way.

Fatiha First *sura* of *The Qur'an,* named The Mother of The Book. It means the opening.

Fuqara Plural for *faqeer.*

Ghifaree One of the earliest companions of the Prophet, known for his asceticism and his spiritual perseverance.

Hadith Words of Prophet Mohammed, whose collection constitutes the Sunna (tradition).

Hadj Pilgrimage to Mecca, fifth pillar of Islam.

Hadra The Holy Presence of the Lord. Also *emara*.

Hagar Second wife of Prophet Abraham, and mother of Isma'eel.

Hál Transitory and partial realization of a spiritual degree.

Hanif Believing in God's unity.

Hunafa Plural for *hanif*, believing in one God.

Iblis Fallen angel who seduced Adam and Eve to take them out of heaven.

Ibnu Al Arabee Murcia, 1165-Damascus, 1240. Named and known as Sheikh Al Akbar, "The Glorious Master." He is the author of many books, the most famous of which are, *Al Futuhat Al-Makkey-ya (The Meccan Revelations), Fusus Al Heekam (The Wisdom of The Prophets)*.

Ibn Sabin Famous Sufi, master in the Platonic philosophy of Frederic II. Died in Ceuta.

Ihram State of sacredness observed during the pilgrimage.

Iman Faith. Also, *eétiqad*.

Jabal An'Nour Mount of light, next to Mecca, where the cave of Heera is; it is the place where Prophet Mohammed received his first divine revelation, (*sura* 96), through the archangel Gabriel.

Ja'far As'sadeq *See* Sadeq.

Jamarat A sum of forty-nine mine stones used to stone Satan; stage of pilgrimage; endeavor, spiritual fight, man's participation to his sanctification.

Kaaba A cube symbolic of God's house, situated in the center of the sanctuary of Mecca toward which Muslims of the whole world turn to pray.

Khalifa Lieutenant and God's vicegerent on earth (Adam, for example), also chief of the community of believers, spiritually and materially.

Khalwa Spiritual retreat.

Lá eláha ella 'Llah Declaration of faith, attesting God's Oneness, "There is no god but Allah."

Lateef One of the ninety-nine names of Allah, meaning The Subtle One.

Maghreb Forth canonical prayer. Also, Morocco.

Majdoob Derivative of the verb *judeeba,* to be enchanted; he who is enchanted, ecstatic. A name given to the lovers of divinity.

Mehdi Mostaghanem (1928–1975), son and successor of Sheikh Adda.

Mashish More or less 1150. See Abdes'Salam Ibn Mashish.

Mohammed Prophet of Islam, born in Mecca around 570 AD, died in Medina in 632 AD. He finishes the cycle of prophethood.

Munajat An intimate conversation with God.

Muqaddam Official in charge, spiritual director of a zaweeya, appointed by the *fuqara* and confirmed by the sheikh.

Mussamme'eh The person who sings poems, giving thus the adequate rhythm and flow in *dikr* performances of the Sufis.

Mutah'haroon The pure, the saints.

Muthakara Words through which the Sufi teachings are transmitted.

Muzdaleefa Place where Satan tempted Abraham; station of pilgrimage.

Nafs *An'Nafs Al Am'mara,* soul which seduces one into sin, *An'Nafs Al Lawama,* soul which blames, *An'Nafs Al Mutma'eenna,* calm and peaceful soul.

Qur'an Sacred book of the Muslims revealed by Allah to Prophet Mohammed in its original form, which is still preserved in heaven on God's tablets (*sura* 85, v, 22). It confirms previous revelations in *The Torah* and The Gospel. It contains 114 *suras* (written texts) composed of verses (*ayat:* signs, miracles). It is the essential foundation of the law and the faith.

Rabee'aa Al Adaweeya Sufi woman, an eminent mystic figure of Islam (713–801).

Rahma Mercy.

Rakaa The three stations of the body during prayer standing, bowing, and prostration. Each prayer involves a certain number of *rakaas.*

Ramadan Ninth month of the Muslim lunar calendar during which fasting is observed from dawn until sunset, third pillar of Islam.

Sabin Murcia (+ 668). Sufi philosopher to whom were submitted, for him to answer, "The Sicilian Questions" of Frederic II of Hohenstaufen.

Sadeq Ja'far As'Sadeq, born in Medina in 702, died in 765.

Salam As'Salamu Alaykum, (peace be upon you); form of greeting.

Salat Derived from the word *wasala* unite, bond. Canonical prayer. Second pillar of Islam.

Sama' Spiritual concert of the Sufi gatherings.

Seeyaha Pilgrimage done to meet members of the brotherhood; exchange ideas in the path of God.

Selah Derived from the verb *wasala* unite, link (bond); bondage.

Selsela Tree of ancestry in *tariqa*.

Seyam Fast of the month of Ramadan. Fourth pillar of Islam.

Shahada Declaration of faith.

Sharee'aa Canonical law.

Sheikh Spiritual Master representing a Sufi line of heritage.

Shiites Partisans of Ali (cousin of the Prophet).

Suffa (Ahl As'Suffa) People of the bench; comrades of the Prophet in Medina.

Sunna Ways and traditions of Prophet Mohammed as reported by his companions.

Sunni (Muslims) Those who observe the Prophet's way and accept his successors (the four *khalifas*).

Sura Chapter of *The Qur'an.*

Tariqa Esoteric path, brotherhood.

Tasbeeh Derived from the word *sabbaha,* which means "to glorify God"; Muslim rosary composed of ninety-nine beads.

Tassawwuf Mystic way of Islam. Sufism.

Tawaf Derived from *ta'fa,* turn, revolution around the Kaaba with it being on the left side of the pilgrim.

Umrah Visitation to Mecca (a small pilgrimage).

Verse *See* Qur'an

Weerd, Dikr Al Am *Dikr of the selseela*—the initial chain of transmission. Started with Al Imam Ash'shadeelee (died in 1258) and is still practiced today. Its goal is to link the disciple to this chain of spiritual mystic masters. It is composed of diverse formulas to recite, in the morning and in the evening, a certain number of times. *Dikr Al Khass* (the special or private *dikr*) is a Divine Name that the Sheikh grants a disciple of his to recite in private, according to his abilities and his merit therein, usually for a definite period of time.

Zaweeya Root word is "angle," it expresses the encounter of the transient and the spiritual; official spot of a Sufi brotherhood.

Other Titles of Interest from Hohm Press

NOBODY SON OF NOBODY
Poems of Shaikh Abu-Saeed Abil-Kheir
Renditions by Vraje Abramian

Anyone who has found a resonance with the love-intoxicated poetry of Rumi, must read the poetry of Shaikh Abil-Kheir. This renowned but little known Sufi mystic of the 10th century preceded Rumi by over two hundred years on the same path of annihilation into God. This book contains translations and poetic renderings of 195 short selections from the original Farsi, the language in which Abil-Kheir wrote.

These poems deal with the longing for union with God, the desire to know the Real from the false, the inexpressible beauty of creation when seen through the eyes of Love, and the many attitudes of heart, mind and feeling that are necessary to those who would find the Beloved, The Friend, in this life.

Paper, 120 pages, $12.95, ISBN: 1-890772-04-6

RUMI—THIEF OF SLEEP
180 Quatrains from the Persian
Translations by Shahram Shiva; Foreword by Deepak Chopra

This book contains 180 translations of Rumi's short devotional poems, or *quatrains*. Shiva's versions are based on his own carefully documented translation from the Farsi (Persian), the language in which Rumi wrote.

"In *Thief Of Sleep,* Shahram Shiva (who embodies the culture, the wisdom and the history of Sufism in his very genes) brings us the healing experience. I recommend his book to anyone who wishes *to remember*. This book will help you do that."Deepak Chopra

Paper, 120 pages, $11.95, ISBN:1-890772-05-4

WOMEN CALLED TO THE PATH OF RUMI
The Way of the Whirling Dervish
by Shakina Reinhertz

This is the first English-language book to share the experience of Turning by women practitioners of the Mevlevi Order of Whirling Dervishes. It outlines the history of the women who have followed this way since Rumi's time, illuminates the transmission of this work from Turkey to America, and highlights the first twenty years of the Order's life in a new country and culture.

Paper, 300 pages, $23.95, ISBN: 1-890772-04-6, 240 black and white photos and illustrations

To order by phone 800-381-2700; by fax 928-717-1779
Visit our website at www.hohmpress.com

About the Author

Sheikh Khaled Bentounès is a tireless pilgrim and writer. Through his teachings and dialogues he invites men and women to recognize that they are the heirs of the message brought by the prophets of all traditions, and inheritors of an extraordinary patrimony, that of wisdom, a gift designed by Divine Mercy in all times and for all people.

Interreligious dialogue has been his lifelong endeavor. In this capacity he has been called on by the French government to consult on the Muslim religion in France. He also met with Pope Jean Paul II, and at the invitation of the Dalai Lama he participated in the *Tradition Exchange* seminar in Savoie, France, 1999. Sheikh Khaled contributed to the international conference, *For an Islam of Peace,* sponsored by UNESCO for peace and dialogue in 1998 and 2000. Together with renowned scientist Jean-Marie Pelt, he led the *Spirituality and Science* conference in the French Senate. At the invitation of the French ambassador to The Vatican, he represented Islam in France at the *Secularism for Europe* conference in Rome.

A sociable man of broad views, Sheikh Khaled is living proof of the universality of Islam. His thinking opens the door of tolerance by proposing an unrestricted and deep reading of Islam. His famous book, *The Inner Man in the Light of the Quran,* is a good example of this openness. Wherever Divine Will takes him, he demonstrates a culture of peace that combines efforts to find the common denominator among all people and the universal values that are the basis for a society that is more just, self-respecting, and enlightened.

Sheikh Khaled devotes himself to the education of youth, his first priority, through seminars and meetings in many countries. In the Maghreb, North Africa, as in Europe, he has worked to establish humanitarian aid for those in need by creating structures–through education, professional training, and health care–leading to greater autonomy. He has been aided in these efforts by the international Friends of Islam Association, founded in 1948 by his grandfather, the venerated Sheikh Adda Bentounès. This organization is known today as Terre d'Europe, and Sheikh Khaled is its honorary chairman.

For more information about his work, or to contact Sheikh Khaled, email: cheikh.bentounes@libertysurf.fr